the prophecy

Ri2o

Published by:
International Arts and Artists
9 Hillyer Court NW
Washington, DC 20008 USA
www.artsandartists.org

Printed on 100 lb Endurance Silt text in United States of America,
through Four Colour Print Group, Louisville, Kentucky

ISBN:
9-780988-349759 (hard cover edition)
9-780988-349742 (soft cover edition)

Library of Congress Control Number: 2016059254

IA&A Design Studio:
Manuel Leon, lead designer
Deanna Luu
David Seager

Editorial & Production:
David Walker
Seth Dorcus
John Long

Author:
Michelle Yun

Contributors:
Lisa Guerrero Nakpil
Ryu Niimi
Ambeth R. Ocampo
Yayoi Shionoiri, translator

Front Cover: *Who Killed Jose (Portrait of José Rizal)*, 2006. Acrylic on Paper, 29 1/2 x 21 1/2"
Inside Cover left: *Number 6F*, 2006, Graphite on Paper, 9 x 12" (color graphically altered)
Inside Cover right: *Number 18*, 2006, Graphite on Paper, 8 1/4 x 11 3/4" (color graphically altered)
Back Cover: reverse of *The Great Martyr*, 2007, Pen and Ink on Paper, 9 3/4 x 9" (graphically altered)

INTERNATIONAL
ARTS & ARTISTS

LORENZANA

Michelle Yun, author

With contributions by

Lisa Guerrero Nakpil
Ryu Niimi
Ambeth R. Ocampo

INTERNATIONAL
ARTS&ARTISTS

LORENZANA

ARCHIVAL COLLECTION

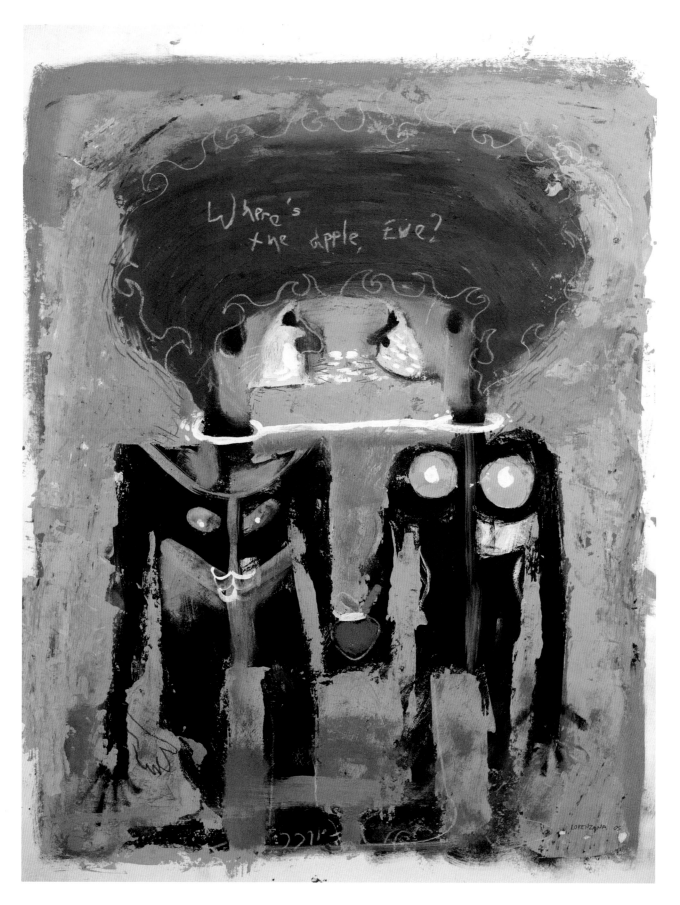

Adam and Eve, 2005, Acrylic on Paper, 27 1/2 x 19 3/4"

CONTENTS

Introduction by David Furchgott ... 8

El Romantico's Greatest Show on Earth: The Early Work of Luis Lorenzana by Michelle Yun ... 10

The Heroes of the Cretaceous Period by Ryu Niimi (English Translation) ... 20

Luis Lorenzana: Re-telling Philippine History by Ambeth R. Ocampo .. 24

Artist Biography by Lisa Guerrero Nakpil ... 32

Plates ... 41
 Paintings .. 43
 Sketchbooks and Studies .. 117

The Heroes of the Cretaceous Period by Ryu Niimi (Original Japanese Text) ... 216

Artist Curriculum Vitae ... 220

Introduction

It is truly an honor for International Arts & Artists to present this complete examination of the Archival Collection of Luis Lorenzana. This unusual and previously undisclosed selection of Lorenzana's work comes from a time early in his artistic evolution, when one can sense his emotions rising roughly to the surface of his paintings and drawings in raw and unrestrained bursts of impassioned force.

Luis Lorenzana fused his passion about his own life and love with his intimate knowledge of the inner workings of his native country, to develop explosive imagery about both. In the Archival Collection, his iconic figures evolve and one can almost taste these as his consuming obsessions.

We are extremely fortunate and thankful to have four varying viewpoints to consider this unexplored terrain. First, Michelle Yun, a curator of extraordinary scholarly depth and a specialist in contemporary and modern Asian art, insightfully examines Lorenzana's work of this period, dissecting its symbolism to provide even greater interest in his already intriguing imagery. Yun's lead and advice throughout the development of this study of Lorenzana has been crucial. She is an astute and gracious collaborator.

Beyond Yun's in-depth analysis of the key works of the Archival Collection, we have the advantage of Ryu Niimi's beautiful lyrical exploration of the entire body of Lorenzana's work. Niimi, a well-known curator and director of one of Japan's newest museums, poetically places Luis Lorenzana's work of this period in the broadest geo-political context.

We also owe great debt to Ambeth R. Ocampo, who is well known in the Philippines and recognized throughout East Asia as a historian and art historian of note. Ocampo explains the key Filipino historic figures presented in Lorenzana's major paintings. Thus he provides those who may not be familiar with the intrigue and drama of the evolution of independence in the Philippines with an opportunity for tremendous empathy and insight into a past that has led to a very tumultuous present.

Finally, most critical to the evolution of this publication—and to an accompanying exhibition in Manila—we are extremely grateful to Lisa Guerrero Nakpil, who has so adeptly portrayed Luis Lorenzana's life and the evolution of his art. Guerrero Nakpil provides us with tremendous awareness into the nature of the artist himself and his background that is consummated in this work. Within this very international team, Guerrero Nakpil was the mainstay who skillfully provided all the onsite organizing necessary to make a complex international pub-

lishing endeavor of this magnitude work effectively.

The independent exhibition that accompanies the release of this book in the Philippines was designed by Liliane Rejante Manahan, who has presented the Collection in an extremely remarkable manner. Jaime Ponce de Leon and Magdalina Juntilla of Leon Gallery International offered their full cooperation and courtesies in all aspects of this project, for which all involved are grateful.

We extend additional thanks to attorney Antonio Manahan, who acted as trusted counsel and advisor to this project. Ryu Niimi's writings on Lorenzana have been adeptly translated through Yayoi Shionoiri, whose guidance extended far beyond that of a translator and who showed great sensitivity toward this entire endeavor.

International Arts & Artists' team responsible for the development of this publication includes Manuel Leon, the lead designer, working side by side with Deanna Luu, another bright young talent within IA&A's Design Studio, and David Seager. Our editorial team included IA&A's meticulous staff editor David Walker and my equally diligent associate Seth Dorcus, who effectively gathered details from seemingly a thousand sources. We also thank John Long, our publication consultant, who ran the final lap in getting our writing and design to press.

Certainly most critical to the project is the artist himself: Luis Lorenzana, without whose genius the work itself and this book would not exist. We congratulate him and thank him for sharing his most intimate and thoughtful self so effectively with us all.

For the Benefit of All,

David Furchgott, *President*
International Arts & Artists

El Romantico's Greatest Show on Earth: The Early Work of Luis Lorenzana

By Michelle Yun

Luis Lorenzana is a self-taught artist whose background in politics has infused his work with a cynicism that belies his longing for a kinder, more equitable world. The artist was born in 1979 in Manila, where he currently lives and works. He received a B.A. in Public Administration from the University of the Philippines in 2000, and took a position the next year under Senator John H. Osmeña at the Philippine Senate, where he remained for four years (2001–2004). By 2005, disillusioned by the blatant corruption he witnessed through his job at the Senate and reeling from a dramatic personal break-up, Lorenzana recused himself from his former life and dedicated his energies to becoming an artist. This transition coincided with his decision to become a born-again Christian, a fact that would subtly inform the content of his works from this period.

This consideration of Luis Lorenzana's artistic practice is focused on a body of early paintings and drawings created between 2005 and 2008 and recently brought together to form the Luis Lorenzana Archival Collection. Formally, this germinal period is characterized by an aesthetic style that at first glance seems naïve but in actual fact makes sophisticated use of various tropes from history, popular culture, and religious doctrine to produce nuanced commentaries on contemporary Filipino culture. Thematically, the works can be divided into two distinct foci, the first of which centers on the dysfunctions of the Filipino political system, and the second, the bitter end of Lorenzana's relationship with his then-fiancée. A large collection of sketchbooks and small drawings on paper complement these two bodies of work. Collectively, this selection provides a comprehensive understanding of the artist's working process and stylistic evolution during this formative period in his career.

The largest painting in the collection, entitled *Akeldama*, 2006 (fig. 1, also seen on plate, page 48) is Lorenzana's first major painting and the most ambitious of his political works. The composition is rife with meaning and its iconography can be used as an index of signs to decipher other works from the period. "Akeldama," which in Aramaic means "field of blood,"

is a biblical reference to an area in Jerusalem that, according to Acts 1:18-19, Judas Iscariot bought with the 30 pieces of silver he received for his betrayal of Jesus.[1] This dire reference sets the stage for the apocalyptic narrative that unfolds across the picture plane like a morality play, replete with references to the Senate, Congress, military, and judiciary sectors of Filipino government. In the foreground, a decadent feast, presumably procured through ill-gotten means, has been set within a walled-off garden. A wine bottle has been upended, perhaps by the well-fed rats that scurry amongst the delicacies on the table. Gloria Macapagal Arroyo, the controversial 14th President of the Philippines, whose term was plagued by fraud and corruption charges, is represented as a blind monster presiding over the repast. She is held captive at the table by fleshy tentacles emanating from a terrifying beast composed of multiple, gaping mouths full of sharp teeth. Across the table, a many-eyed ghoul representing the Congress partakes in the spoils. Behind the President, a fellow bureaucrat from the Senate cowers behind the Filipino flag, which hangs down like a stage curtain, its orientation with the red band to the left signaling the country in a state of war. In the upper left of the painting, the Malacañan Palace, official residence of the Filipino President, is under siege by a U.F.O. from above and by a mythical kraken from below. The one-eyed avatars in capes dispersed throughout the composition represent those wronged by the system, who now bear witness to this violent rebuttal to corruption. A banner flying above the palace proclaims, "If Not Us, Who? If Not Through This, How? If Not Now, When?"[2] As if in response, the Filipino national hero José Rizal (1861–1896) descends from the sky on a cloud from the upper right quadrant, shedding tears of rage, which create a deluge that threatens to engulf the palace, while thunderbolts emanating from his fingers subdue the hapless politicians who just moments before were feasting on their ill-gotten banquet. Rizal's bullet-riddled suit and cleric's collar signal his martyred status as a fallen hero, and his vengeance on the corrupt political elite serves as retri-

[1] According to the book of Matthew 27: 3-10, Judas returned the money to the local temple as an act of repentance, but, as the donation was considered "blood money," it could not be accepted and was used instead to purchase the land known as "Akeldama" that was subsequently referred to as "Potter's Field" and used until the mid-19th century to bury foreigners.

[2] According to the artist, this proclamation was paraphrased from a church sermon he attended. The original phrase is attributed to the first century BCE Jewish religious leader Hillel: "If I am not for myself, who is for me? and if I am only for myself, what am I? and if not now, when?" http://jewishencyclopedia.com/articles/7698-hillel. Accessed December 1, 2016.

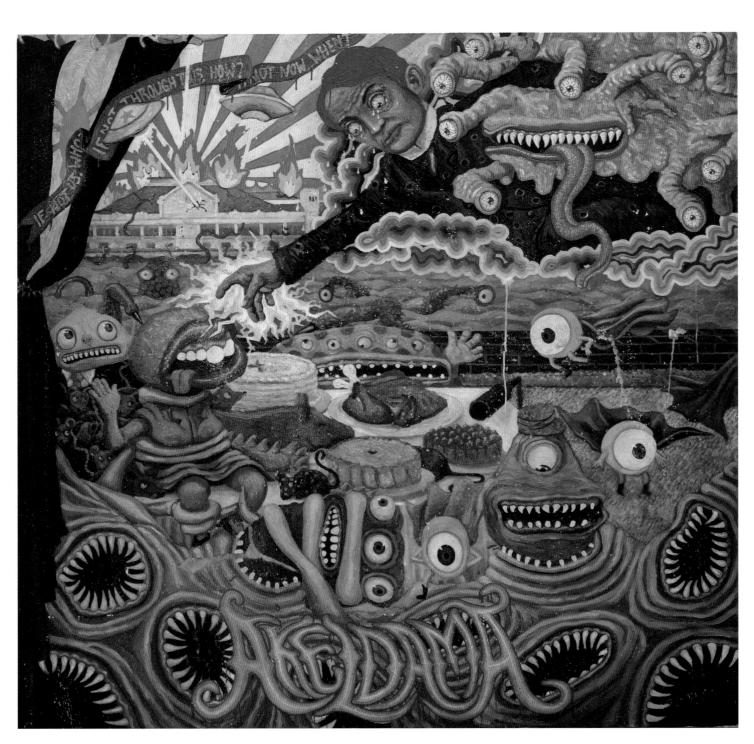

FIGURE 1 *Akeldama*, 2006, Oil on Canvas, 72 x 72"

bution for their betrayal of the people they were elected to serve and protect.

Akeldama is related to a suite of four painted portraits from 2006 that respectively memorialize four national heroes from Filipino history: Andrés Bonifacio (1863–1897), General Antonio Luna (1866–1899), Apolinario Mabini (1864–1903), and the aforementioned José Rizal. These individuals were each persecuted by corrupt government systems, usually at the behest of colonial powers, for their efforts to liberate the Philippines from colonized rule. As such, they are depicted by Lorenzana as secular icons, albeit rendered in the vernacular style of street art posters. The allusion to traditional religious iconography is reinforced in *Who Killed Jose (Portrait of José Rizal)* (fig. 4, also seen on plate, page 44) and *The Agony of Apo Superstar (Portrait of Apolinario Mabini)* (fig. 5, also seen on plate, page 46), the latter of which employs a version of the stylized halos used to signify holy figures in religious art. Lorenzana also artfully acknowledges, through his use of horizontal and vertical black and white lines over the surfaces of the paintings—which evoke the visual static on old film reels caused by scratches and dust—that the ideals upheld by these figures have become lost to the past. Lorenzana's caricaturization of his subjects, his garish palette, and his reliance on text to provide compositional and narrative structure, emphasize the graphic, carnivalesque aesthetic of his work during this period. This visual strategy has been similarly employed by many contemporaries, among them Shepard Fairey (fig. 2), as an effective vehicle for socio-political critique.

Who Killed Jose (Portrait of José Rizal) memorializes the country's most revered national hero, José Rizal, who was executed by firing squad by the Spanish colonial government for his alleged role in the Filipino Revolution. As with all the portraits in this series, Lorenzana appropriates an iconic image of Rizal from popular culture, allowing for an immediate recognition of his subject. This populist sensibility is heightened by the artist's rough painting style, which, paired with the sensationalist inscription "WHO KILLED JOSE," is piquantly reminiscent of pulp fiction book covers and old movie posters. Yet another nod to popular culture is the iPod and headphones Rizal wears, signifying the growing influence of Western culture on contemporary Filipino youth culture, and the concomitant apathy of today's

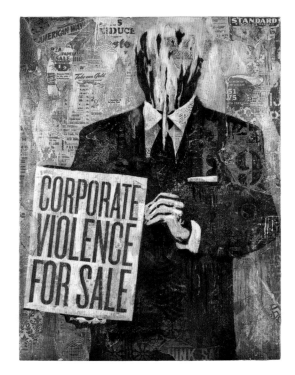

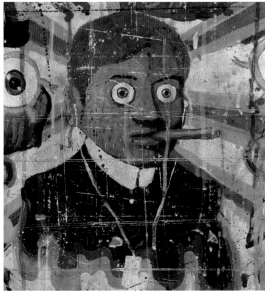

TOP FIGURE 2 Shepard Fairey, *Corporate Violence for Sale Canvas*, 2011, Mixed Media: Stencil, Silkscreen, and Collage on Canvas, 41 x 30", Courtesy of Shepard Fairey/Obeygiant.com

BOTTOM FIGURE 3 detail of *Who Killed Jose (Portrait of José Rizal)*, 2006, Acrylic on Paper, 29 1/2 x 21 1/2" (full image on plate, page 44)

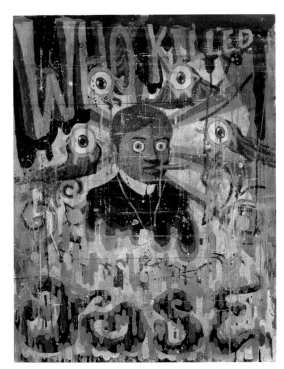

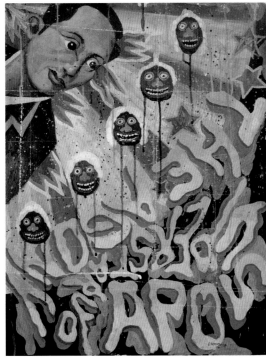

Filipino youth toward governmental politics (fig. 3). The caped eyeballs in the painting, as in *Akeldama*, function as symbolic surrogates for the masses.

 La Tragedia de Supremo (Portrait of Andrés Bonifacio) (fig. 6, also seen on plate, page 45) memorializes Bonifacio, more commonly referred to as El Supremo, the father of the Filipino Revolution and unofficial President of the Tagalog Republic. He is depicted as a youthful figure against an abstracted, camouflaged background, wearing his iconic red neckerchief. Around Bonifacio's bust the phrase "MERRY–GO–ROUND" is inscribed to resemble a memorial wreath. Two white candles flanking the text on either side are meant to further illuminate the importance of remembrance. These, coupled with the inscription below—"LA TRAGEDIA DE SUPREMO"—give a funereal emphasis to the artist's admonishment against the continuing cycle of political corruption in the Philippines and the need to remember the populist ideals behind Bonifacio's legacy. *The Agony of Apo Superstar (Portrait of Apolinario Mabini)* features a portrait of Apolinario "Apo" Mabini, a theoretician and author of the constitution for the Republic in the wake of the Philippine Revolution. In this representation, Mabini sheds tears of blood on behalf of the wayward Filipino youth of today, who are represented by five ghoulishly smiling "brown" faces sporting blond "European" coiffures. Lorenzana's representation of Mabini bears a striking resemblance to the commemorative stamp released to celebrate his 150th year anniversary in 2014. The fourth from this series of portraits, *Mal Precedente (Portrait of General Antonio Luna)* (fig. 7, also seen on plate, page 47), commemorates General Antonio Luna, whose older brother was the renowned painter Juan Luna. Other politically driven works, like *Congrie Returns (Congressman Returns)*, 2006 (plate, page 58), *Senator Oink*, 2006 (plate, page 53), and *Madam President*, 2006 (plate, page 50), are dark caricatures featuring members of the legislative body of government. Another very early painting from 2005, *Taxes*, (plate, page 54) is notable as one of Lorenzana's earliest diatribes against dirty politics and is a direct response to the corruption he witnessed during his time working in the Senate.

 The autobiographical paintings chronicle Lorenzana's personal experiences of heartbreak and his disillusionment with government and society. Aesthetically, they share with his po-

TOP FIGURE 4 *Who Killed Jose (Portrait of José Rizal)*, 2006, Acrylic on Paper, 29 1/2 x 21 1/2"
BOTTOM FIGURE 5 *The Agony of Apo Superstar (Portrait of Apolinario Mabini)*, 2006, Acrylic on Paper, 29 1/2 x 21 1/2"

litical paintings a sideshow poster-like sensibility, as regards to the choice of palette, painting style, iconography, and compositional format. The autobiographical works are rife with examples of lowbrow slang from popular culture, and many exude a nightmarish quality that often manifests itself in misogynistic attitudes. The female characters featured in these works are frequently demonized, as in *Heart Stealer*, 2006 (fig. 8, also seen on plate, page 78). In this work, a Manananggal—the Tagalog term for a mystical, vampire-like witch who reverts to an ordinary woman by day—takes center stage. She sports a maniacal grin as she grips a human heart, perhaps the artist's own, in her claw-like hands. This negative portrayal of women is reflective of the larger cultural ambiguity regarding female authority in Filipino culture. The Philippines has a matriarchal society, and women are primarily in control of all household and financial affairs. Thus in some regions, folk mythology has spawned diabolical creatures like the Manananggal, who manifest patriarchal anxieties about women and power. Similarly, *Night Crawler*, 2007 (plate, page 66), casts the role of the feminine as a menacing octopus with the capacity to entangle others in an inextricable situation. Historically, octopi have been associated with the Greek Gorgon Medusa, whose steely gaze literally turned men to stone. Medusa, in turn, has been interpreted as the embodiment of female rage. In this work, the malevolent octowoman sports a Pinocchio-like nose that has the power to trap her hapless victim in a tangle of memories and lies. The titles of these two works conjure images of fantastical sideshow attractions that objectify women and are akin to the fabled Bearded Lady, Ape Girl, and other oddities of nature (fig. 9).

Other works, like *Corned Beef*, 2006 (plate, page 80), are more sexually explicit in nature. The title of this work acts as a double entendre: Corned beef, since its introduction during colonial times, has become a dietary staple of Filipino culture, but it is also a regional colloquialism and scatological reference to oral sex. A compliant but clearly distressed woman is depicted with a bouquet of thorny stemmed roses emanating from her mouth. Thus the bouquet reiterates the reference to oral sex, albeit in sadistic form. *Stranger in the Night*, 2006 (plate, page 74), can be interpreted through a similar lens. Sisi means "regret" in Tagalog, but it also means "yes" in Spanish, so the painting's inscription can be read as a double meaning. The

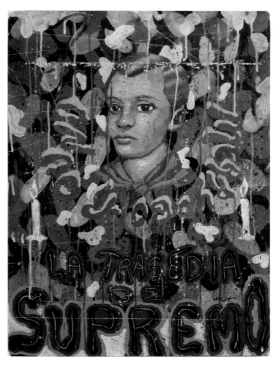

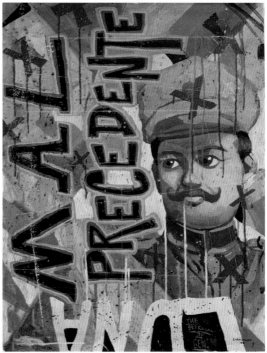

TOP FIGURE 6 *La Tragedia de Supremo (Portrait of Andrés Bonifacio)*, 2006, Acrylic on Paper, 29 1/2 x 21 1/2"
BOTTOM FIGURE 7 *Mal Precedente (Portrait of General Antonio Luna)*, 2006, Acrylic on Paper, 29 1/2 x 21 1/2"

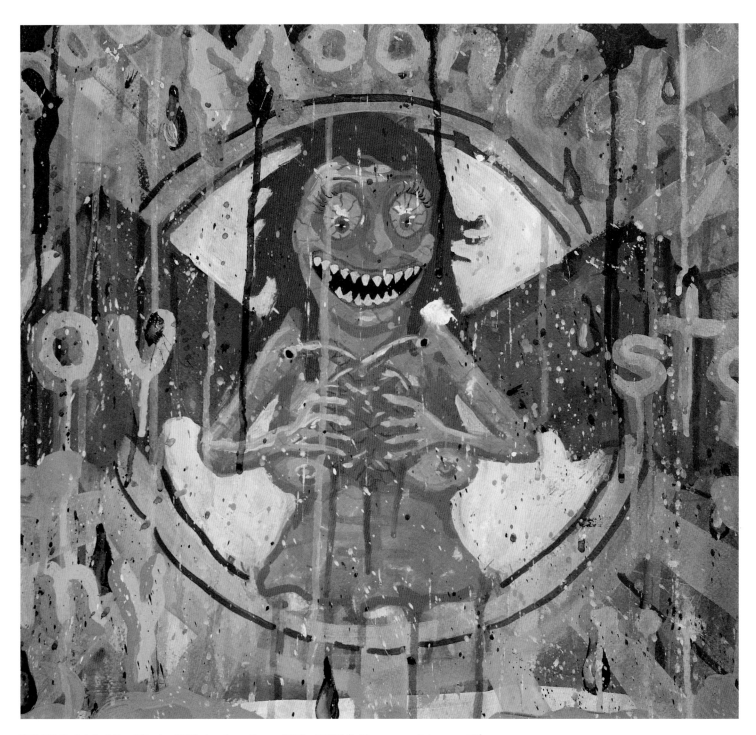

FIGURE 8 detail of *Heart Stealer*, 2006, Acrylic on Paper, 27 1/2 x 19 3/4" (full image on plate, page 78)

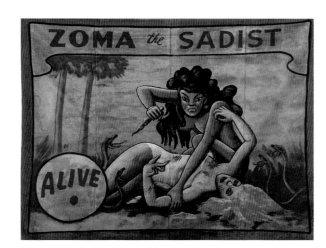

FIGURE 9 *Zoma the Sadist*, c. 1950s, Sideshow banner

woman in this painting is portrayed as a typical siren: red hair, red lips, big teeth, and big breasts. She is clad in a white dress and is holding down her skirt in a manner reminiscent of Marilyn Monroe's famous scene in *The Seven Year Itch*. As a nod to the punning nature of this inscription, she appears both defensive in her body language and inviting with her smile: a contradiction in terms, a tease. A plump, pink tentacle extending from the bottom left toward the woman acts as a phallic symbol that reinforces the sexual innuendo.

Many of Lorenzana's paintings and drawings from this period function as self-portraits. In *Adam (Self-Portrait)* from 2006 (plate, page 79), the artist depicts himself with a forced smile that is meant to mask his sadness and pain. He sports a shock of red hair, a motif used often by Lorenzana to denote anger—as in his rendering of José Rizal's hair in *Akeldama* and *Who Killed Jose (Portrait of José Rizal)*. Lorenzana's body, which is being squeezed by a presumably female octopus, seems to dissolve under the pressure, and his limbs have all but disappeared, rendering him helpless. The apple just out of his reach signifies abundance and the promise of a fruitful future; however, it is a promise that seems unattainable. On a still more melancholic note, *TWIFOLP (The World is Full of Lonely People)*, 2007 (plate, page 62), depicts the artist mourning the death of love. He appears as a cycloptic, veiled figure who finds himself, at this stage of grief, more bereft than angry. Among these self-portraits are references to Lorenzana's artistic ambitions.

D' Great Pretender, 2006 (plate, page 86), features the artist as a tentative protagonist on an empty stage full of potential and opportunity. Others, like *El Tomador*, 2006 (plate, page 99), and *Pity Party*, also from 2006 (plate, page 98), display a reflective consideration of his self-destructive behavior.

These two series of paintings are complemented by a bounty of small drawings on paper and sketchbook studies. What makes these intimate drawings so compelling is the deeply personal and uncensored self-expression reflected in Lorenzana's cast of characters, which ranges from despair and self-doubt in works such as *Mr. Why*, 2006 (plate, page 119), to anger (plate, page 102), disgust (plate, page 176), and frivolity (plate, page 118). It is through these studies that the artist crafted his visual shorthand, and collectively they function as a key to his paintings. Sexual innuendo abounds in these works, tinged with an adolescent sensibility reminiscent of the American cartoonist Robert Crumb's counter-culture characters. The self-portraits are plentiful among these studies as well, some bearing Lorenzana's pseudonym *Master Toyo*, 2007 (plate, page 134), and others professing a resistance to growing up and accepting accountability, as illustrated in *I Want to Be Peter Pan*, 2007 (plate, page 144). These works are rendered in a broad range of materials and styles, from very graphic ballpoint pen studies (plate, page 174) to highly sophisticated multimedia compositions, the latter exemplified by *Love Spinster*, 2005 (plate, page 110). This drawing in particular illustrates Lorenzana's masterful technical range and his ability to produce a delicate, nuanced rumination on love and loss. A discrete series of nine drawings from 2008 (plates, pages 206-214) created on vintage parchment paper signify the beginning of Lorenzana's aesthetic shift to his more recent body of work. These characters have a solidity and refinement not present in his earlier work. Their rounded surfaces and softer personalities share an affinity with the American pop-surrealist painter Kenny Scharf's street aesthetic. Collectively, Lorenzana's drawings from this three-year period reflect a fertile incubatory platform from which he could experiment and nurture his ideas while also exorcising his demons. The drawings raise issues found in the larger paintings regarding the fluid relationship between high and low art forms, and reinforce the importance of the grotesque as a trope in Lorenzana's work.

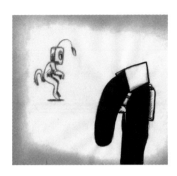

FIGURE 10 Eko Nugroho, *The Breeder*, 2003, Single-channel animation with sound, Duration: 2 minutes, 20 seconds, Asia Society, New York: Gift of Dr. Michael I. Jacobs, 2011.5. Image courtesy of the artist.

By his own admission, Lorenzana has largely worked outside the contemporary art scene in Manila. However, the concepts and formal vocabulary present in his paintings and works on paper from this period share an affinity with many of his forebears and contemporaries, whose practices artfully appropriate elements from tradition and popular culture—and more specifically, graffiti art—to critique the rapidly shifting socio-political climates of their respective countries. Lorenzana's use of graffiti aesthetic has a century-old genealogy that can be seen in such legacies as the European Modernist fascination with Primitivism, Paul Klee's interest in children's art, Cy Twombly's works with their scatological inscriptions, Jean Michel Basquiat's street art cum socio-political critique, as well as present-day artists like Yoshitomo Nara and Barry McGee, whose impish humor and pessimistic view of the urban experience are sympathetic to the tenor of Lorenzana's work from this period.

Likewise, the timbre of Lorenzana's socio-political caricatures echoes those of the 19th century French artist Honoré Daumier, whose witty satires exposed the corruption and hypocrisy inherent in French politics of his day.

Throughout the twentieth century and into our own, Southeast Asia has seen enormous social and economic change, and this has had a fundamental effect on contemporary art movements in the region. Lorenzana and his counterparts, such as the Indonesian artist Eko Nugroho (fig. 10), came of age during a time of dramatic political transition in their home countries, which compounded the impact of these societal shifts. Southeast Asia boasts the largest youth demographic in the world; the region's overall population accounts for more than a quarter of the world's total population. The voices of this younger generation highlight the growing disparities between urban and rural spaces and—by way of their booming youth culture—tradition and modernity. Like many artists of his generation, Lorenzana employs humor and parody to address social issues, such as endemic corruption in a rigged political system, the breaking of cultural taboos by the younger generation, and shifting attitudes towards religion, which includes the recent rise of Islamic fundamentalism. His cartoon-like characters enact narratives that illuminate the subtle political and social contradictions inherent in any realignment of power, as well as its effects on the population at large. Seeing these works side-by-side as a body of work in the Luis Lorenzana Archival Collection, one can finally trace the evolution of the artist's individual style within a larger global context, and chart his search for equilibrium within the pendulous relationship between cynicism and an idealistic hope for the future.

MICHELLE YUN is Senior Curator of Modern and Contemporary Art, Asia Society Museum. She oversees the modern and contemporary exhibition programs and the Museum's permanent collection of contemporary art. Yun was formerly the curator of the Hunter College Art Galleries. She has served as the Project Director of Cai Guo-Qiang's studio and as a Curatorial Assistant in the Department of Painting and Sculpture at The Museum of Modern Art, New York, in addition to organizing independently curated exhibitions. Yun is a frequent lecturer on contemporary Chinese art. In addition to coauthoring *No Limits: Zao Wou-Ki* and the revised and expanded *Treasures of Asian Art: The Asia Society Museum Collection*, and coediting *Nam June Paik: Becoming Robot*, her writings include *Patti Smith: 9.11 Babelogue*, and contributions to *Cai Guo-Qiang: I Want To Believe*, the *Benezit Dictionary of Asian Artists* and *The Grove Dictionary of Art* (Oxford University Press), among others.

Photo by Edward Mapplethorpe

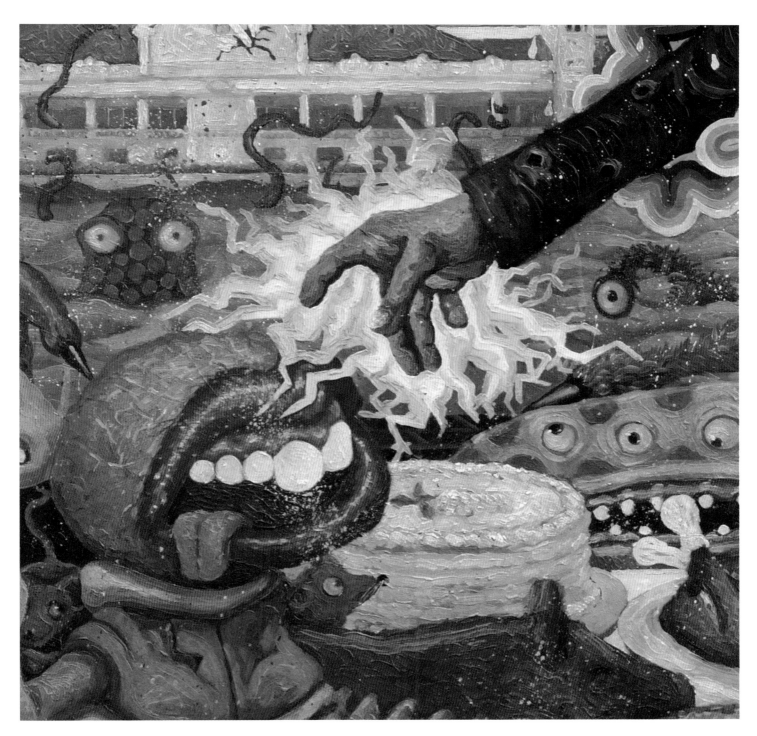

FIGURE 11 detail of *Akeldama*, 2006, Oil on Canvas, 72 x 72" (full image on plate, page 48)

The Heroes of the Cretaceous Period

By Ryu Niimi

Heroes

9/11. That was, in fact, the beginning of an escalation in unending conflicts among ethnic groups.

3/11. The 2011 Tohoku earthquake and tsunami in Japan. That was, in fact, the start of Nature's revenge—broken and plundered by humanity—the threat of technology, and the beginning emergence of monster-like forms. Having lived through post-modernism and since 2010, there has never been a time without "heroes" throughout the course of history as much as today.

Lorenzana's extremely "of the moment" heroes—these monsters of the Cretaceous Period—soon take on the form of our very selves, being reflected in modern society or perhaps appearing in the ghostly anima of nature, and emerge to counterattack against civilization, as future "monstrosities" and apparitions. In this way, Lorenzana is himself that very hero who strikes revenge against civilization, who suddenly came into being in modern society's bawdy, entangled, entirely strange, fantastical, painfully gruesome, "eye of the storm"-esque black spot that is the Philippines. Lorenzana's motifs predict our future selves, and are in the process of transfiguration by inverting time and space. This is simultaneously the transformation of civilization, as well as a modification of art history, whereby the very origin of "painting" is questioned. Therefore, Lorenzana's paintings can never stop at merely being portraits of "our present selves" that recriminate civilization. This is because variously eminent paintings—even if their origin theory is ultimately not correct—not only beget the question of "what is painting," but, of their essence, are "paintings that provoke questions," and Lorenzana's paintings more than carry their weight in doing so.

Art History Reductio ad Absurdum

Our collective post-modern-esque memory as it relates to Western painting can be likely traced back to the 1980s. Conclusion first, it is possible that our Lorenzana will be its final word, even above and beyond the group of internationally famous artists who paint in what is referred to as the globally trending Neo-Pop style (that intimate, personal, fragmented and fragile

method which portrays a "tiny story").

The period of winter-like hardship in the 1970s that came after the hot rhapsody of the 1960s, Neo-Dada, and Pop. 1975: when the Vietnam War was hurtling to its end, and the Ho Chi Minh army's regiments were welcomed by the overwhelmingly feverish fanaticism of the people as it marched into Saigon victorious.

It extends back further, to the arrival of Neo-Expressionism, that "new painting," where art having passed through conceptualism and minimalism, projected itself again into figurative expressionism as we plunged into the Cold War era. The *Zeitgeist* exhibition at Martin-Gropius-Bau—an exhibition that even appeared to prefigure the eventual fall of the Berlin wall—sparked it. And then came Basquiat who was originally from Haiti, and then came Keith Haring, who brought to the Manhattan underground the archaeological layers of American Indians and the "Co-existence of life and death" of the Mayan and Incan murals. To compare, it's on par with Henry Darger, who lived out his days as a night watchman in a Chicago hospital and was posthumously discovered, now receiving global acclaim, with his monstrous creatures considered the crown jewels of New York's American Folk Art Museum.

And yet, Lorenzana's paintings penetrated all of this instantaneously, about thirty years after Imelda Marcos left her immense designer shoe collection and her thousands of couture dresses in her palatial estate, and disappeared by helicopter together with her husband. Lorenzana portrays not only the modern paralyzing sense of emptiness, but that transient and desolate, yet "noble" life force. Thirty years later, the hero has turned into a monster, and has arrived to wreak havoc on painting and to overturn art history since post-modernism. And of all places, in the Philippines.

The Romance of Winter

Perhaps rather unexpectedly, I also see a certain romanticism in Lorenzana's crisp "northern" expression.

Roman candles in winter.

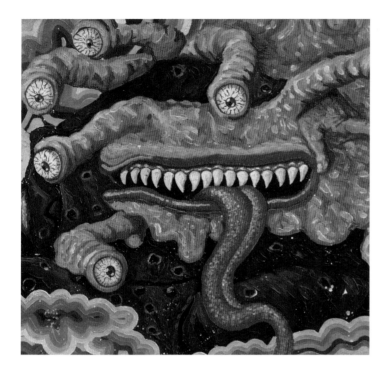

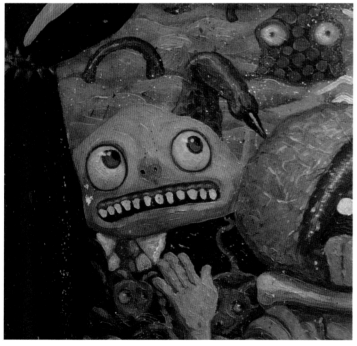

TOP AND BOTTOM FIGURE 12/13 details of *Akeldama*, 2006, Oil on Canvas, 72 x 72" (full image on plate, page 48)

I have only visited Manilia once, and even where the entire city is filled at night with Christmas parols big and small (those vibrantly colored light decorations that take the form of the holy family, where the lights turn round and round), I am unable to forget José Rizal Park, hushed to the point where one could hear a pin drop, nearly empty and seemingly indifferent, the state of that white plaza, vulnerable to insubstantiality, on that wintry day. This flood of southern light physically rejected humanity too much for it to be referred to as Spain-like.

Roman candles in winter.

Finding its locus in the Philippines, a tropical zone where the heat rises hot and heavy, even if it is not in the equatorial region, when I see Lorenzana's groundbreaking new corpus, that is to say, his oeuvre of tremendous expression that appears to make the most of the savagery of new representative expressionism, being full of life and Neo-Primitive-Pop-esque, I cannot help but be surprised at the unexpectedly strong "romantic sensibilities" underlying Lorenzana's distinct character. Even more than is endemically attributed, this means that a northern sensibility, the romanticism that got its start in the eighteenth to the nineteenth century—that is a foil to Apollo, the god who embodies "Classicism" based on reason and proportional balance of physical substance—that god of passion, the dancing Dionysus, finds life in the "here and now" of the Philippines, and Lorenzana's work serves as eye-opening evidence of its existence. This is why it goes without saying that Lorenzana smells of "heroism"—that certain je ne sais quoi which all romantics, by definition, inevitably have.

That which Lorenzana draws, taking either his palette or imagery, is representative of extremely tragic modern day saviors, literally actualizing the reminiscence of the people's pathos upon a hero's arrival.

So, what is this "heroism"—what does it triumph and what does it mean to project? Clearly, it is not the José Rizal-esque ethnic myth, but it is in relation to the time and space of the Philippines, that which "constantly loops, with the compression of each and every instant, from genesis to extinction, and from infinity to the infinitesimal."

To compare, what vibrates there is akin to *The American Four Seasons*, composed by Philip Glass in 2009, who pioneered American avant-garde music, and to be even more specific, *Winter*, where as the violins shiver, nihilism pulsates. At the core of Lorenzana's painting, the degeneration of rhythm lumbers, similar to the drums of contemporary music, *musique concrète*, and minimal music that "nihilistically" resound. And this also is the post-modern-esque and multi-cultural driving creative force scooped up by the likes of Glass and Reich from the cadence and dynamism of music from the non-European regions. In 2012, I heard Steve Reich perform his own magnum opus, *Drumming*, which was composed in 1971. After it finished, and in the second half, during *Clapping*, where Glass also participated, I recall being roused by the moving force of the overwhelming rhythm, that progression of continuity and repetition, as if marching towards nothingness. Barber's violin concerto has become almost too famous, but perhaps there is also some comparison to be made to its last movement that "shaves off," "drills down" and then embodies a "scent of nothingness."

Lorenzana does not portray actually existing people but "monsters" of the unconscious that lord over us in Jungian fashion. That is probably why Lorenzana's work—representing heroes of the Cretaceous Period come back to the modern day—forever captivates us, excites us and incites us to riot.

NOTE: Translation by Yayoi Shionoiri. Original essay in Japanese can be found on pages 216-219.

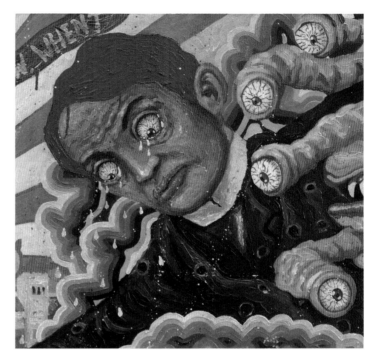

FIGURE 14 detail of *Akeldama*, 2006, Oil on Canvas, 72 x 72"
(full image on plate, page 48)

RYU NIIMI was born in 1958 in Hiroshima Prefecture. Mr. Niimi graduated from Keio University in Tokyo, where he majored in French Literature, Faculty of Letters. He worked for the Seibu Museum of Art (later the Sezon Museum of Art) from 1982 to 1999, when he became professor of the Department of Arts Policy and Management, Musashino Art University. Niimi also worked as Curatorial Advisor for the Isamu Noguchi Garden Museum Japan, was a visiting fellow of the Keio University Art Center, and served as the Curatorial Advisor of the Art Biotop Nasu, Niki Resort, Inc. In 2013, Niimi became the first director of the new Oita Prefectural Art Museum in Oita Prefecture.

Mr. Niimi's areas of expertise include the history of modern and contemporary design and art; contemporary art theory; new museology covering art, design and management; study of space comparison and space perception originating in Japonisme; influential history of art, design and architecture; history of reception; history of comparative culture; and art sociology. In addition to being a curator, Mr. Niimi is also an exhibiting artist.

Luis Lorenzana: Re-telling Philippine History

By Ambeth R. Ocampo

The Philippines is a young country with a long and complex history. While Philippine history continues to be written and rewritten based on new research and fresh insight, it is unfortunate that most people's first experience of this story comes from a boring textbook that oversimplifies the multifaceted narrative and draws cardboard versions of the people who figure in the birth of the nation. Luis Lorenzana must have been under a good teacher in his youth, because long after his formal education he continues to exhibit an interest in the past, which has stirred him to rescue four 19th century men, all national heroes of the Philippines, from the proverbial dustbin of history by painting them in a new light that provides them with a new life and relevance in the 21st century.

Lorenzana's paintings of José Rizal, Andrés Bonifacio, Apolinario Mabini, and Antonio Luna were all composed from old photographs that have since become iconic images, fossilized into permanence by way of monuments, paper bills, coins, and commemorations. However, in Lorenzana's playful rendering, these dead heroes live again to challenge and inspire the nation and people for whom they sacrificed their lives.

JOSÉ RIZAL (1861–1896), novelist, poet, artist, and ophthalmologist, may not fit the mold of most military heroes of national liberation, since his battle was fought in the realm of ideas and his weapon of choice was a pen. Distilled words fermented into three books: a first novel, *Noli me tangere*, or *Touch me not* (Berlin, 1887); an annotated edition of Antonio de Morga's 1609 history *Sucesos de las islas Filipinas*, or *Events in the Philippine Islands* (Paris, 1890); and his second novel, *El Filibusterismo*, or *The Subversive* (Ghent, 1891). The history book was Rizal's reflection on the Philippines before the Spanish conquest; the first novel, a critique of the Philippines in his time; and the sequel, a hopeful gaze into the future of the Philippines. In his books, Rizal laid down the foundations of a nation, imagining a nation long before it came to be. For this he has been called, in the words of the eminent Filipino diplomat and writer Leon Ma. Guerrero, the "First Filipino."

"Filipino," the current word that pertains both to citizens of the Philippines and to their national language, carried a different meaning in the Spanish colonial Philippines (1565–1898), when it referred to a Spaniard born in the islands: i.e., an "insular," considered racially inferior to the "peninsular," who was a Spaniard born in Spain. Like the indigenous peoples of Spanish America, the natives of the Philippines were called "indios," an allusion to Columbus, who referred to the native Americans as "Indians," believing he had landed in India. "Indio" eventually became pejorative in the Philippines, but this started to change after 1889, when Rizal and his friends visited the Universal Exposition in Paris and caught the Buffalo Bill Wild West Show. They were so impressed by the American Indians in the show that they nicknamed themselves the "Indios Bravos" (Brave Indians), turning "indio" from a word of shame into a badge of courage against the racial stereotypes they were reduced to back home. From then, it was only a matter of time before "Indio" turned into "Filipino," as Rizal and his generation came

to regard themselves not only as the "Ilustrados" (The Enlightened Ones) but—rightly—as "hijos del pais" (sons of the country). When they began to see, and refer to, themselves as Sons of the Philippines, rather than of Mother Spain—when they appropriated the term "Filipino" from the Spaniards and used it proudly—the tide was irreversible, and the seeds of independence, separation, and nationhood had been sowed.

Lorenzana depicts Rizal in his trademark black suit, the formality eased with a cigar. The image is stiff, like the many monuments that dot the towns in the archipelago, and it closely resembles a portrait of Rizal in the Rizalist church outside Rizal's birthplace in Calamba, Laguna, whose adherents believe

FIGURE 15 detail of *Gloria/Bonifacio/José Rizal* (study), *Who Killed Jose letterings* (study), 2006, Graphite on Paper, 9 x 12" (study for *Who Killed Jose (Portrait of José Rizal)* and *La Tragedia de Supremo (Portrait of Andrés Bonifacio)* seen on plate, page 44 and 45 respectively)

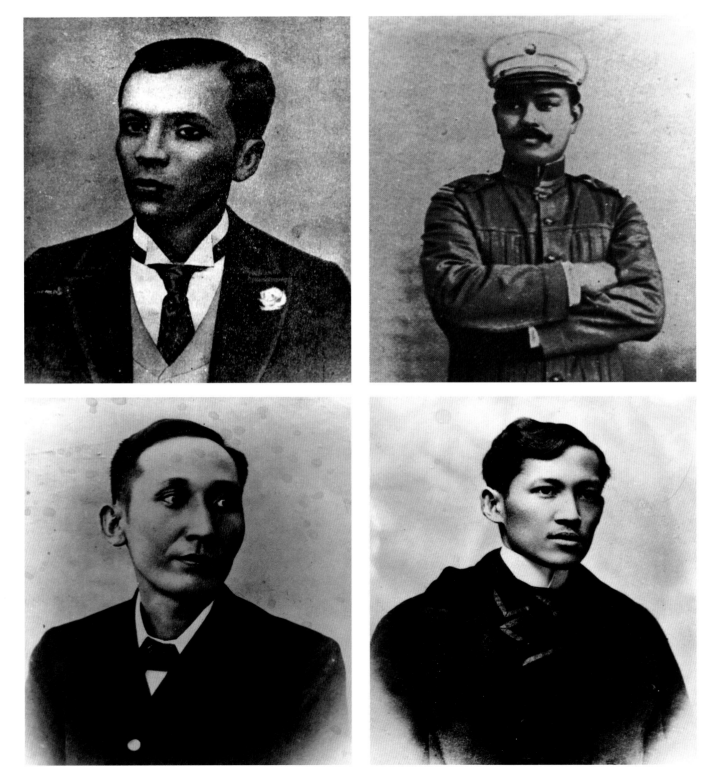

TOP LEFT FIGURE 16 Andrés Bonifacio **TOP RIGHT FIGURE 17** Antonio Luna **BOTTOM LEFT FIGURE 18** Apolinario Mabini
BOTTOM RIGHT FIGURE 19 José Rizal (from the Retrato Collection of the Filipinas Heritage Library, images color enhanced)

Rizal is God. In his painting, Lorenzana gives Rizal wide-open eyes, which are mirrored by other, disembodied eyes floating in the background, along with the words: "Who killed Jose [Rizal]?" (plate, page 44) A loaded question, whose standard textbook answer should be—the Spaniards, who shot him on December 30, 1896! Then again, Rizal is not a hero in a vacuum. What he did, and what he was, was determined by his socio-historical context. One could say that José was killed by the social situation he was unfortunately born into; nevertheless, in a time when so few appear to have learned from the past, it often seems as if little has changed in Philippine life since the day Rizal was shot: a painful observation made clear to Lorenzana when he worked in the Philippine Senate.

Though many hail him today as a martyr who laid down his life for his country, there is still speculation about what Rizal meant when he remarked, "I die without seeing the dawn." Lorenzana, reflecting on the social, political, and economic problems of our time, prods us to ask—who killed José? Did Rizal die in vain? When Rizal looks down on the 21st century Philippines from the Rizal monument in Manila, the site of mindless commemorations of Independence Day (June 12) and Rizal Day (December 30), would he have regretted his decision to die for his country? Are his people still waiting for the dawn of a new age? Who killed José?... Perhaps the nation and people who do not read Rizal.

ANDRÉS BONIFACIO (1863–1897), unlike the well-traveled, well-educated Dr. Rizal, was homegrown and homeschooled. He is not known to have gone abroad, and is thought to have acquired from his tutors only a fourth-grade education, which he later rounded off in adulthood with voracious reading and participation in folk theater. For a time, Bonifacio worked as a warehouseman or stock clerk for foreign trading houses in Manila. He worked during the day and read all night, finishing, among other books, a history of the French Revolution and a biography of the Presidents of the United States. Naturally, he read Rizal's works, and was in attendance when Rizal established the progressive association Liga Filipina in Manila in 1892. When Liga was disbanded by the government, and Rizal was deported down south to the island of Mindanao (1892–1896), a new, more radical association rose in its place: the Kataastaasan Kagalanggalang na Katipunan ng Mga Anak ng Bayan (K.K.K.A.N.B.)—literally, the Supreme and Most Honorable Society of the Children of the Nation—better known as the Katipunan, or KKK for short. Bonifacio rose to the leadership of this group and was sometimes referred to (in Spanish) as the Supremo. Under Bonifacio, the Katipunan took on a separatist character; and eventually, in August 1896, Bonifacio launched the Philippine Revolution against Spain.

In his painting, Lorenzana depicts Bonifacio as more youthful than he appears in the only existing photograph of the hero, and uses a style that reminds one of the universal pop art of Yoshitomo Nara. The cheerful tone of the painting is offset by the title, *La Tragedia de Supremo (Portrait of Andrés Bonifacio)*, (fig. 21, also seen on plate, page 45) which can be read either as a reference to Bonifacio as the "Supremo"—Head of the Katipunan—or literally as the "supreme" tragedy that befell Bonifacio, who was killed by the very revolution he begat. Although a good organizer and a rousing speaker, Bonifacio of Manila was replaced as leader of the struggle for national liberation by a fellow Katipunero named Emilio Aguinaldo, who was from Cavite, a province south of Manila. When the Katipunan was reorganized from a revolutionary movement into a revolutionary government in March 1897, Aguinaldo was elected President, and Bonifacio, Secretary of the Interior. Several contentious events, including allegations of fraud and an insult to Bonifacio's person, led the latter to declare the election void and to storm out of the meeting. Adamant in his refusal to recognize the newly elected government, Bonifacio was arrested, tried for treason, and executed in the Maragondon range on May 10, 1897. It is a painful episode in Philippine history, involving as it does Filipinos killing a fellow Filipino. Today the story continues to disturb, which might explain why Aguinaldo, though President of the First Philippine Republic, does not figure in the paintings of Lorenzana, who chose instead to immortalize two of the most prominent in Aguinaldo's government: Antonio Luna and Apolinario Mabini.

ANTONIO LUNA (1866–1899) was one of a brood of seven whose male members all rose to national prominence: Manuel Luna, an accomplished musician; Juan Luna, regarded as the greatest Filipino painter of the 19th century; José Luna, a famous medical doctor and toxicologist; and Joaquin Luna, a politician and legislator in the early 20th century. Before he rose

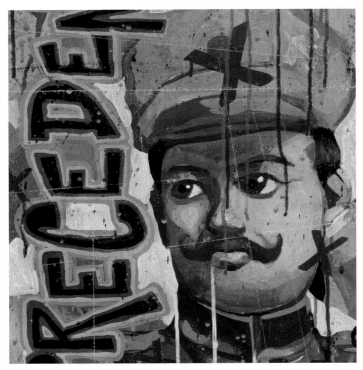

FIGURE 20 detail of *Mal Precedente (Portrait of General Antonio Luna)*, 2006, Acrylic on Paper, 29 1/2 x 21 1/2" (full image on plate, page 47)

to become one of the greatest generals of the Filipino-American War, and attain the rank of Captain General in the First Philippine Republic, Antonio Luna was many things: a scientist who trained in Madrid and Paris; a journalist who wrote for *La Solidaridad*, the reformist Filipino paper in Spain; and, reputedly, one of the best swordsmen and guitar players of his generation.

Lorenzana based his depiction, which shows Luna in full military uniform, on one of the many photographs of the general. The dripping paint on the painting's surface, punctuated by blood-red X's, refers to Luna's brutal assassination by the blades and bullets of President Aguinaldo's bodyguards, a treacherous lot, loyal only to Aguinaldo, that Luna had earlier disciplined and disarmed for insubordination. The title, *Mal Precedente (Portrait of General Antonio Luna)* (fig. 20, also seen on plate, page 47)—literally, "bad precedent"—is a play on words to suggest "bad President," a reference to Emilio Aguinaldo, who was so threatened by Luna that the accusing finger of history has settled on him as the mastermind in the murder of his rival. Luna was

recently the subject of a 2015 Filipino film that went viral due largely to its unstinting depiction of the general's bluster, bad temper, and intemperate language, which shocked and galvanized a young generation of viewers into a burning desire for change and national renewal that can be summed up neatly by a line in the film: "Bayan bago ang sarili" ("Country before self"). Curiously, the film's version of Luna seems, in retrospect, almost a prophecy of the 2016 election of the equally colorful Rodrigo Duterte to the Philippine presidency.

APOLINARIO MABINI (1864–1903), like Bonifacio, came from humble beginnings. Unlike Rizal and Luna, he was homegrown and did not have the opportunity to study abroad; his only overseas trip would be his exile to Guam in 1901, after the Americans bought the Philippines from Spain at the end of the Spanish-American War. (The Americans paid $20 million, which came to about 50 cents per person, with the land thrown in for free.) A licensed teacher and lawyer, Mabini was recommended to Aguinaldo for a position due to his quiet demeanor and sharp intellect. He soon rose to be Prime Minister and Foreign Minister of the First Republic, and acted as head of Aguinaldo's cabinet and as his most trusted adviser; no papers or decrees left the President's office without the comment, recommendation, or notice of Mabini. In fact, so many official documents—now in the National Library in Manila or in the Library of Congress in Washington, DC—bear Mabini's small scrawl in the margins in lieu of the President's signature, that many now regard Mabini as the true power behind the First Republic. He was a man who saw and knew all. So threatened were some of his underlings that they referred to Mabini, behind his back, as the *Camara Negra*, or "Dark Chamber of the President." But in the end, Mabini's undoing was his adherence to principle and fair play in the corridors of power, where personal interests and political alliances sometimes ran roughshod over loftier ideals of patriotism, self-sacrifice, and love of country.

Lorenzana depicts Apolinario Mabini as red-faced, and bills him as the "Agony Superstar": an apt description, given that Mabini and Luna—a pair who believed in fighting for freedom, even if it meant dying to the last man—could easily be said to embody the conscience of the young republic (fig. 23, also seen on plate, page 46). Both of them advocated for war at a time when more pragmatic officials in the Aguinaldo gov-

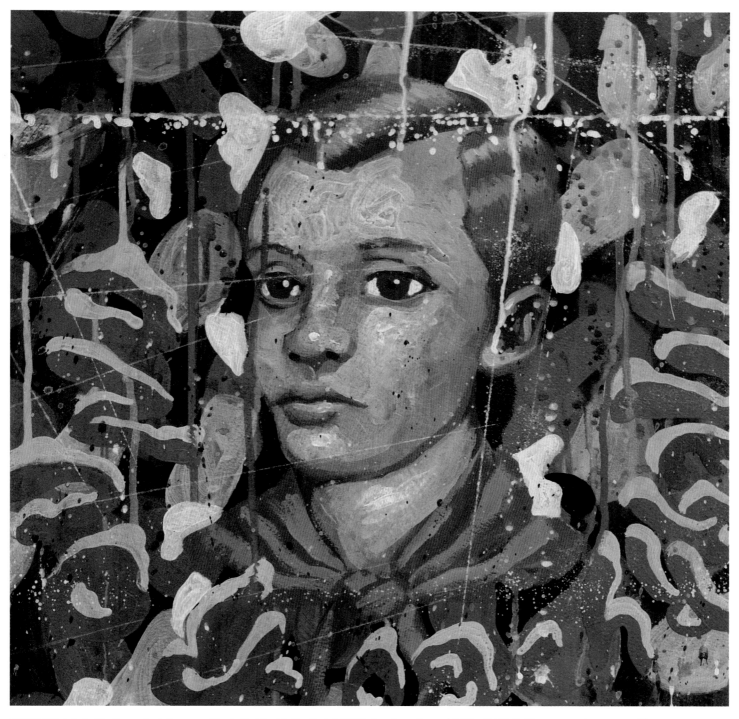

FIGURE 21 detail of *La Tragedia de Supremo (Portrait of Andrés Bonifacio)*, 2006, Acrylic on Paper, 29 1/2 x 21 1/2" (full image on plate, page 45)

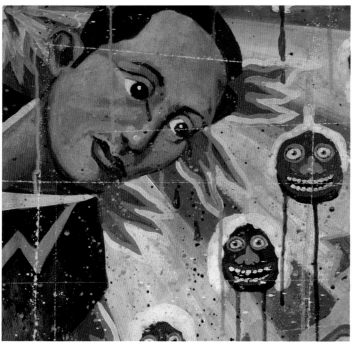

TOP FIGURE 22 *Who Brought Apo to Tears* (study), 2006, Graphite on Paper, 9 x 12" (study for *The Agony of Apo Superstar (Portrait of Apolinario Mabini)*)
BOTTOM FIGURE 23 detail of *The Agony of Apo Superstar (Portrait of Apolinario Mabini)*, 2006, Acrylic on Paper, 29 1/2 x 21 1/2" (full image on plate, page 46)

ernment argued for "peace" through surrender to the Americans. Some of these traitors to the cause of freedom are still on the roster of heroes, despite the cynical alacrity with which they jumped from the First Philippine Republic to positions of political and social influence under the Stars and Stripes. It could be said that Luna was removed by assassination, while Mabini was removed by intrigue. Mabini lost the use of his legs to adult polio, a disability his critics claimed was due to syphilis in order to discredit him. When he was nominated for the post of Chief Justice of the Supreme Ccurt, he was told—contemptuously, by a legislator—that he could not fulfill the duties of the office because he was a paralytic, to which his quick and sharp reply was, "Does the job entail a lot of walking?" Mabini is a reminder that fidelity to duty does not always reap compliments and rewards—but often criticism and contempt.

Finally, we come to *Akeldama*, a painting that was shortlisted as one of the 20 national finalists in the 2006 Philippine Art Awards (plate, page 48). Lorenzana depicts an aged Rizal in the sky, angry and pointing to a lying mouth whose hands are raised in surrender. Rizal throws waves at a burning building—Malacañan, the presidential palace in Manila—set against a background that shows a Philippine flag and the "bukang liwayway," an image representing the dawn of a new day. Painted during a period of political turmoil, Lorenzana's image of a monstrous, ying mouth seems an allegory for then-Philippine President Gloria Macapagal Arroyo, who apologized to the nation for exerting undue influence on a Commissioner of Elections, possibly to secure her win in the polls. "Akeldama" refers to a place known as the "Potter's Field," where rich red clay was sourced. It is also associated with Judas Iscariot, the apostle who betrayed Jesus for a bag of silver; hence the other meanings of Akeldama: "Field of Blood" or "Traitor's Field." So honest was the political comment in this painting, so direct the call to action inscribed on it in Tagalog ("Kundi tayo sino? Kundi sa ganito pano? Kundi ngayon kelan?": "If not us, who? If not this way, how? If not now, when?") that many galleries refused to exhibit it. Lorenzana began by trying to see the Philippines through the eyes of his heroes, only to realize that their struggle did not end with their deaths but goes on, even into our own time. Lorenzana's paintings declare that things do not have to be the way they are; that in the souls of the men and women who have been raised to the pantheon of heroes can always be found a glimmer of hope: In them we see our own capacity for greatness.

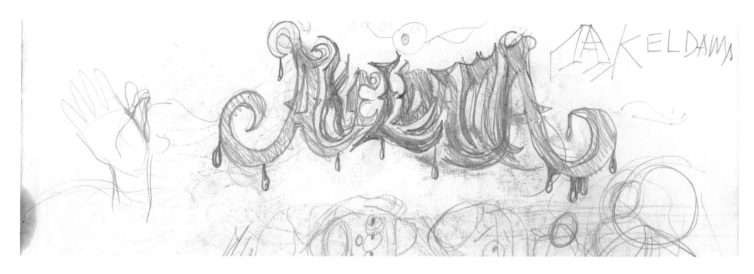

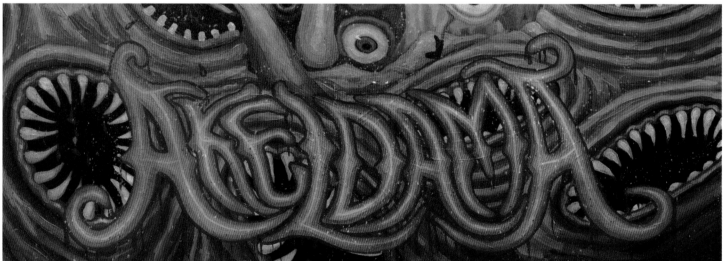

TOP FIGURE 24 detail of *Akeldama lettering* (study), 2006, Graphite on Paper, 9 x 12" (study for *Akeldama*) **BOTTOM FIGURE 25** detail of *Akeldama*, 2006, Oil on Canvas, 72 x 72" (full image on plate, page 48)

AMBETH R. OCAMPO is Associate Professor and former Chair of the Department of History, Ateneo de Manila University. He has served in government as Co-Chair of the Manila Historical Commission, Chairman of the National Historical Commission of the Philippines, and as Chairman of the National Commission for Culture and the Arts. Dr. Ocampo has published over 22 books, writes a widely read op-ed column for the *Philippine Daily Inquirer*, and moderates a growing Facebook Fan Page. In 2016, he was awarded the very prestigious Fukuoka Academic Prize, the Pan-Asian prize annually awarded to honor the outstanding work of an individual preserving Asian culture.

Artist Biography

By Lisa Guerrero Nakpil

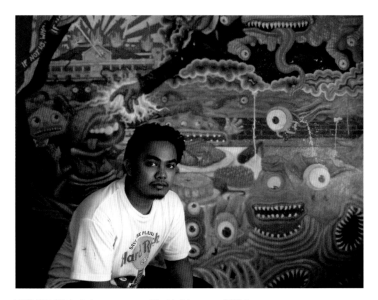

FIGURE 26 Luis Lorenzana with *Akeldama*, c. 2006

Luis Lorenzana was born in Pandacan, Manila, on February 3, 1979, a third-generation *Manileño* (as opposed to the hordes of self-styled Manilans who have migrated to the capital from outlying provinces). The late seventies were the restless, twilight years of the twenty-year reign of the Marcoses; the EDSA People Power Revolution, which would overthrow them in 1986, was less than a decade away.

Pandacan is a staunchly middle-class district, just across the river from the Malacañan presidential palace and once peopled by a few grandees—including the family of Imelda Romualdez Marcos—who built elegant mansions in the 1920s. Lorenzana's father, Luis Lastrella Lorenzana, captained a production line of capiz-shell furnishings as early as age fifteen, rising through the ranks and eventually marrying the boss' daughter, Florence Andres. The factory did a roaring trade with the Japanese market, and Lorenzana's family enjoyed the profits, luxuriating in various electronic gewgaws brought over by the Tokyo buyers.

Lorenzana began painting, he recalls, at age six or seven, choosing for his first scene—oddly enough for a city boy—a pastoral of farmers working the rice-fields; and then another of a moon shining down on thatch huts in the countryside. The middle child of his family, he attended district public schools for grade school and high school: a budgetary measure by his frugal parents, who had married in their teens. (The public school system was founded by the American colonial administrators and was basically free.) Throughout his school years, Lorenzana brought home many academic honors, and won several national children's competitions for painting, including an arts program sponsored by Caltex Oil, who had set up shop in the district. By the 1990s, Pandacan had suffered the typical fate of Manila's inner-city neighborhoods: the once-prosperous homes had devolved into disrepair. Lorenzana was accepted by the best schools, but chose instead to stay close to home, where he was widely regarded as the neighborhood's best hope of bringing back some honor and riches to the community.

At first, it looked as if he would not disappoint them. In 1996, having made up his mind to become a lawyer and pursue a career in government service, he set aside his paintbrushes and enrolled—on a full scholarship—at the University of the Philippines' National College of Public Administration and Governance, an elite school whose graduates often went on to jobs in Congress or the Department of Finance or were elected to local office. There, he met the woman who was to be the first love of his youth, a fellow pre-law student who came from a family of overachieving professionals, and they planned to marry.

Lorenzana was now a part-time activist, with many interests and convictions, and would join the militant League of Filipino Students, only to leave its ranks after a few months. As a college senior, he interned in an important government department, but was crestfallen to see its parking lot brimming with expensive SUVs used to chauffeur around the various officials. (Years later, his work *Taxes* [plate, page 54] would make sardonic reference to such sights.) Nevertheless, he was not deterred, and in 2000 he took his degree and was ready to become a public servant. However, disaster struck: His childhood home burned to the ground, taking with it his books, early artworks, his clothing, and all of his family's earthly possessions. To make matters worse, the family's export business had slowed down and closed. It took them the rest of the year to recover from the shocking loss.

So it was with some relief that Lorenzana chanced one day upon an advertisement soliciting entries for the 2000 Philip

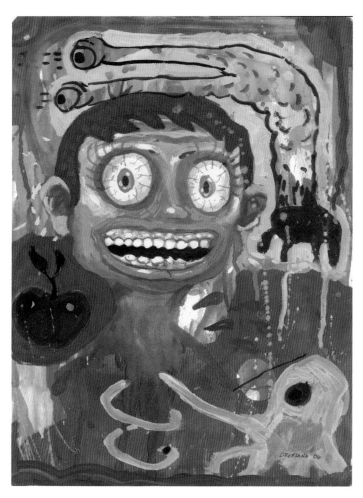

FIGURE 27 *Adam (Self-Portrait)*, 2006, Gouache on Paper, 16 1/2 x 11 3/4"

Morris Philippine Art Awards, one of the most prestigious art contests in the country. For a lark, he submitted some of his work, and won a place among the Top 50 Finalists. (The Filipino artist Nona Garcia took the grand prize and went on to a successful career.)

By 2001, he had settled down enough to make a formal application to join the office of Senator John Henry Osmeña, widely regarded as the political heir to an illustrious grandfather, Sergio Osmeña, who had ascended to the heights as the fourth Philippine President. He was accepted.

Lorenzana says, however, that his ambitions of "making a difference" were quickly brought down to earth at the Philippine Senate, where, despite all his years of meritorious study, he found himself constantly eclipsed by others who lacked his education but had the "right" connections; and saw that he had merely been a big fish in the rather small pond of Pandacan. And, as an insider to the workings of the so-called august corridors of power, he became increasingly disenchanted and demoralized.

But he would not yet be persuaded to leave his government job. As a Senate staff member, Lorenzana enjoyed a sizable salary for his age, which he began to spend on expensive oils and canvases, painting constantly to keep up his plummeting morale. While still at work in the Upper House, he continued to enter contests, placing as a semi-finalist every year from 2001 to 2004 in the annual Metrobank Art Competitions, another testing ground for young artists.

In 2001, he took to the streets to join the phenomenon widely called "*Edsa Dos*," the latest exercise in People Power that would soon unseat yet another president, Joseph Ejercito Estrada, on charges of malfeasance. He camped out on the famous thoroughfare Epifanio Delos Santos Avenue (EDSA) for the three or four days it took to bring down the government. In Estrada's place, Vice President Gloria Macapagal Arroyo, herself a daughter of another past Philippine President, was installed. Lorenzana remembers that the air was electric with hope for possible reforms, and for the new president Arroyo to be their instrument. That hope was dashed by a series of scandals that soon clouded her administration. Nevertheless, in mid-2004 Arroyo retained the presidency after a hotly-contested election that, among other things, swept Lorenzana's boss Senator Osmeña out of

power. By this time, Lorenzana had had enough of government and was seeking ways to become a full-time painter. He had, in the meantime, been recruited by another senator, whom he had earlier impressed in a battery of interviews (including, astoundingly, an interview by the senator's personal feng-shui master). He decided at the last minute not to show up for his first day of work, concealing his intentions from his mother, who nevertheless found out about it when the senator's office rang his home looking for him.

Instead, Lorenzana began to paint full time, confident that his savings would tide him over for at least a year. He busied himself with drawing and sketching as well as with painting. What he did not count on was an art scene that would for years regard him as an outsider, and a fiancée who was slowly withdrawing her affections because of his increasing financial instability—and what he described as his "maniacal" devotion to perfecting his technique, which left very little time for her.

In 2004, he joined the painting competition sponsored by the Spanish embassy's cultural arm, the *Instituto Cervantes*. The chosen theme was the old walled city of Intramuros in Manila, and Lorenzana recalls that he thought so little of his chances that he spent the whole afternoon drinking among the ruins; nevertheless, he turned in a painting that took home the grand prize. Along with the purse, he was given a small sketchbook, which he used for drawing and—significantly—to outline an ambitious ten-year plan for his art career and personal life.

It was during this time that Lorenzana joined what was termed a "nude painting session," organized by galleries and featuring a few established artists as well as a number of younger ones. The gallery would pay for a model to pose in *deshabilleé,* and each artist would turn in one work for the privilege of attending, keeping the rest for themselves or for sale to collectors. In the session Lorenzana attended, the featured greats were Benedicto "Bencab" Cabrera (already a Philippine National Artist) and Mauro Malang Santos, whom Lorenzana greatly admired, and whose gouache works would later inspire him to experiment in the same medium. Lorenzana recalls being astounded by the queues lining up to pay large amounts for just an afternoon's work by these masters. His sketches titled *Hubad (Nude) I, II, and III* (2005) are from that day. Lorenzana further

FIGURE 28 detail of *Self-Portrait*, 2002, Graphite on Paper, 8 3/4 x 5 1/2" (full image on plate, page 180)

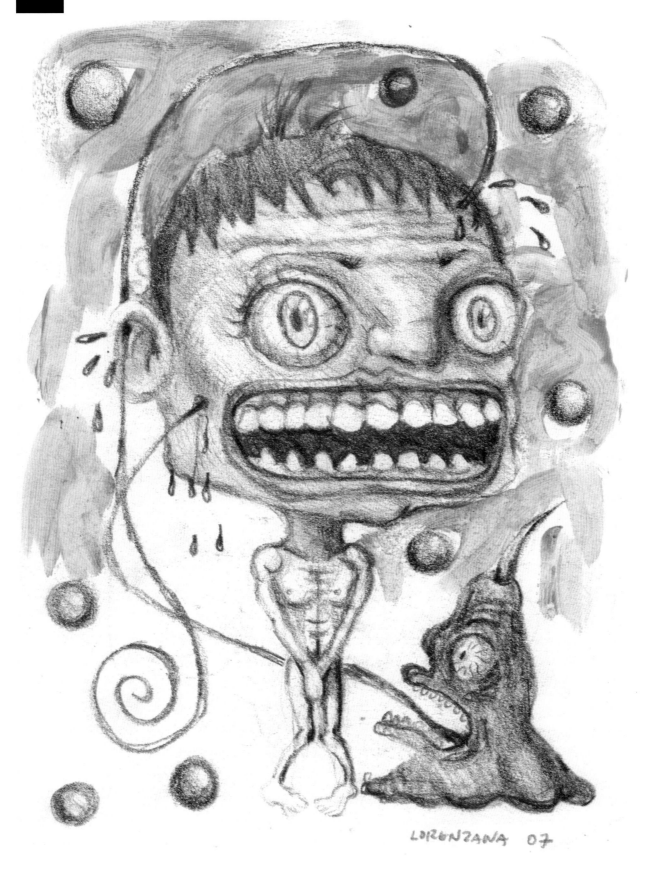

FIGURE 29 *Self-Portrait*, 2007, Gouache and Graphite on Paper, 8 1/4 x 5 3/4"

notes that he has never featured a graphic or overt sexuality in his works, preferring instead to use sexual metaphor, as in his later works *Corned Beef* (plate, page 80) and *Stranger in the Night* (plate, page 74). He has called his work "*romantico*"—not so much in the sense of a Casanova as of a gentleman.

By 2006, Lorenzana was teetering on the verge of financial ruin, and his stock of paints and canvases was perilously low. His paintings had found no favor with Manila's galleries, and he did not have the wherewithal to replenish his materials. Desperate, he applied at a small gallery (which also specialized in giclées) to give the children of its rich clients art lessons. He was engaged at minimum wage, roughly $10 a day, to give multiple sessions each day. The students were supplied with expensive art supplies, including French paper that had been used for test prints for the gallery's printing business. Lorenzana pined after the paper, and in the evenings would ask his employer for the leftovers. The works *Senator Oink* (plate, page 53), *Senator Gator* (plate, page 52), *Green 2* (plate, page 107), *Last For the Road* (plate, page 92), and the *Beauty Queen* (plates, pages 192-195) series were all done on this paper, which accounts for their uneven sizes; and (Lorenzana says) some were even painted on top of the trial giclées. In fact, on the reverse sides of the senatorial works can be seen the color wheels the students had to turn in as part of their assignments in color theory.

His fiancée, meanwhile, was running out of patience with him, and it was from brooding on this that he created *The Great Love Spinster* (plate, page 93), *Love Spinster* (plate, page 110), and other works, all in reference to her on-and-off treatment of him. Continually, she pressured him to give up painting and return to a more stable career in government. (She herself had gone on to finish law school, which Lorenzana himself had refused to continue.) Finally she had had enough, and broke off with him, sending Lorenzana into a tailspin.

Seeking solace, he joined the ranks of born-again Christians, a branch of Protestantism. He had first attended the worship sessions at the instance of his girlfriend, but after their separation, he began to attend the bible study classes alone and in earnest, requiring emotional rescue.

Still looking for a way to make his painting self-sustainable, he decided to use his last oils and canvas on one final bid to enter the 2006 Philip Morris Philippine Art Awards. His entry, *Akeldama* (plate, page 48), was a scathing commentary on the rule of Gloria Macapagal Arroyo, then still firmly in power, and though Lorenzana was shortlisted as one of the 30 finalists, he proceeded no further. Later he was told privately by one of the judges that his work was found to be "too activist." Still, he was determined to press on, and today Lorenzana regards 2006 as the beginning of his "real" art career—and himself as the contemporary of such artists as Jigger Cruz and Lynyrd Paras, even though they are some five years younger.

For his next project, Lorenzana needed a concept for a singular body of work that would get him an exhibition. But what would it be? To his mind, the Philippine national heroes José Rizal, Andrés Bonifacio, Apolinario Mabini, and Antonio Luna were among the most hallowed of all; appropriately, it was they who now came to the rescue of their impoverished admirer. Originally, he had planned to include in his pantheon of painted heroes Benigno "Ninoy" Aquino, whose assassination had sparked the downfall of Marcos; but he eventually decided that a contemporary hero would be ill-suited to the mythic, historical thrust of the paintings—of which *Who Killed Jose (Portrait of José Rizal)* (plate, page 44), about the martyred intellectual José Rizal, is an especially vivid example.

However, Lorenzana had run completely out of supplies. To map out his paintings, he had to manufacture two sketchbooks—one large, one small—with materials purchased with his meager savings. He bought a few sheets of paper for about a dollar each, washed them unevenly with pink acrylic, which he thought would make a good contrast to his pen and ink studies, and hand-cut them into 5 x 7" pieces. These became what are now the works in the "small sketchbook." For drawings that he felt needed a larger field, he made a second notebook in the same style, but bigger and plainer, measuring 9 3/4 x 9". There is another set, done on office A4s, that are studies for such works as *Akeldama*, *The Agony of Apo Superstar (Portrait of Apolinario Mabini)* (plate, page 46), *La Tragedia de Supremo (Portrait of Andrés Bonifacio)* (plate, page 45), *Stranger in the Night*, *Corned Beef*, *Madam President* (plate, page 50), and his *Self-Portrait* (plate, page 79). Lorenzana has said that these sketches were essential to plot out his paintings, as he could ill afford to make any mistakes. Today, he no longer uses studies

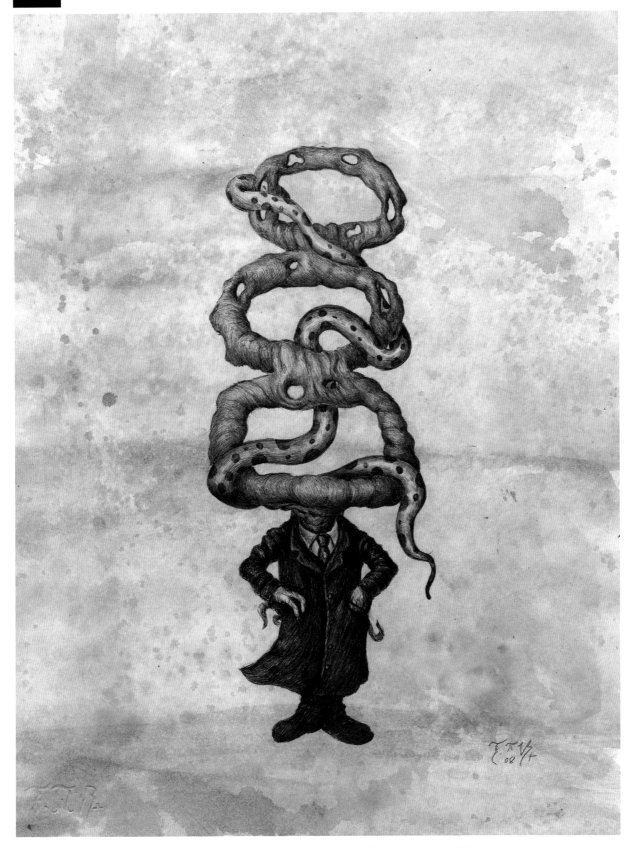

FIGURE 30 *Untitled*, 2008, Ballpoint on Toned Paper, 16 1/2 x 11 3/4" (reverse of *Illegit*, plate, page 56)

or sketches, but paints directly on the canvas, without even using any guiding lines. Therefore the sketches in the Archival Collection are the last artifacts of their kind.

The works beginning mid-2006 and through 2007 were all created using acrylic—an inexpensive, quick-drying medium—on paper. For other works, Lorenzana would scrimp and save to buy *Conté à Paris* oil pastel sticks, one at a time, in sepia, which he used sparingly for such works as *Choco Lava* (plate, page 198) and *Princess* (plate, page 199). He would mostly use a Parker pen and ink, diluted with water, to make his own watercolors. At one point, money was so short that he would char chicken bones and mix them with linseed oil to make his own black paint.

He would occasionally style himself as "Luis" beginning in 2007, signing his works in the ancient Filipino Baybayin script (fig. 30), which predates the coming of the Spanish. Those three characters appear on various works (plates, pages 173, 174, 176) and those on vintage parchment (plates, pages 202-213). At other times he would use the alias "Master Toyo." "Toyo" is the Filipino word for "soy sauce" but is also street talk for "madman."

Lorenzana calls the period of the Archival Collection the "reckless years," when he cared little for the opinions of others, whether they were fellow artists or gallery owners—who continued to reject all his offerings. He would diligently make the rounds of the gallerists with a small, handmade catalogue of works, reproduced on photographic paper, but to no avail. He still could not sell a single one. Finally, he rolled them up and stored them in his mother's house—in her cupboards and under her bed—banished as mementos of an unhappy life.

In 2008, after the period of the Archival Collection, he decided to follow the gallerists' advice and try his hand at figurative works, but resolved to try the most difficult kind—the style of the Renaissance masters. He read voraciously on Michelangelo and Caravaggio, and painstakingly researched their techniques; nevertheless, all the new works were ignored, just as his others had been. Finally, by merest happenstance, he attracted the notice of an American gallery based in California, who immediately placed an order for his works. He had to advise them that he did not have the money for shipping, for which they advanced the funds. What followed was a series of exhibitions in the United States (California, Maryland) and Europe (Berlin).

In 2009 he applied to a Manila-based gallerist who, glancing at his résumé, mistook him for a Mexican artist, and quickly arranged a studio visit. At any rate, it finally came to be—in December 2009—that Luis Lorenzana had his first solo exhibition in his own country. Since then, he has attracted a growing circle of collectors and admirers. In 2010, with his earnings, he was finally able to journey to Europe and see first-hand the Old Masters in the Louvre, spending weeks studying the paintings. He continues to exhibit widely, not only in the Philippines but in Southeast Asia's art centers in Singapore and Hong Kong.

The Archival Collection was discovered completely by accident—and yet in synch, perhaps, with the surreal ways of the Philippines. One afternoon in 2016, the collector who was eventually to acquire the entire body of works happened to admire a painting hanging in Lorenzana's studio and asked him who the artist was, considering that its style was so different from Lorenzana's present work. That painting was *Who Killed Jose (Portrait of José Rizal)*.

LISA GUERRERO NAKPIL is an independent curator and art consultant based in the Philippines. She has co-authored various catalogues, including "Filipinos in the Gilded Age," for an exhibition on 19th century Philippine art; and "Alfonso Ossorio"; both organized by León Gallery.

PLATES

PAINTINGS I-III
SKETCHBOOKS AND STUDIES I-IV

Paintings

I

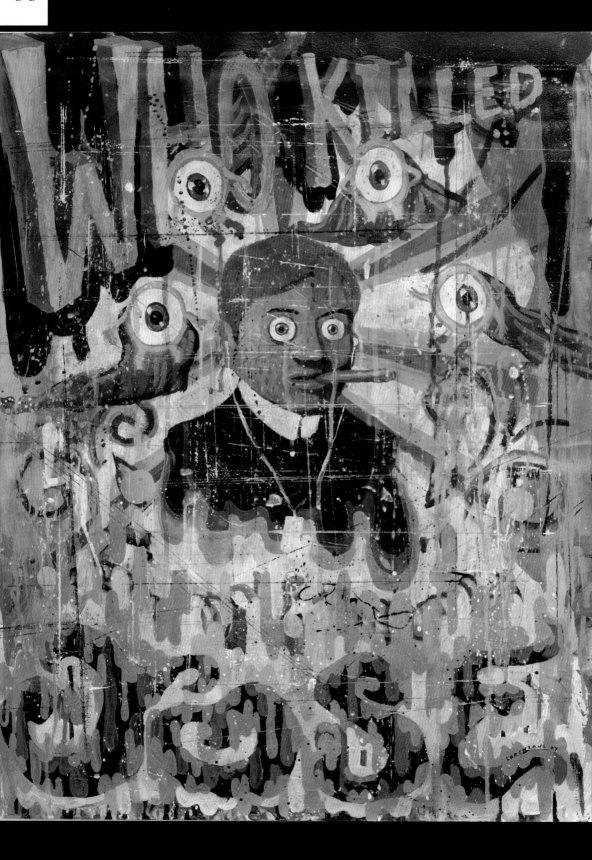

Who Killed Jose (Portrait of José Rizal), 2006, Acrylic on Paper, 29 1/2 x 21 1/2"

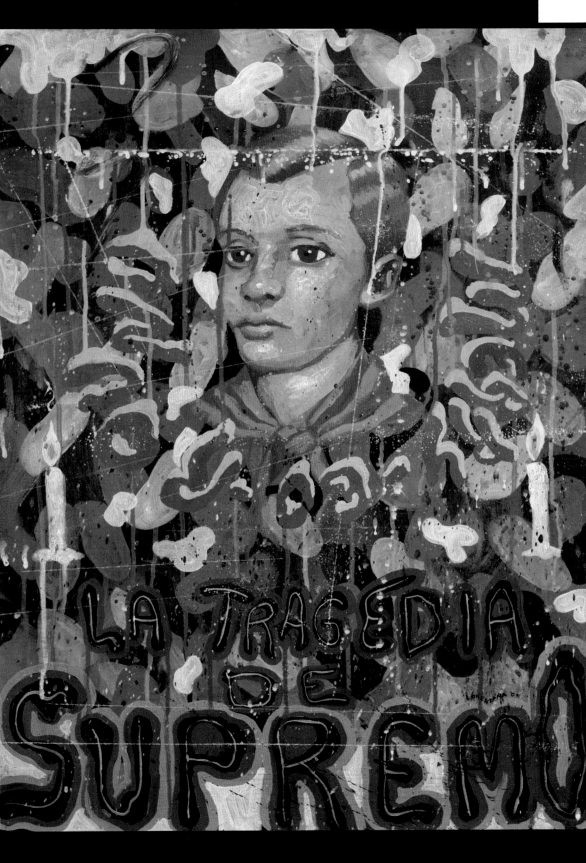

La Tragedia de Supremo (Portrait of Andrés Bonifacio), 2006, Acrylic on Paper, 29 1/2 x 21 1/2"

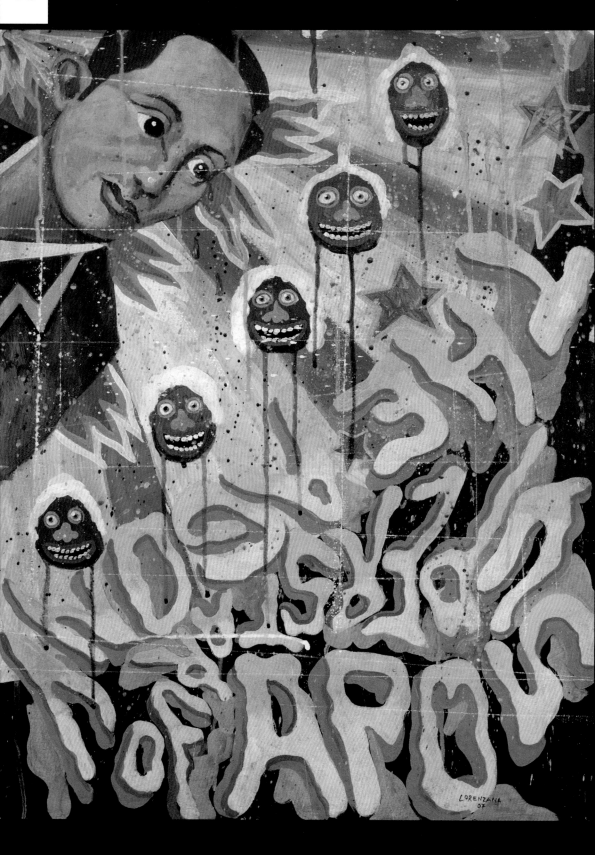

The Agony of Apo Superstar (Portrait of Apolinario Mabini), 2006, Acrylic on Paper, 29 1/2 x 21 1/2"

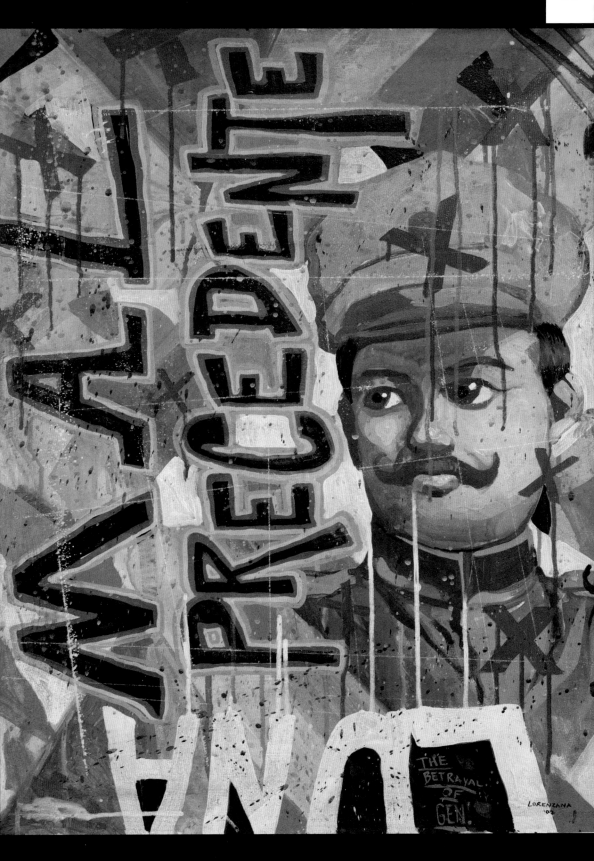

Mal Precedente (Portrait of General Antonio Luna), 2006, Acrylic on Paper, 29 1/2 x 21 1/2"

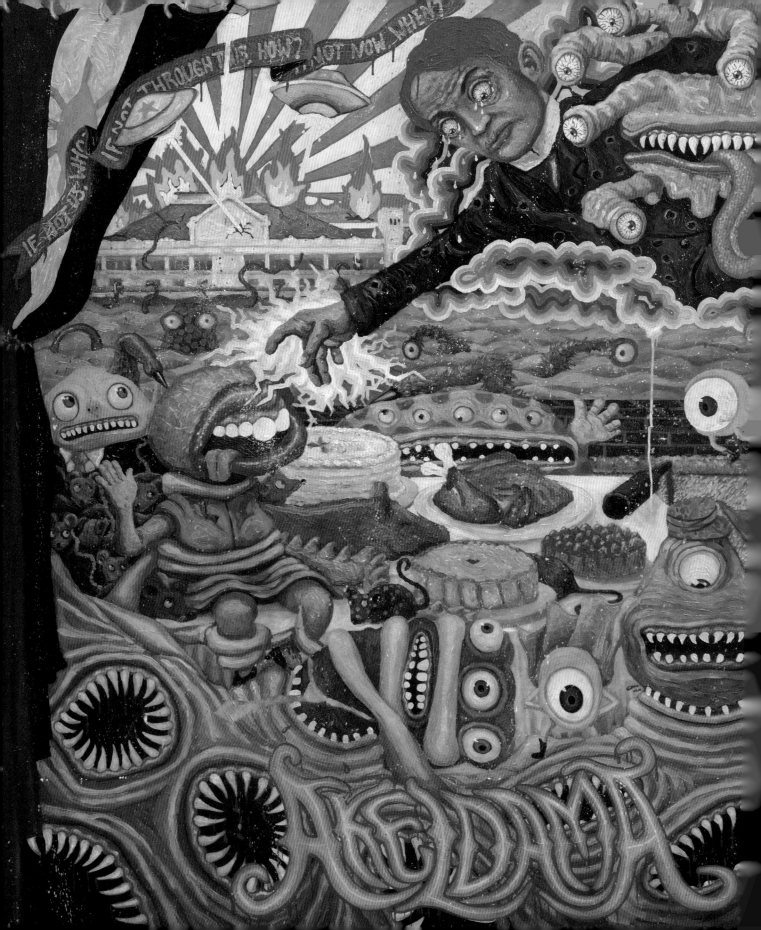

Akeldama, 2006, Oil on Canvas, 72 x 72"

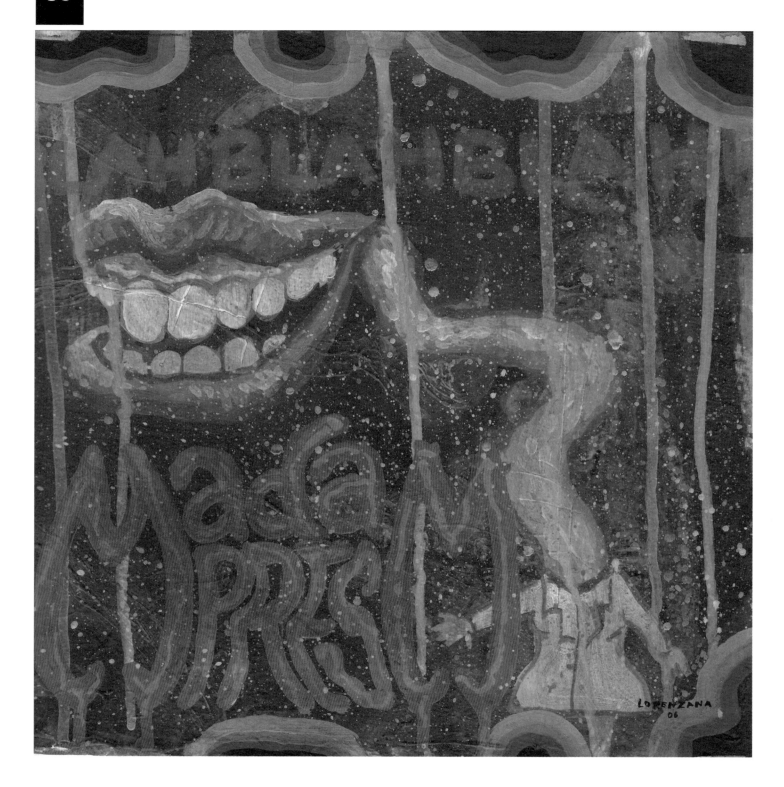

Madam President, 2006, Acrylic on Paper, 11 1/2 x 11 3/4"

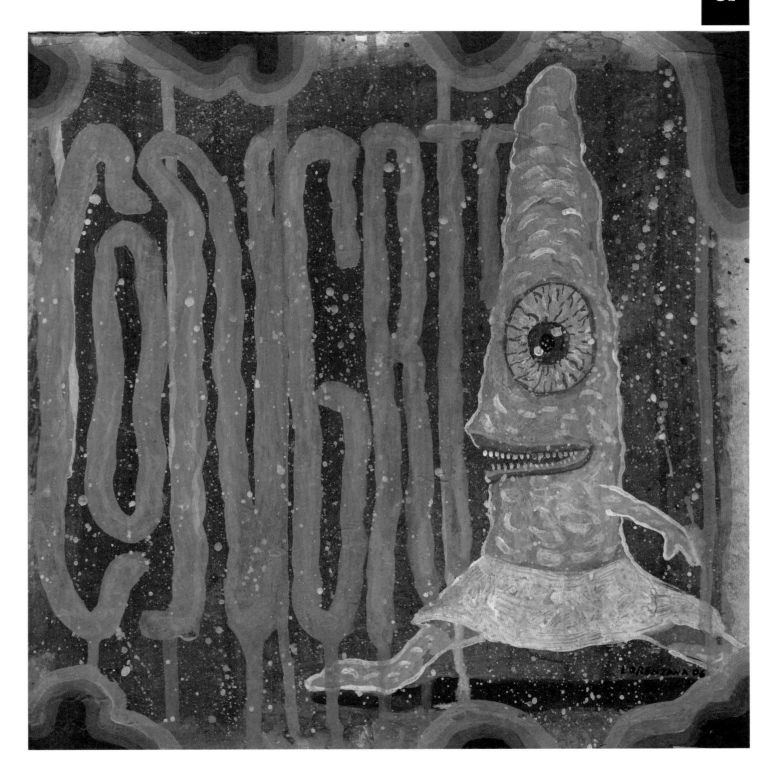

Congrie (Congressman), 2006, Acrylic on Paper, 12 x 12"

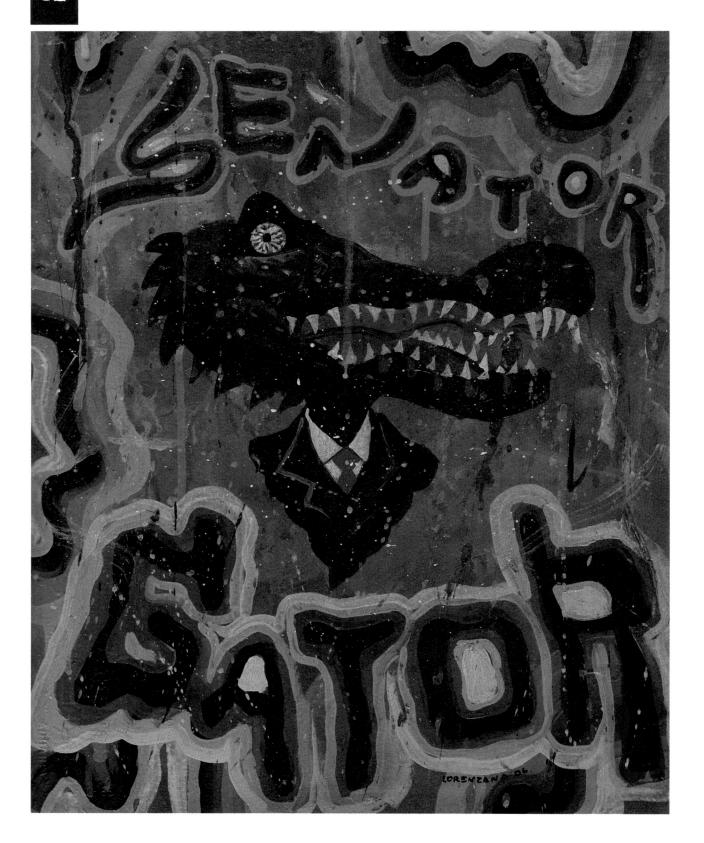

Senator Gator, 2006, Acrylic on Paper, 15 x 12"

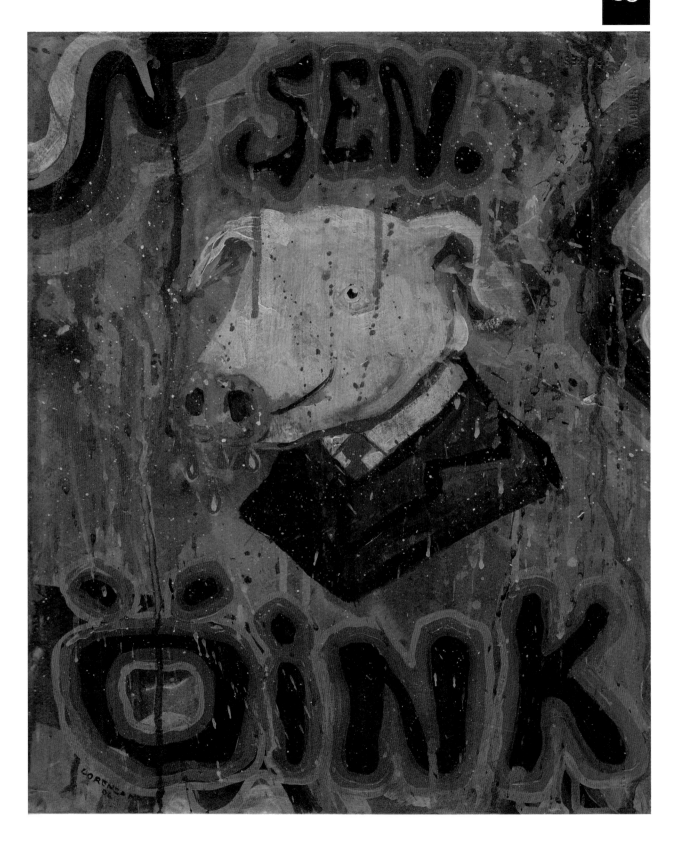

Senator Oink, 2006, Acrylic on Paper, 15 x 12"

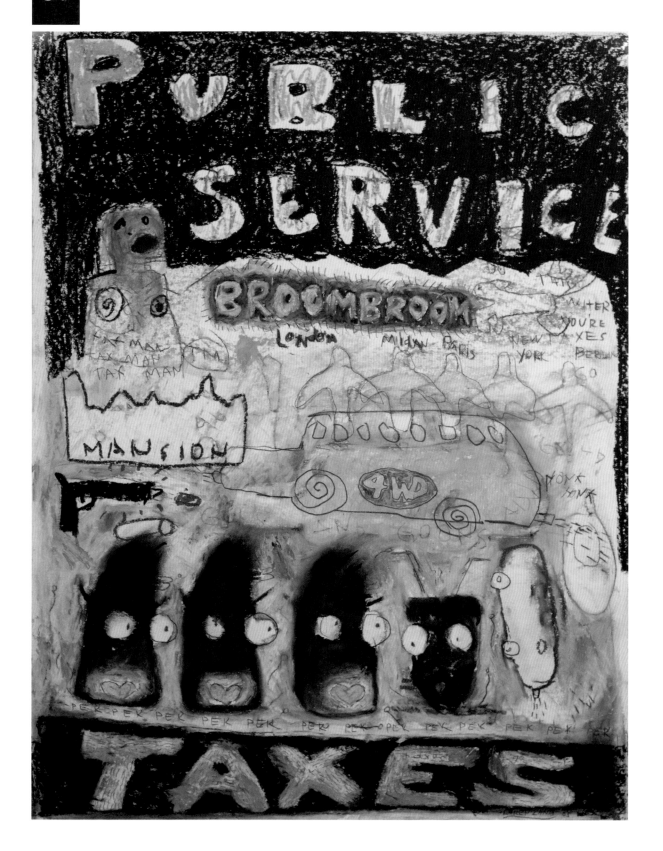

Taxes, 2005, Oil Pastel on Paper, 26 x 19 1/4"

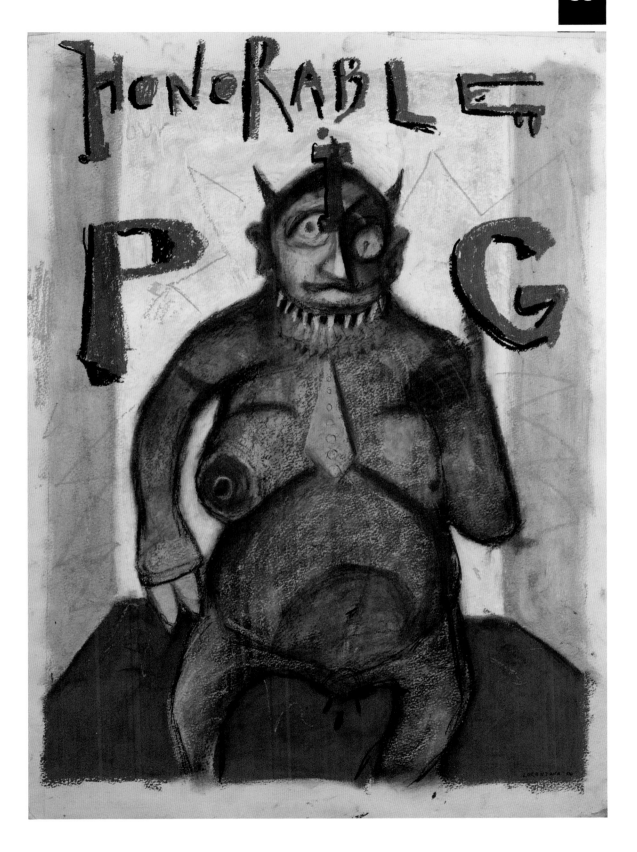

Honorable Pig, 2006, Acrylic and Oil Pastel on Paper, 29 1/4 x 21 1/2"

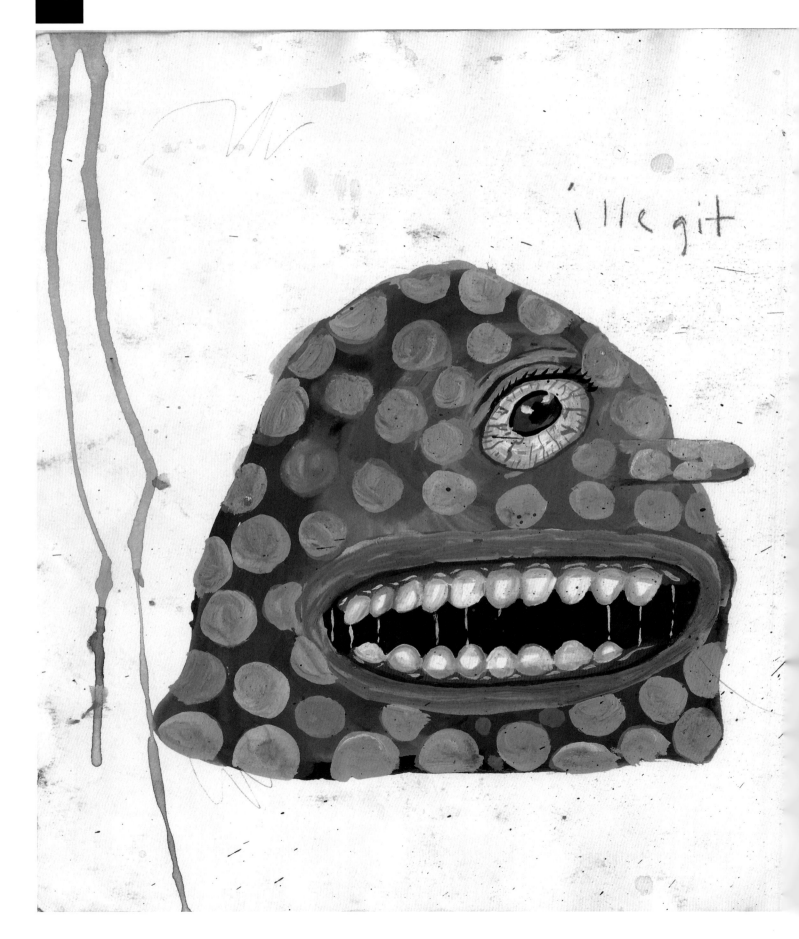

Illegit, 2007, Gouache on Paper,
11 3/4 x 16 1/2"

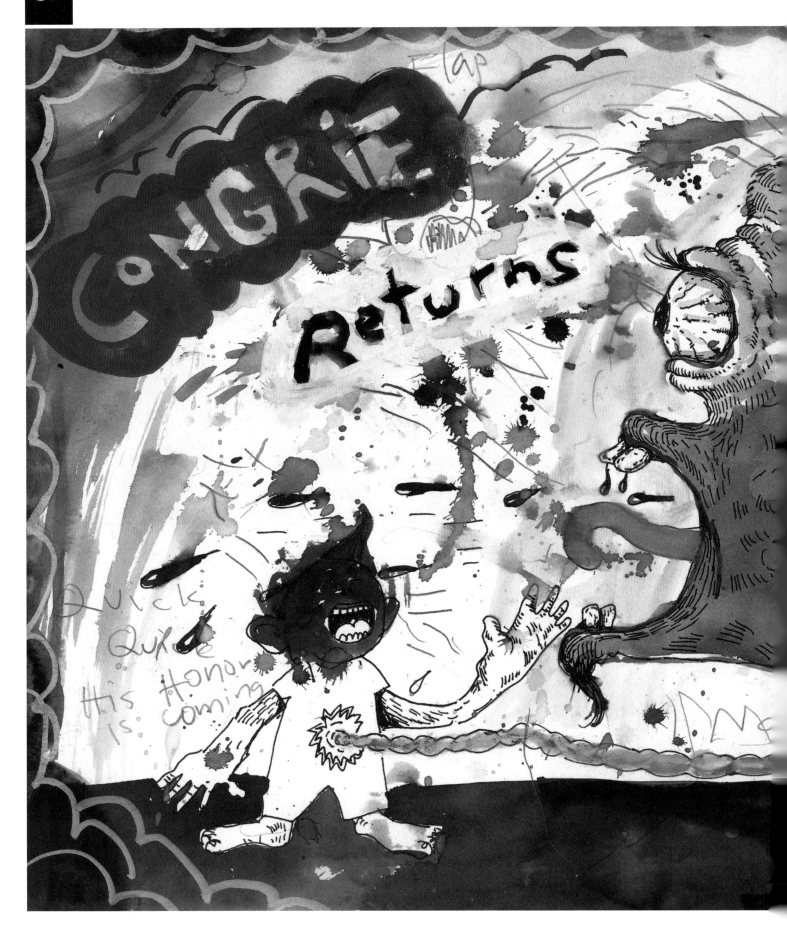

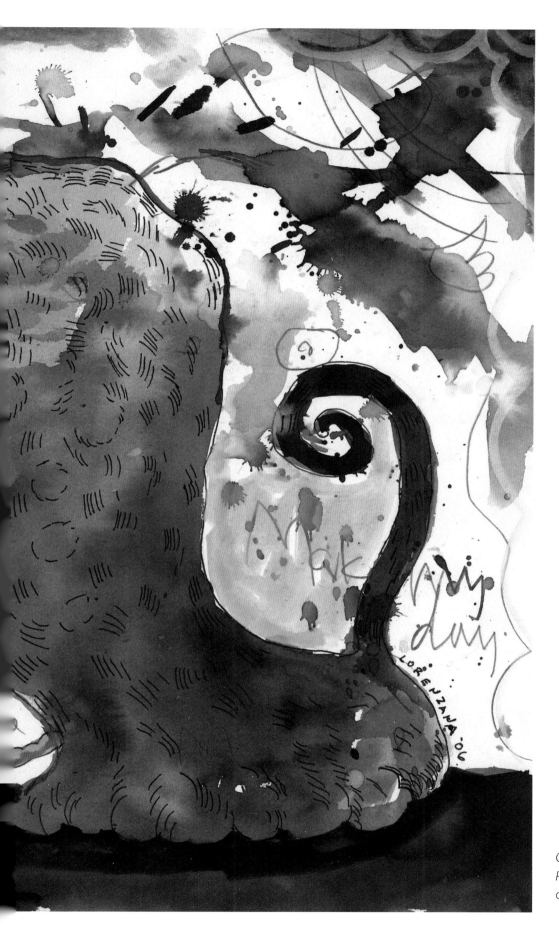

Congrie Returns (Congressman Returns), 2006, Gouache and Pen and Ink on Paper, 11 3/4 x 16 1/2"

Paintings

II

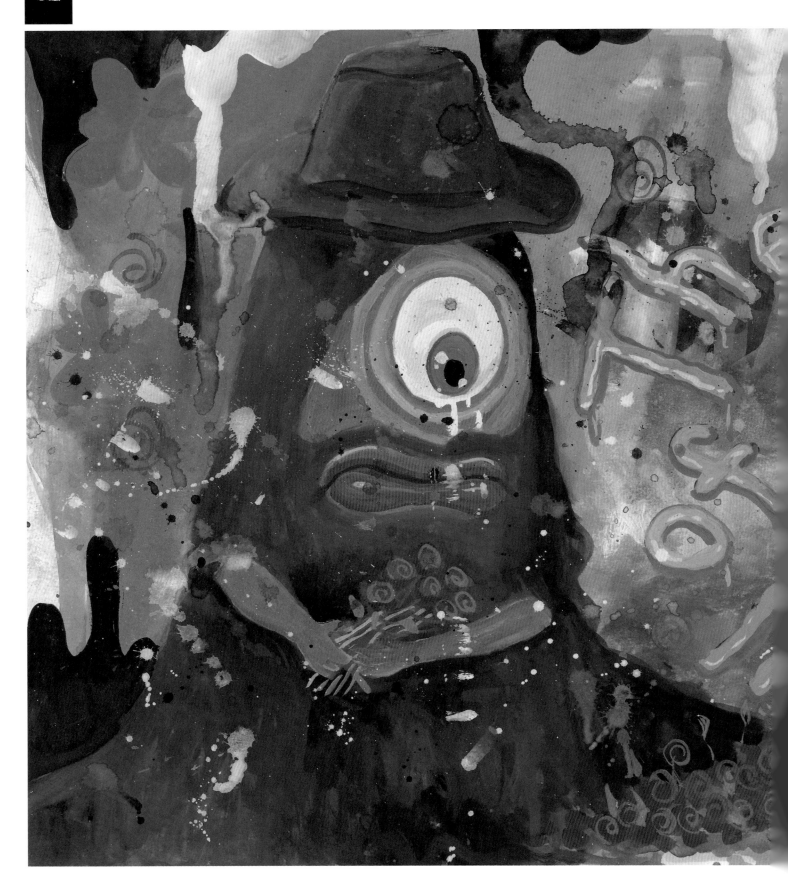

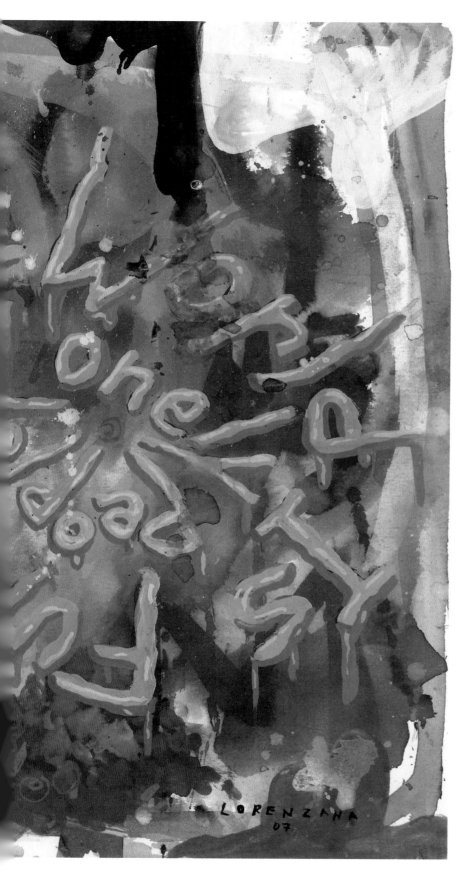

TWIFOLP (The World is Full of Lonely People),
2007, Gouache on Paper, 11 3/4 x 16 1/2"

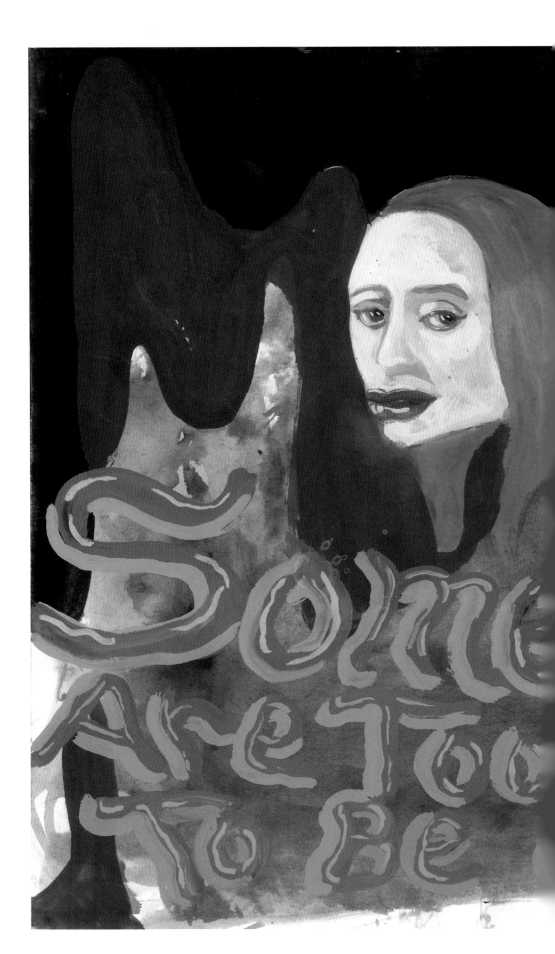

Beautiful Bird, 2007,
Gouache on Paper, 11 3/4 x 16-1/2"

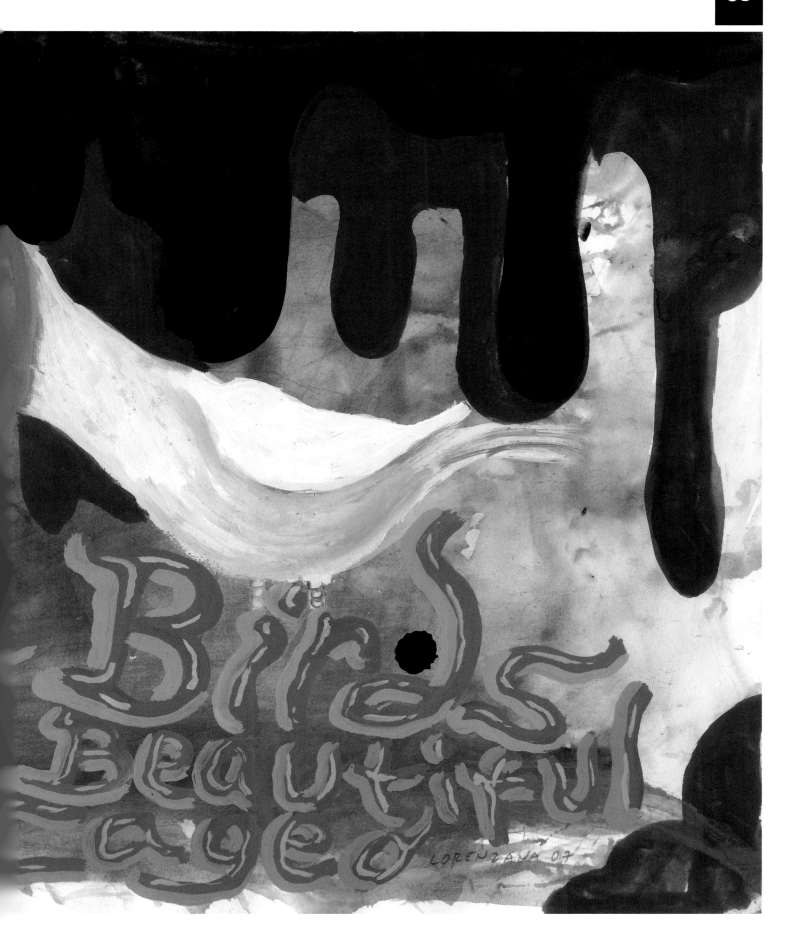

Birds Beautiful Eyes

LORENZANA 07

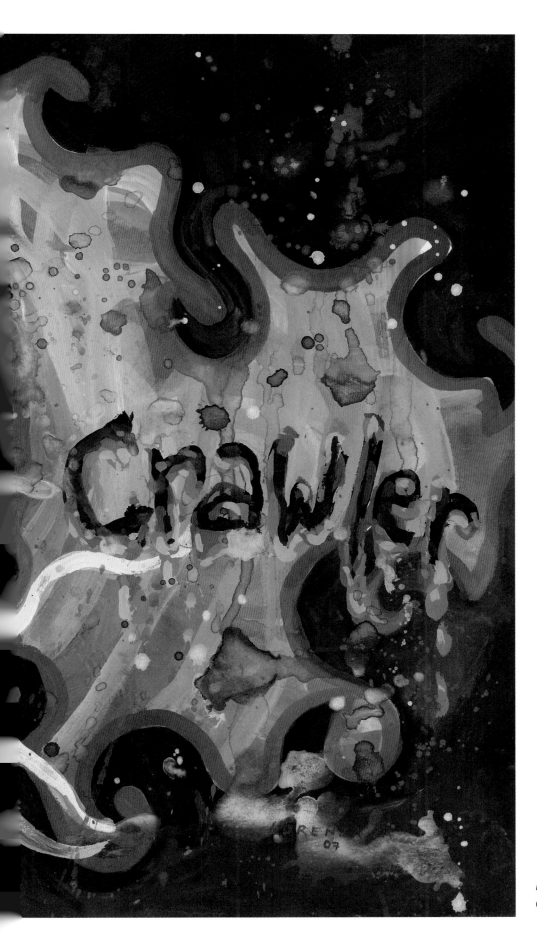

Night Crawler, 2007,
Gouache on Paper, 11 3/4 x 16 1/2"

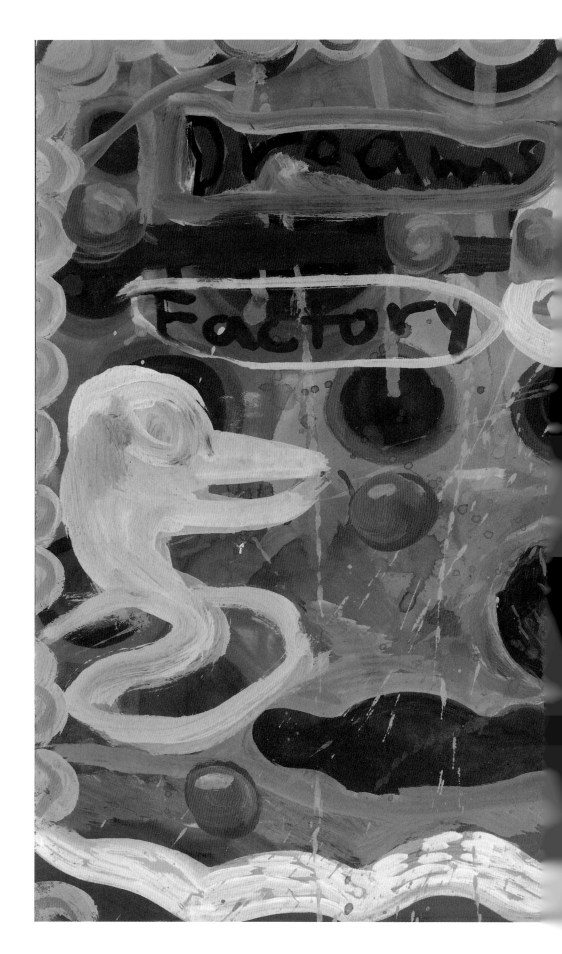

Dreams Factory, 2006,
Gouache on Paper, 11 3/4 x 16 1/2"

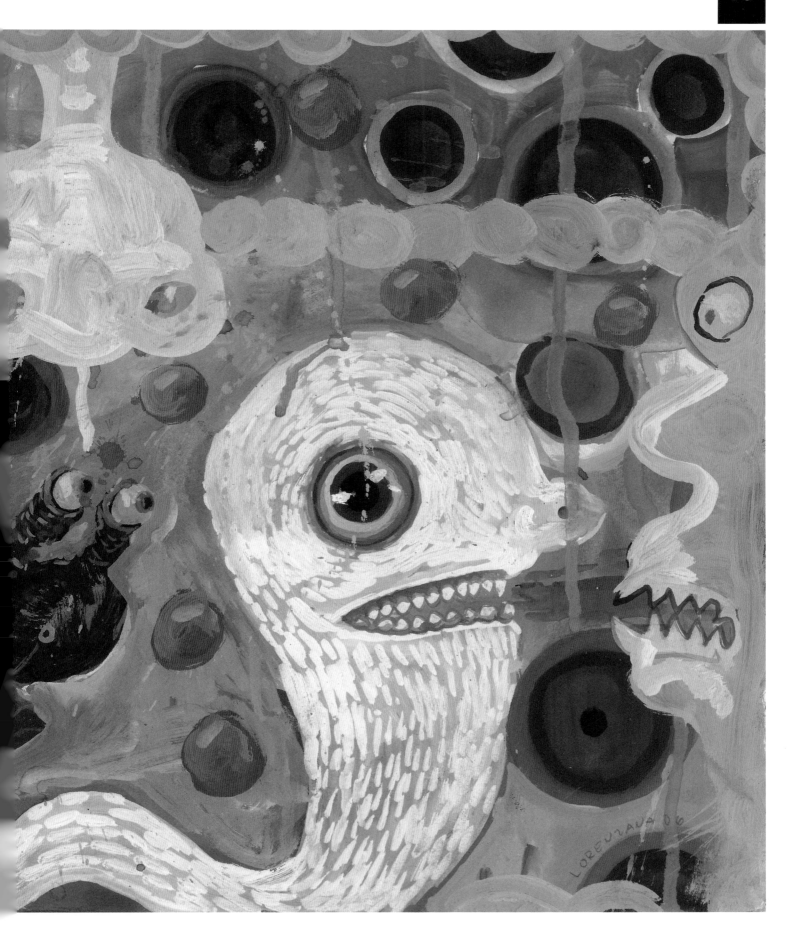

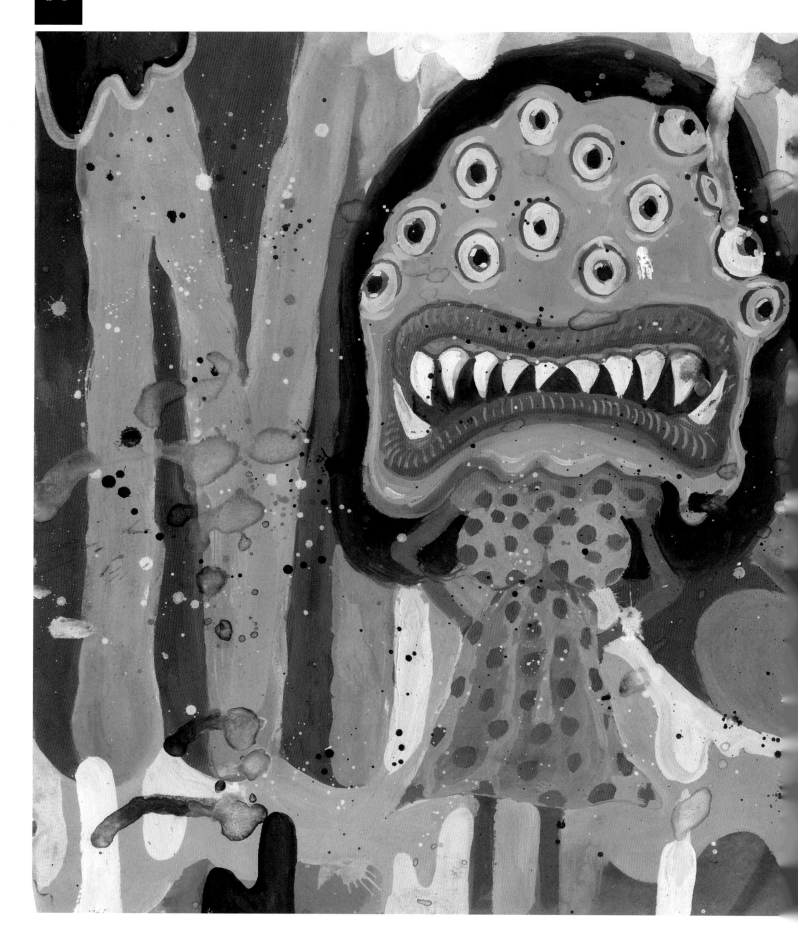

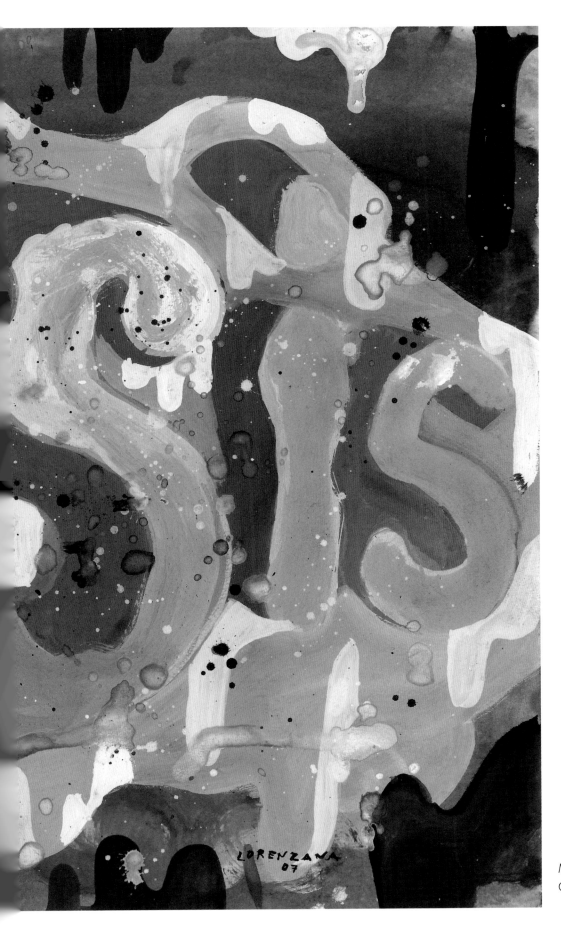

Misis, 2007,
Gouache on Paper, 11 3/4 x 16 1/2"

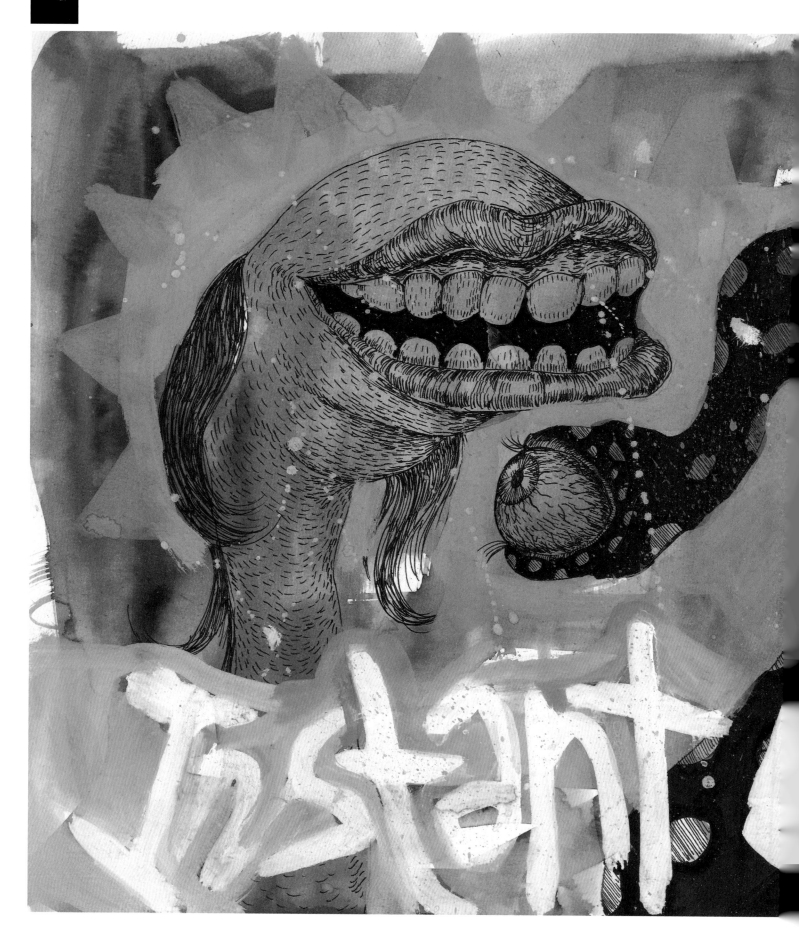

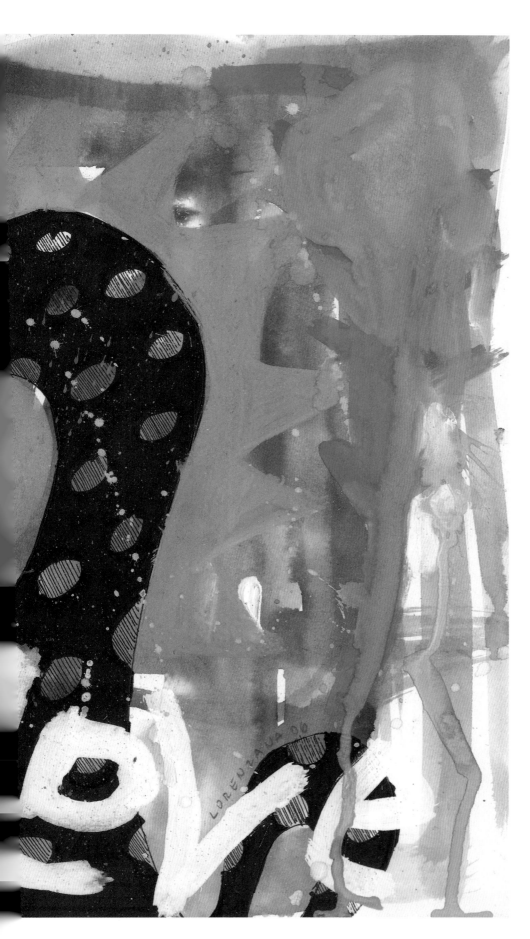

Instant Love, 2006,
Gouache and Pen and Ink on Paper,
11 3/4 x 16 1/2"

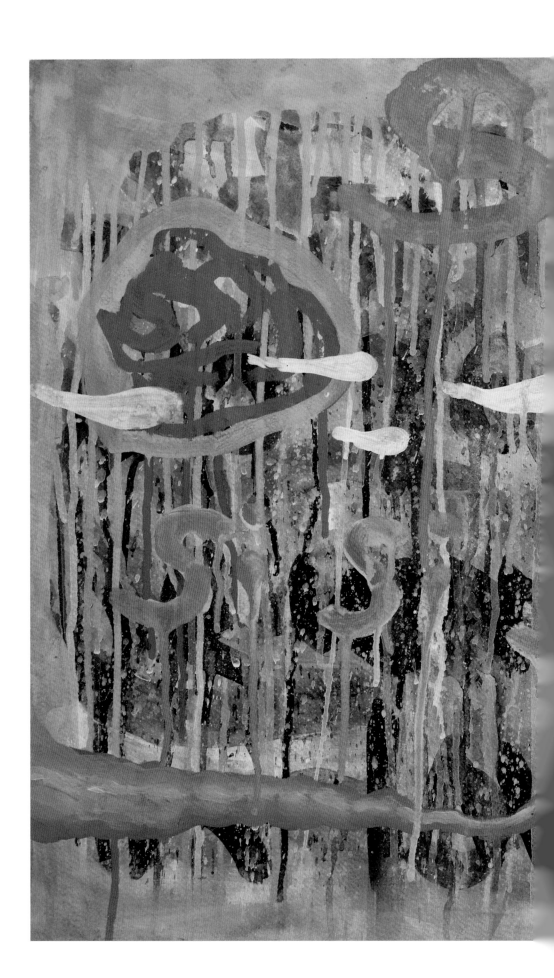

Stranger in the Night, 2006,
Acrylic on Paper, 19 3/4 x 27 1/2"

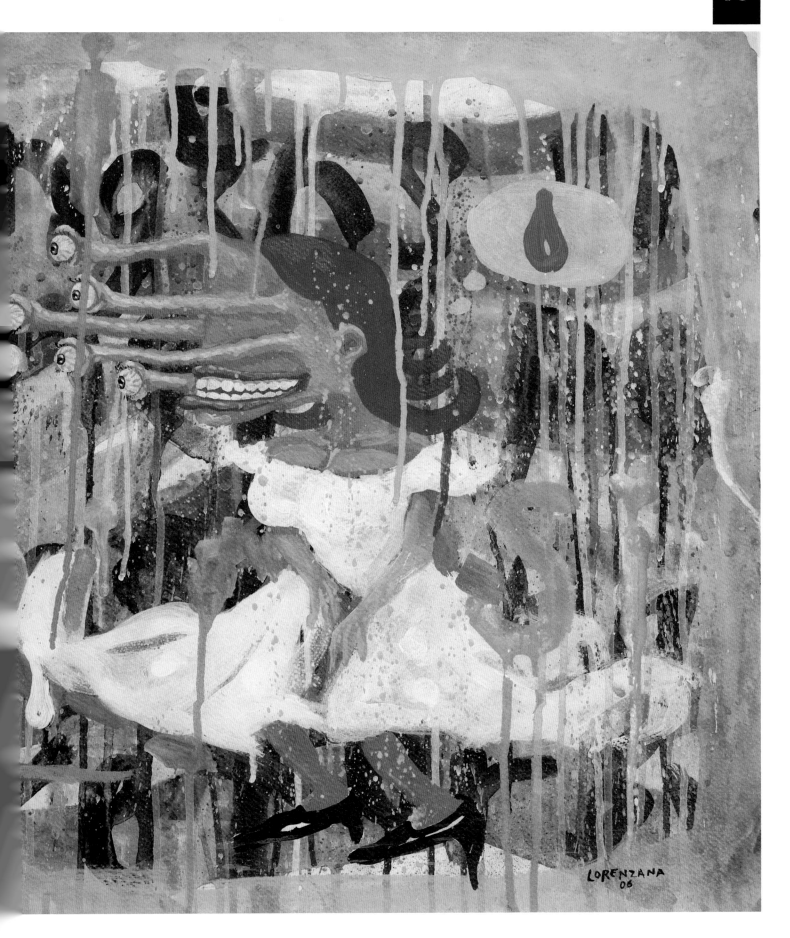

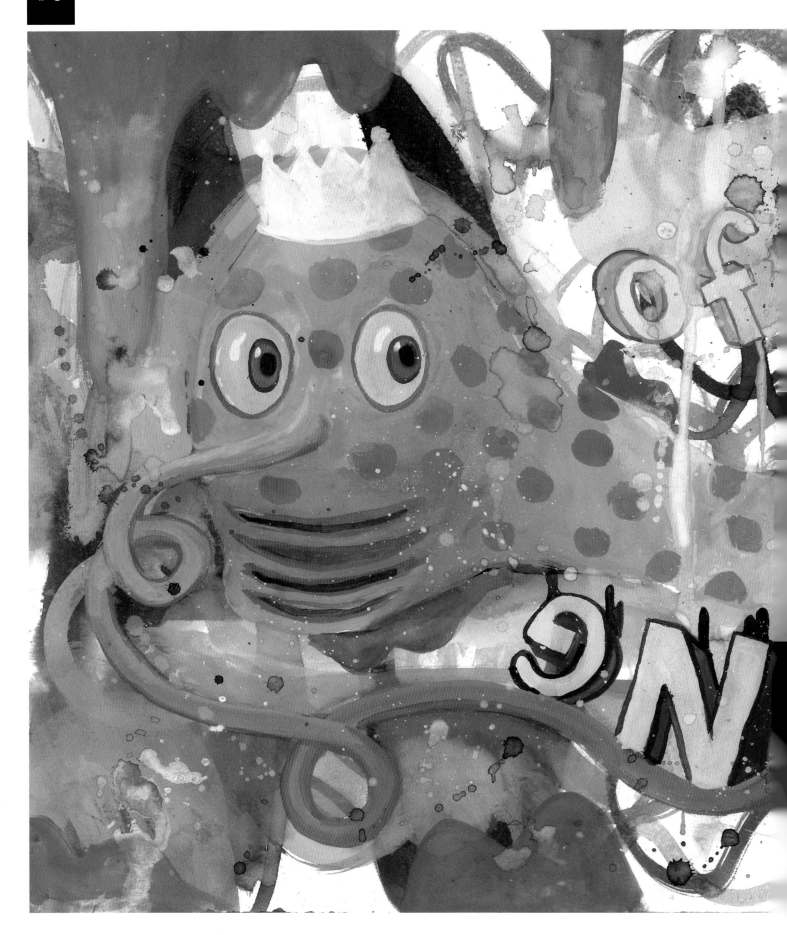

King of Lies, 2007,
Gouache on Paper, 11 3/4 x 16 1/2"

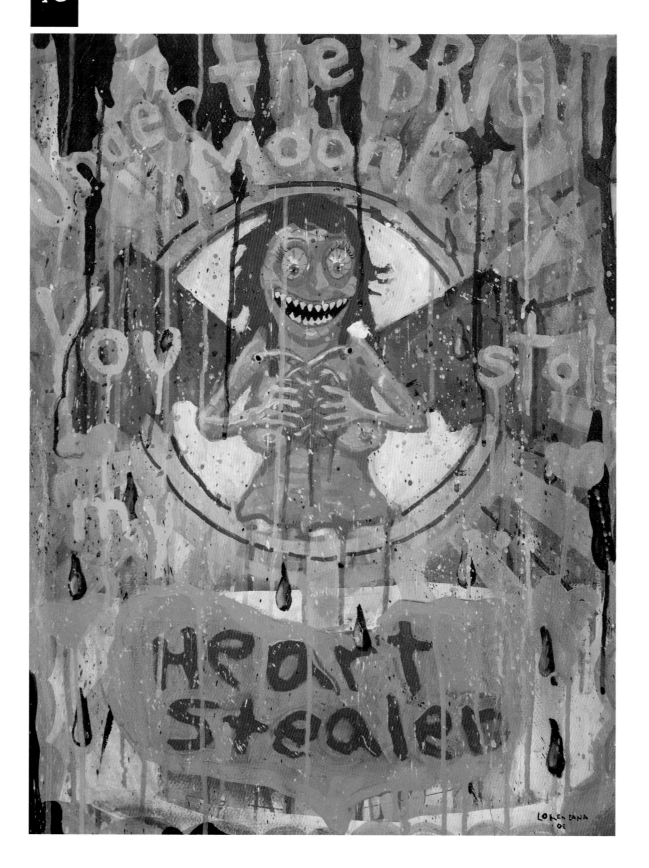

Heart Stealer, 2006, Acrylic on Paper, 27 1/2 x 19 3/4"

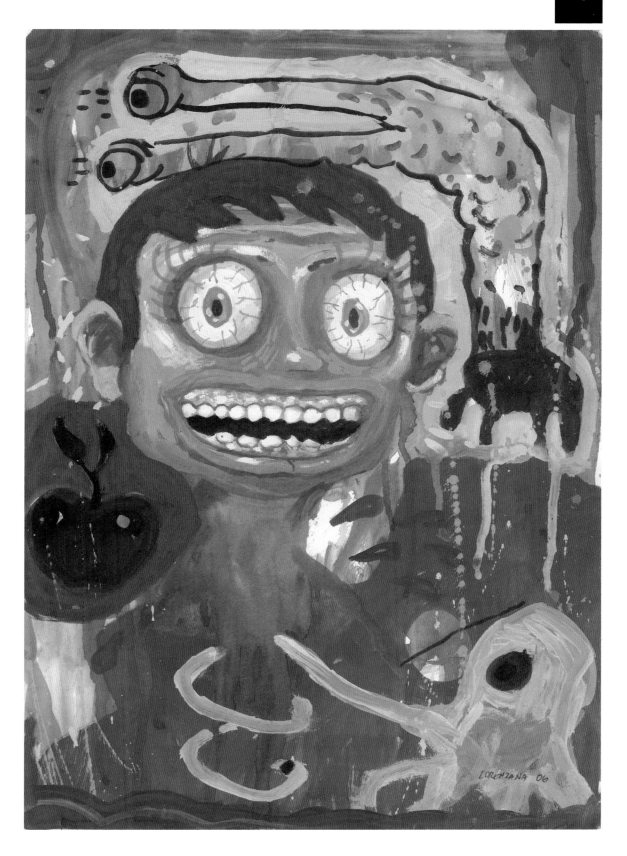

Adam (Self-Portrait), 2006, Gouache on Paper, 16 1/2 x 11 3/4"

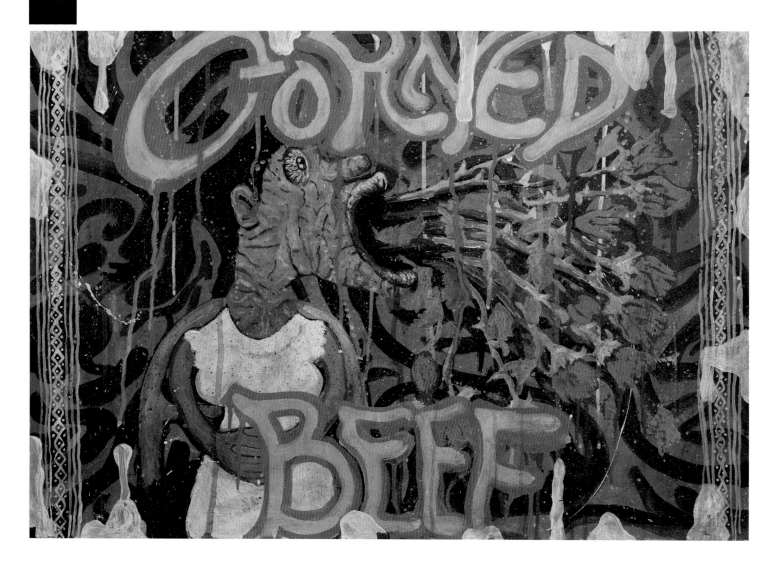

Corned Beef, 2006, Acrylic on Paper, 21 1/2 x 28 3/4"

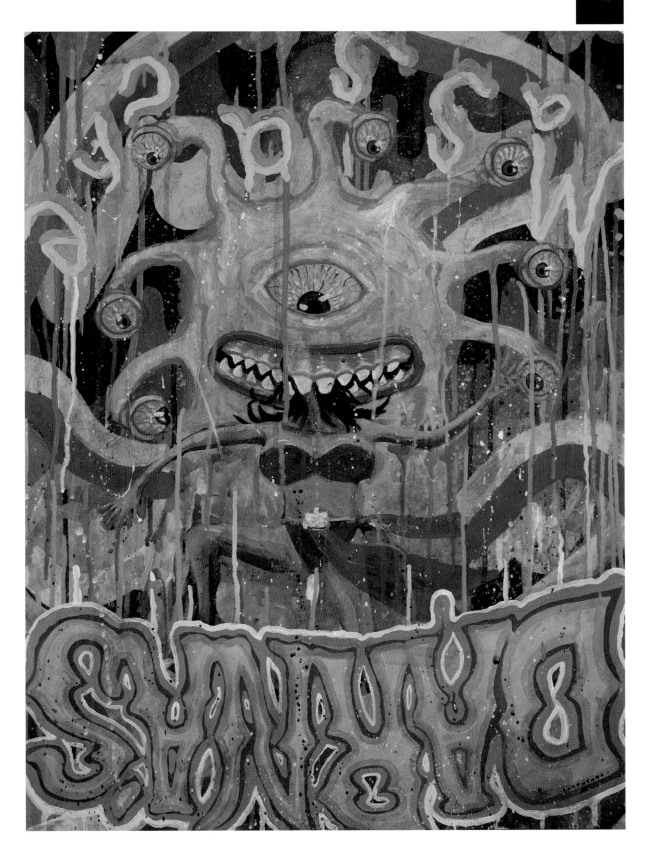

Darna's Massacre, 2007, Acrylic on Paper, 27 1/2 x 19 1/2"

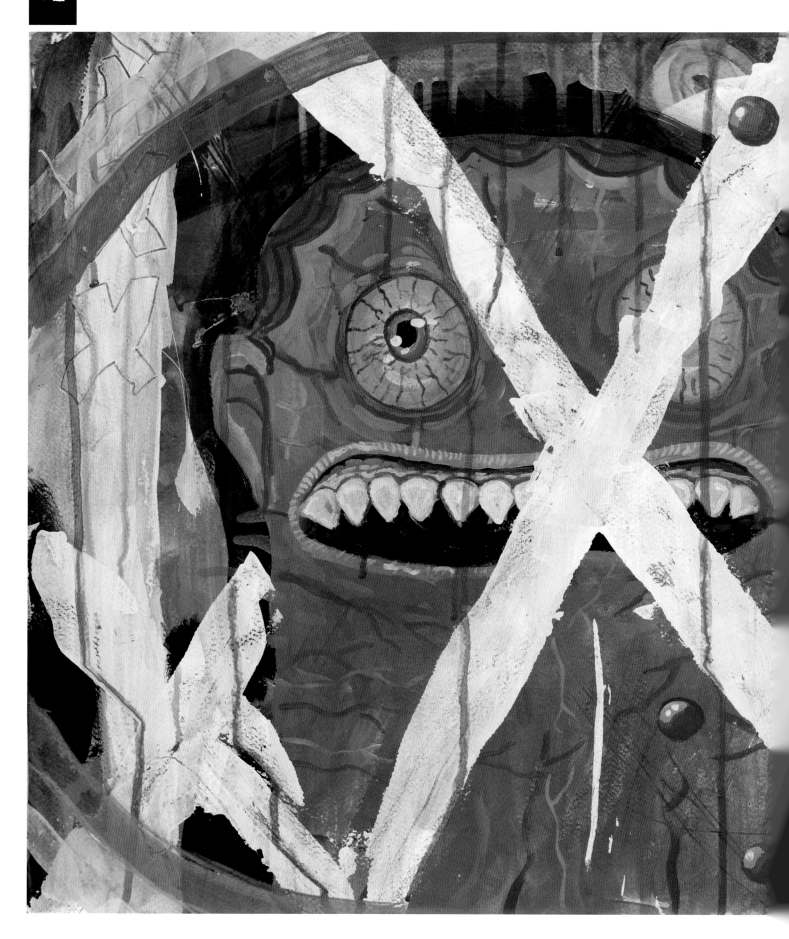

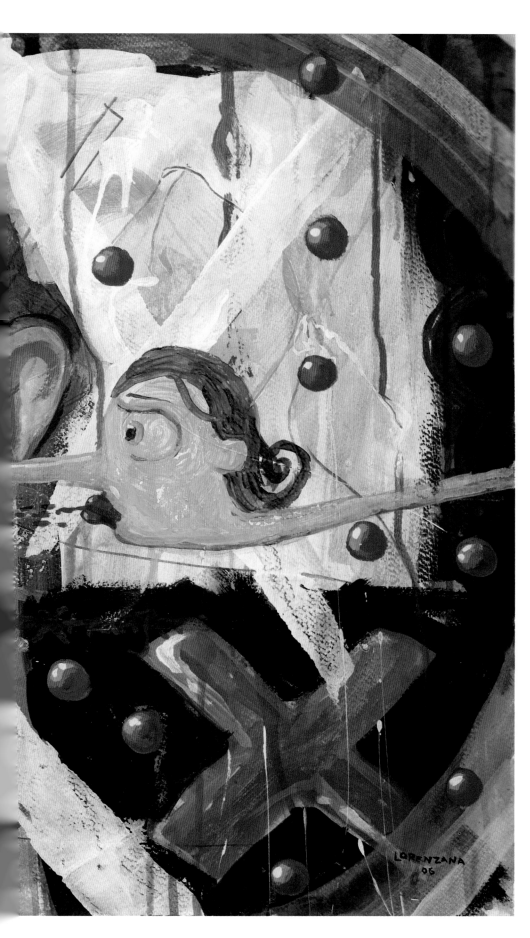

XXX, 2006,
Acrylic on Paper,
19 3/4 x 27 1/2"

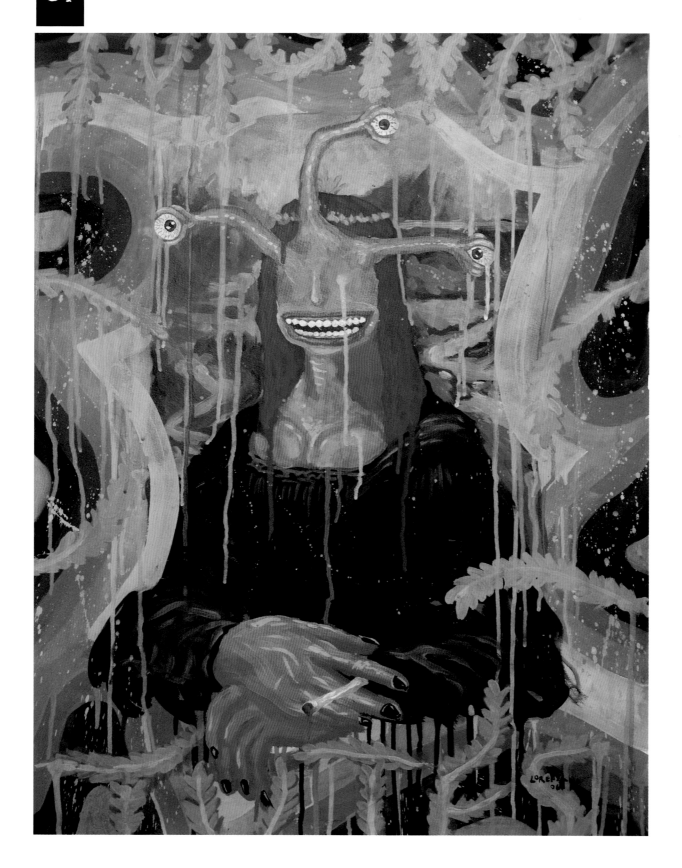

Mona Ganja, 2006, Acrylic on Paper, 29 x 21 1/2"

El Bosero, 2006, Acrylic on Paper, 12 x 12"

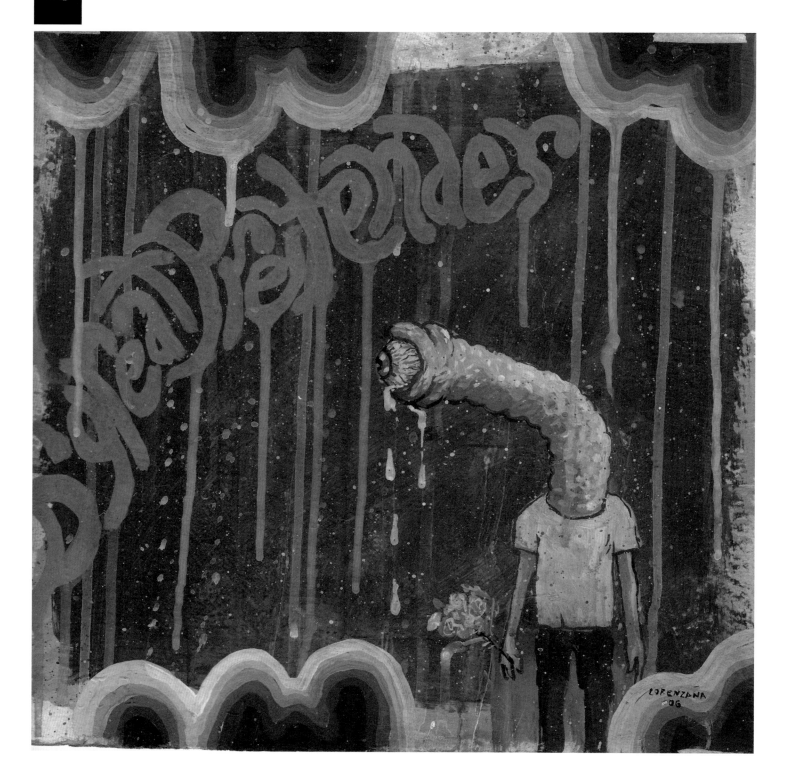

D' Great Pretender, 2006, Acrylic on Paper, 12 x 12"

Beauty Queen, 2006, Acrylic on Paper, 12 x 12"

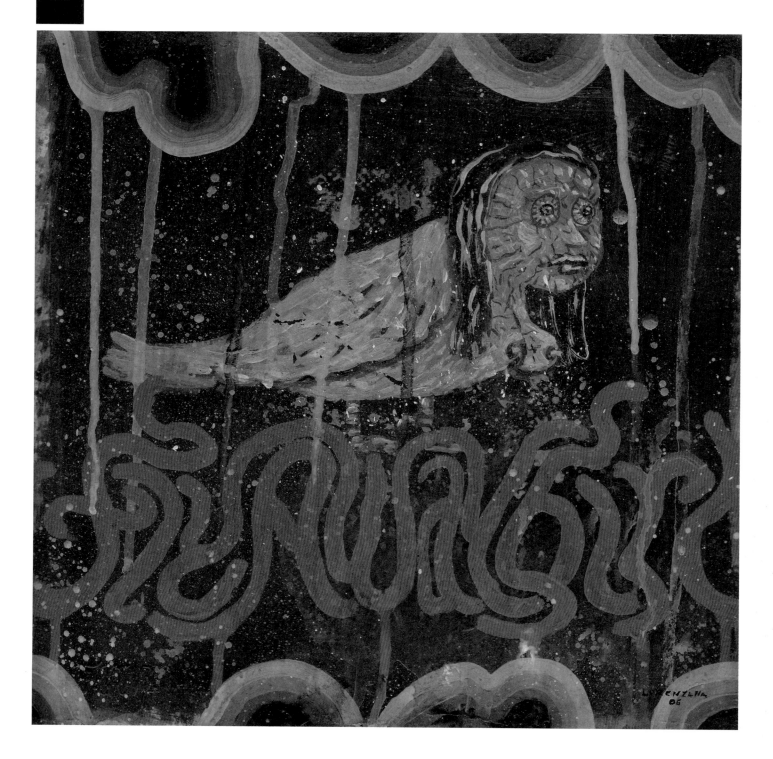

Fly Away Girl, 2006, Acrylic on Paper, 12 x 12"

Paintings

III

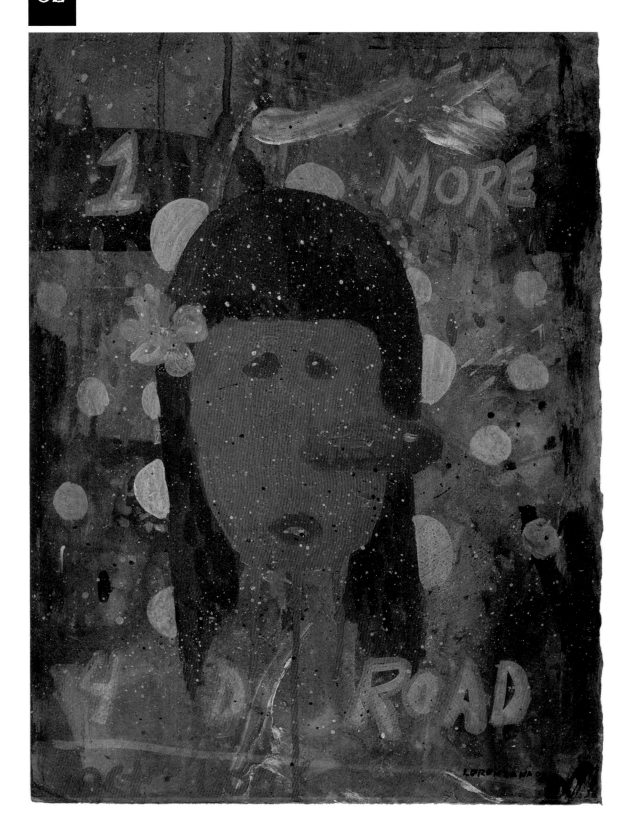

Last for the Road, 2006, Acrylic on Paper, 15 x 10 3/4"

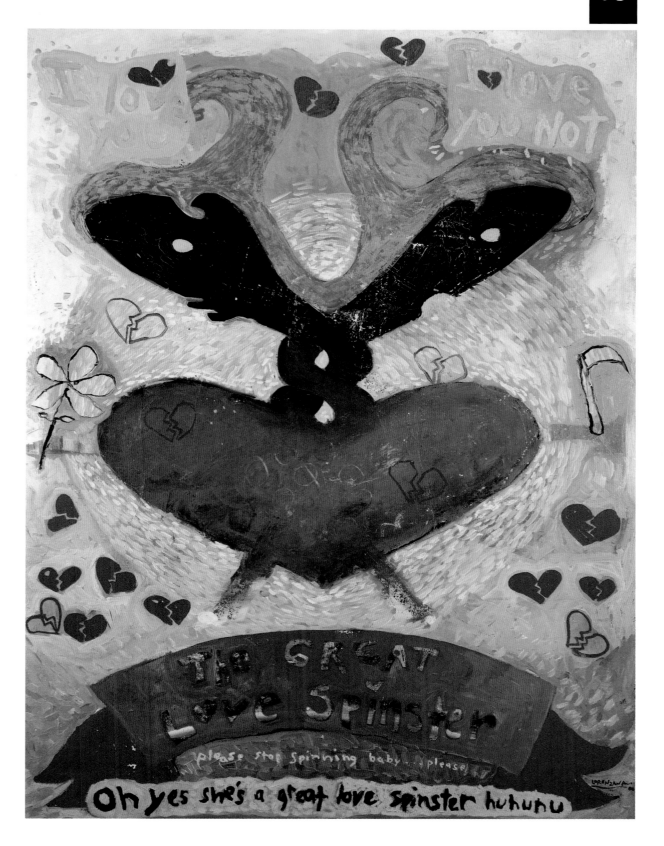

The Great Love Spinster, 2006, Oil on Canvas, 40 x 30"

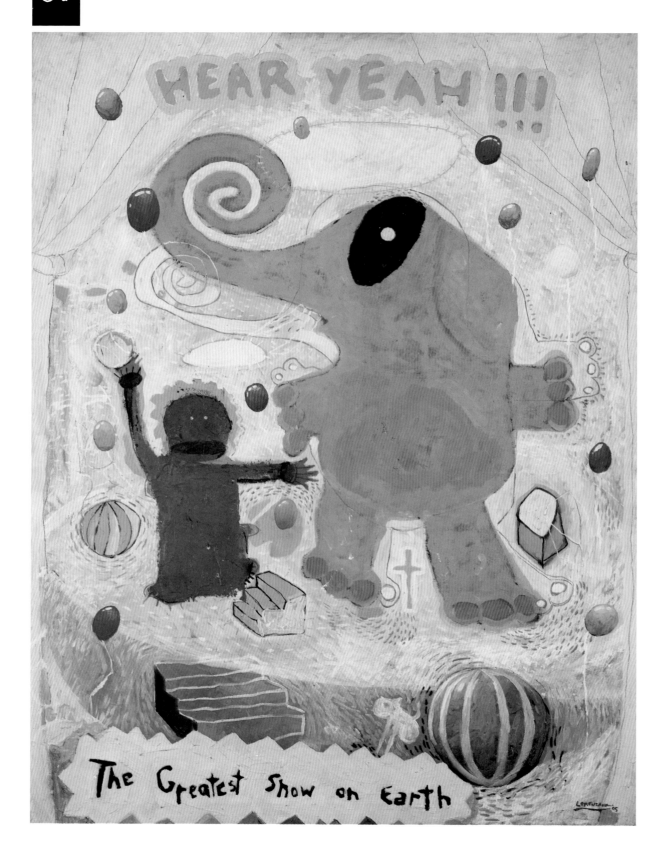

The Greatest Show on Earth, 2005, Oil on Canvas, 48 x 36"

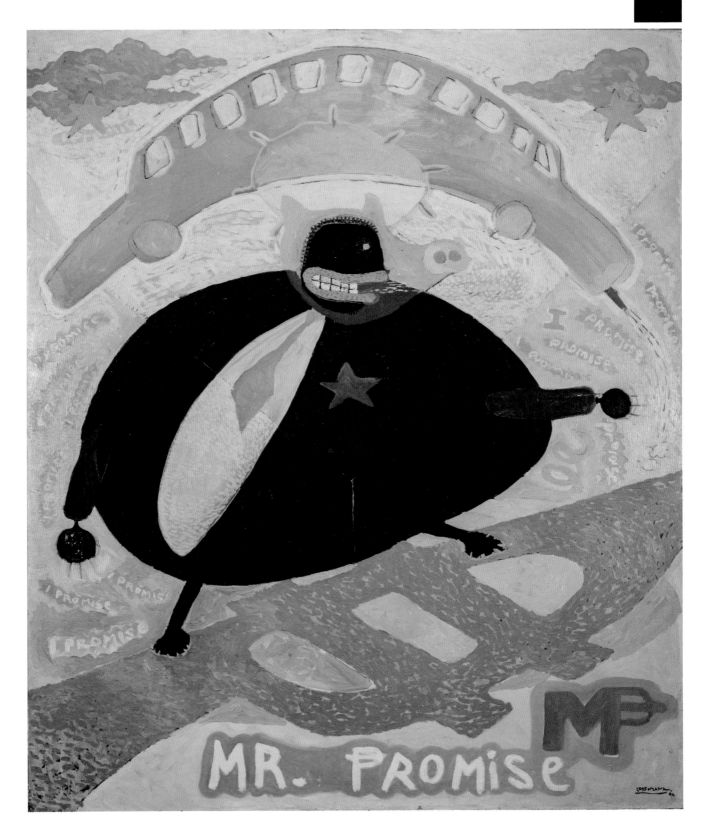

Mr. Promise, 2006, Oil on Canvas, 44 x 36"

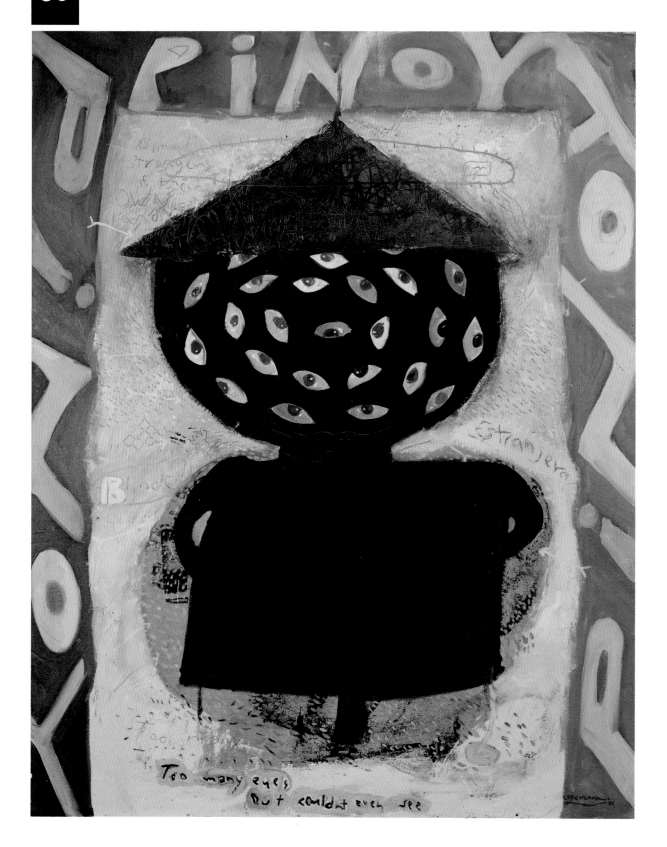

Pinoy, 2006, Oil on Canvas, 40 x 30"

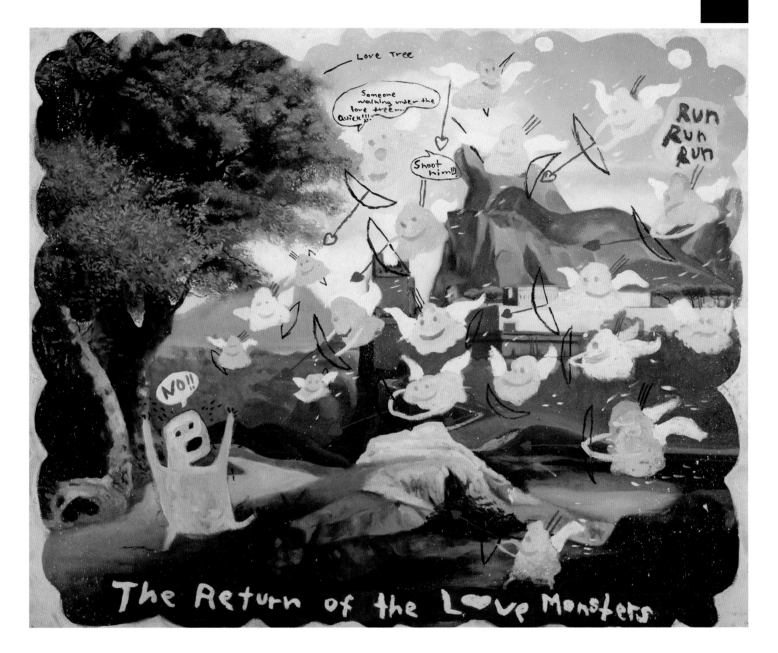

Love Monsters, 2006, Oil on Canvas, 35 x 40"

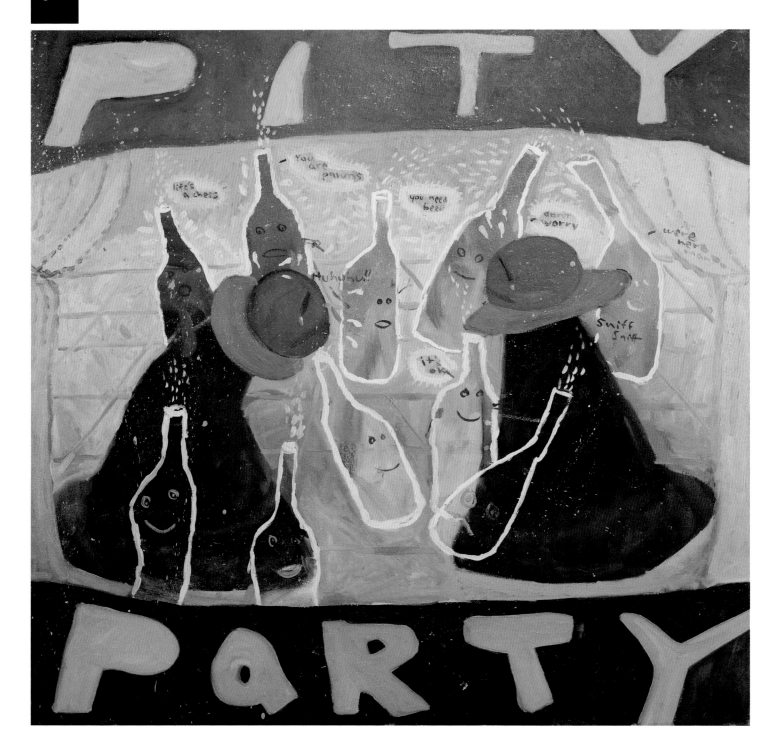

Pity Party, 2006, Oil on Canvas, 30 x 30"

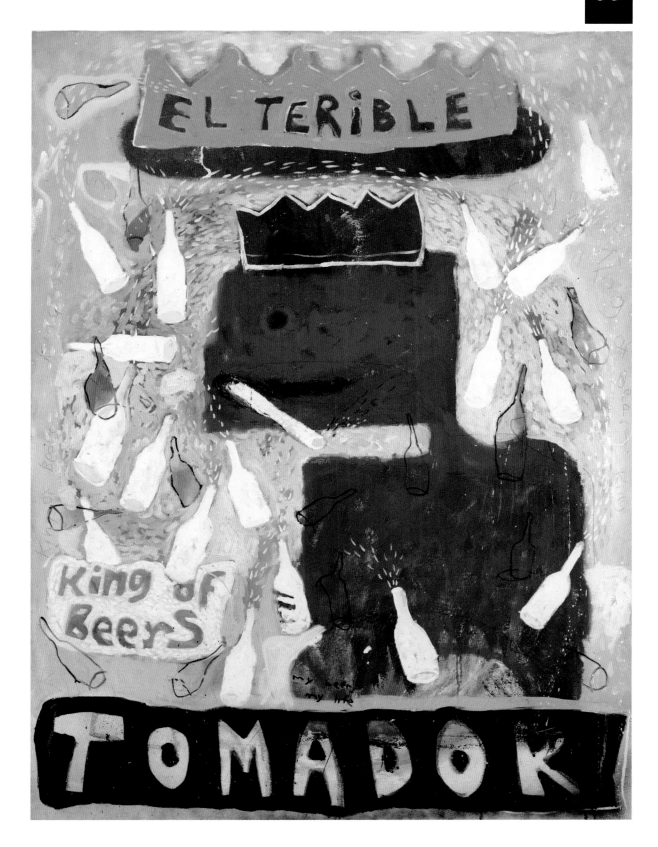

El Tomador, 2006, Oil on Canvas, 40 x 30"

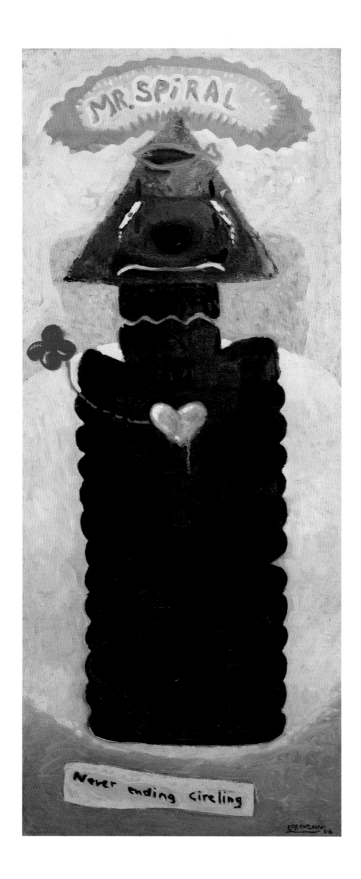

Mr. Spiral, 2006, Oil on Canvas, 33 x 13"

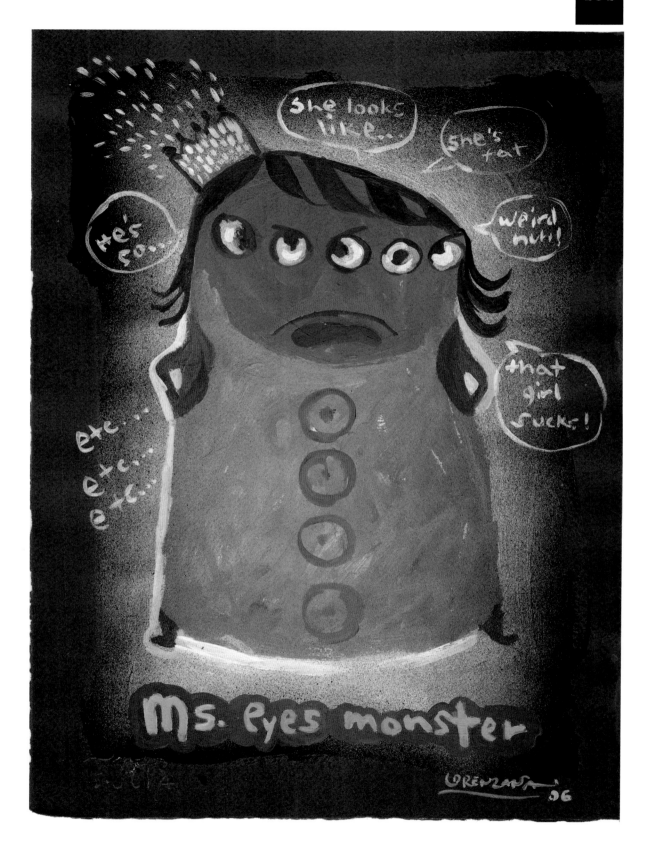

Ms. Eyes Monster, 2006, Acrylic on Paper, 13 x 9 1/2"

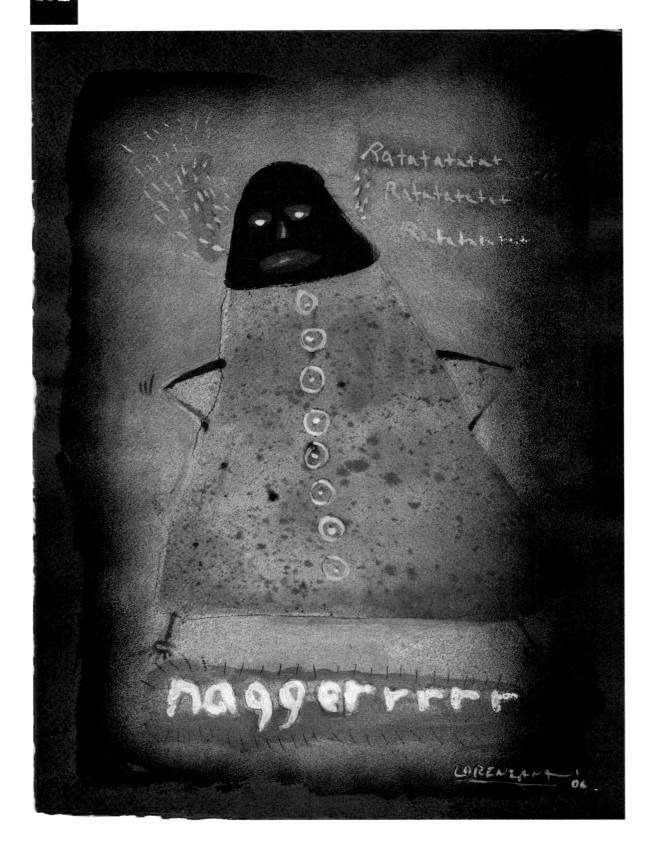

Naggerrrr, 2006, Acrylic on Paper, 13 x 9 1/2"

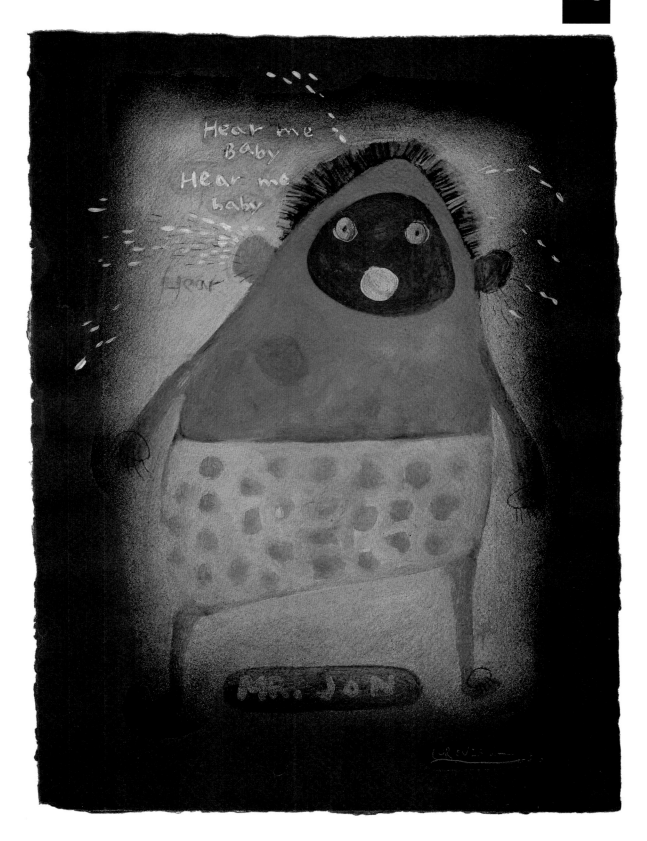

Mr. Jon, 2006, Acrylic on Paper, 13 x 9 1/2"

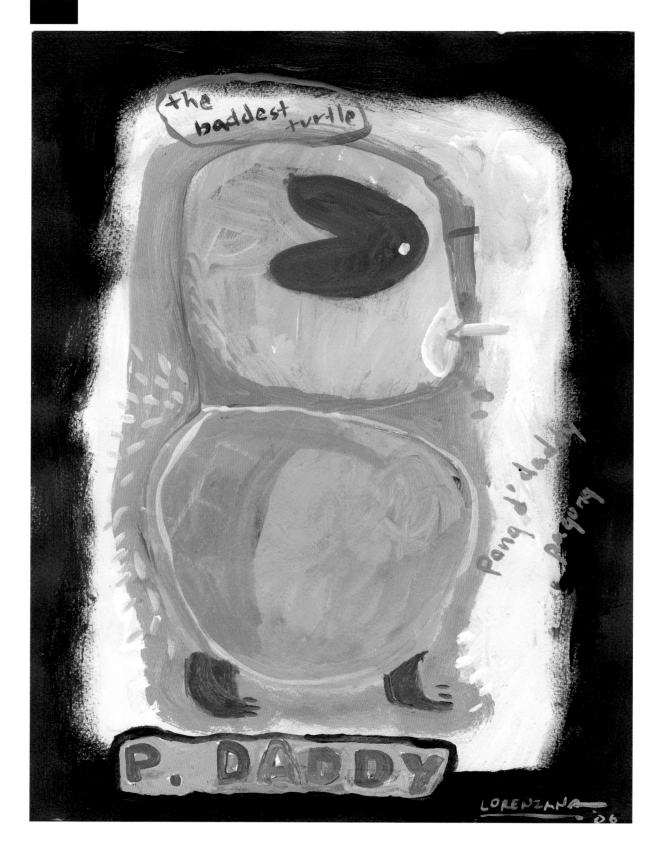

P. Daddy, 2006, Acrylic on Paper, 12 1/4 x 9 1/2"

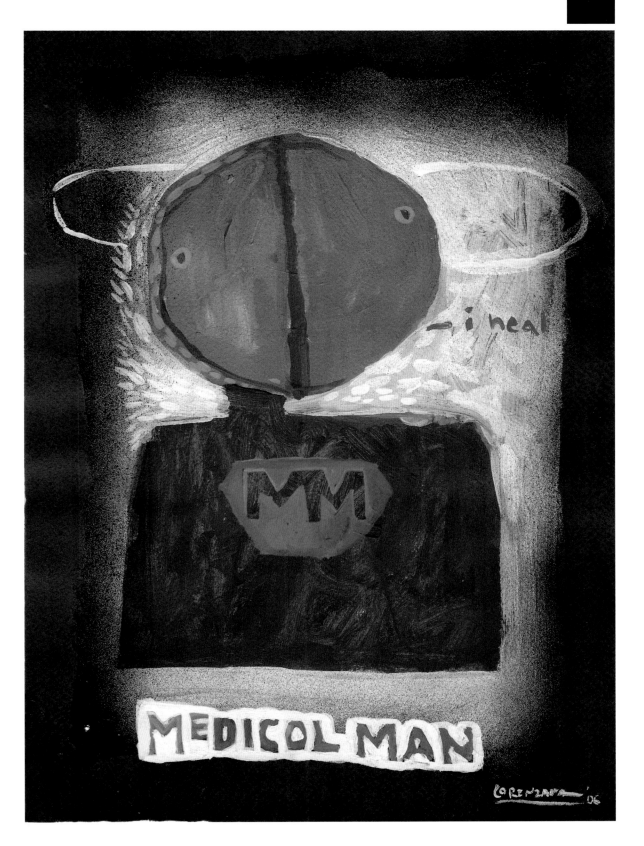

Medicol Man, 2006, Acrylic on Paper, 13 x 9 1/2"

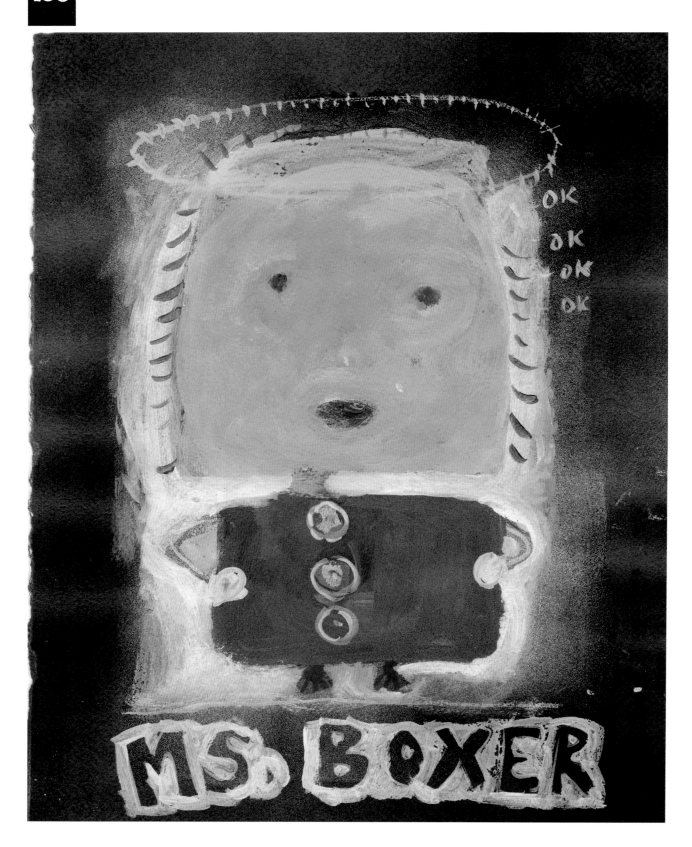

Ms. Boxer, 2006, Acrylic on Paper, 13 x 9 1/2"

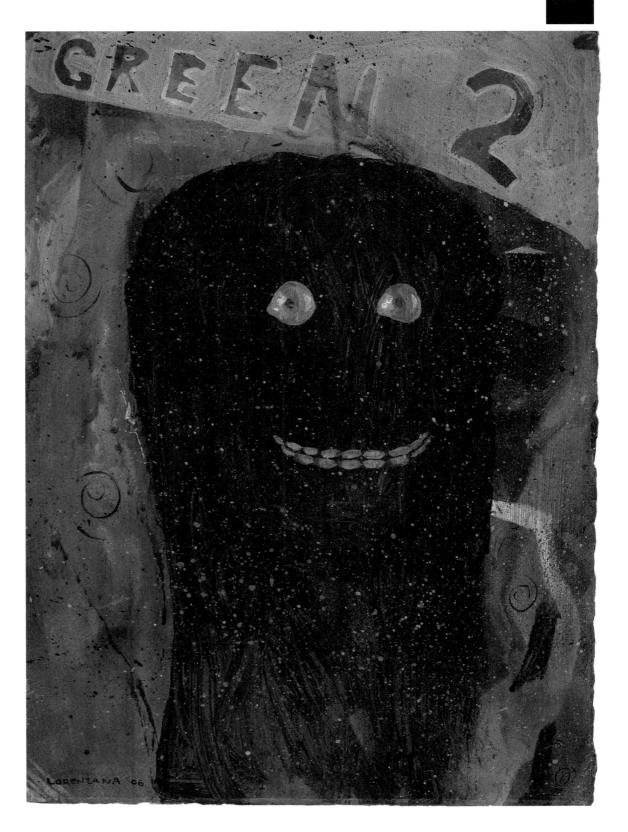

Green 2, 2006, Acrylic on Paper, 15 x 10 3/4"

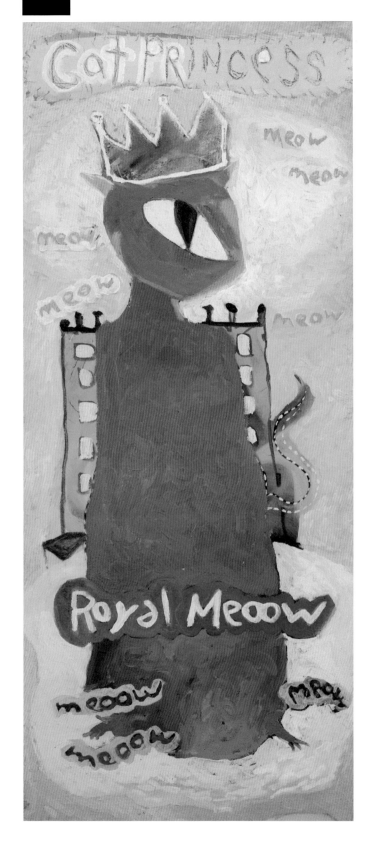

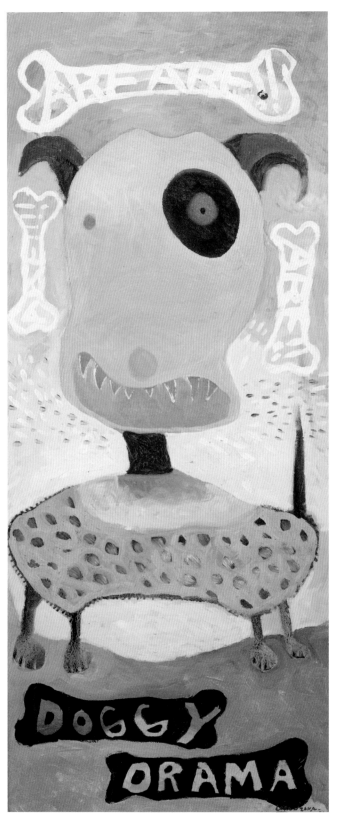

Royal Meoow, 2006, Oil on Canvas, 33 x 13"

Doggy Drama, 2006, Oil on Canvas, 33 x 13"

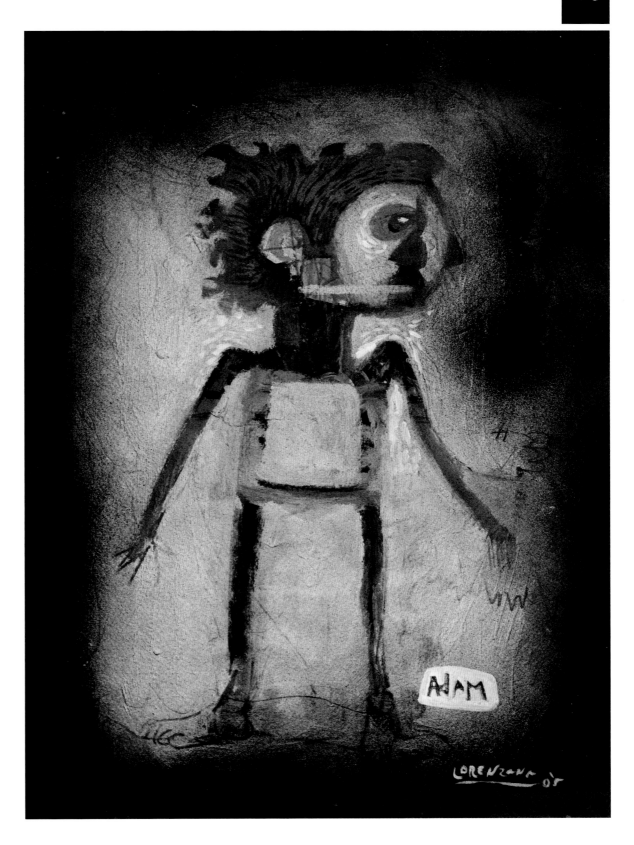

Adam, 2005, Acrylic on Paper, 12 7/8 x 9 1/2"

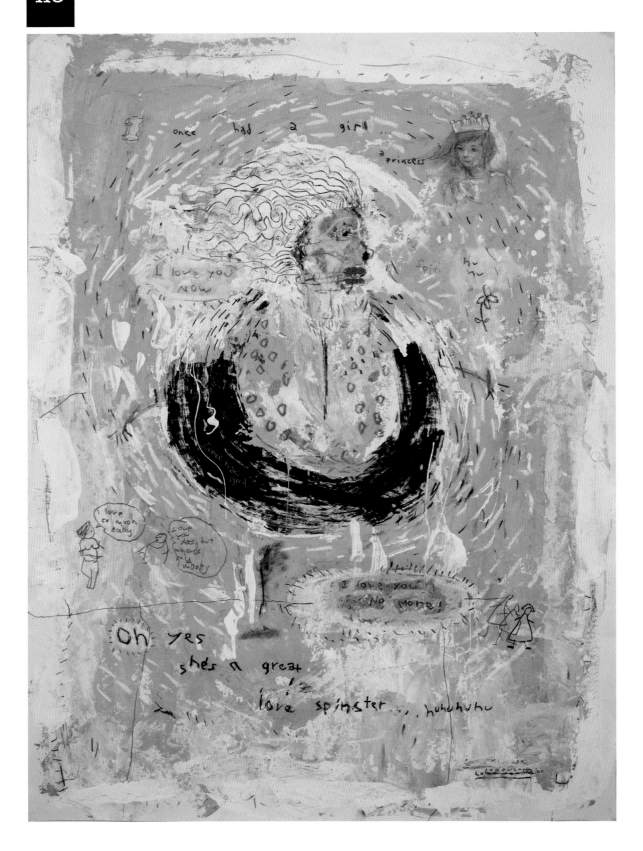

Love Spinster, 2005, Acrylic on Paper, 27 1/2 x 19 1/2"

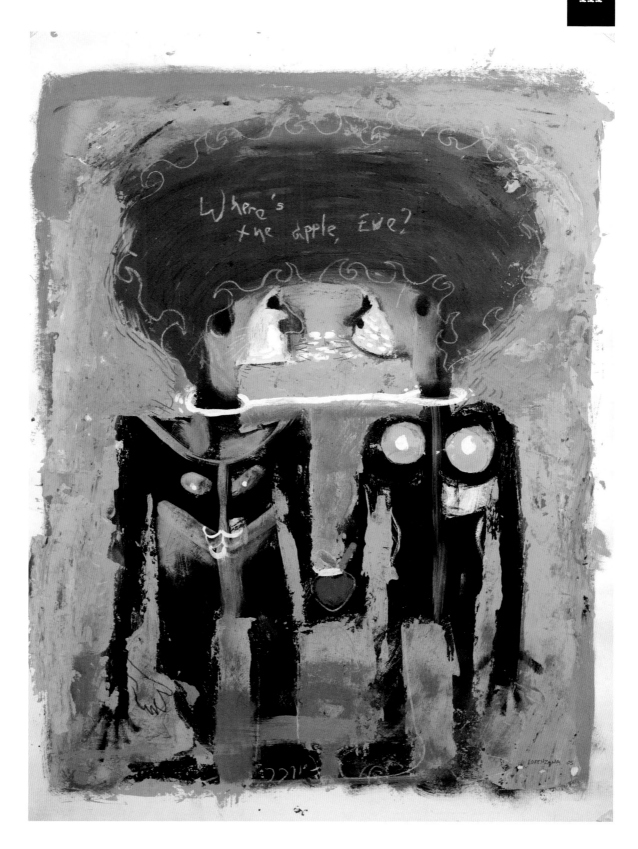

Adam and Eve, 2005, Acrylic on Paper, 27 1/2 x 19 3/4"

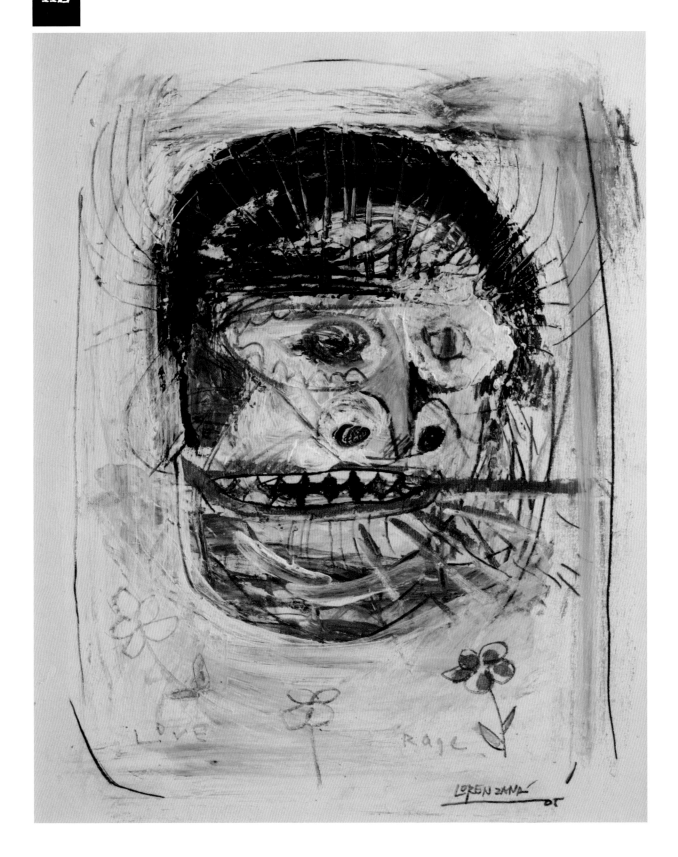

Love and Rage, 2005, Acrylic and Pastel on Paper, 11 1⁄4 x 8 1/2"

Blue Moon, Yellow Stars, and Pink Elephant, 2005, Acrylic and Pastel on Paper, 10 3/4 x 8"

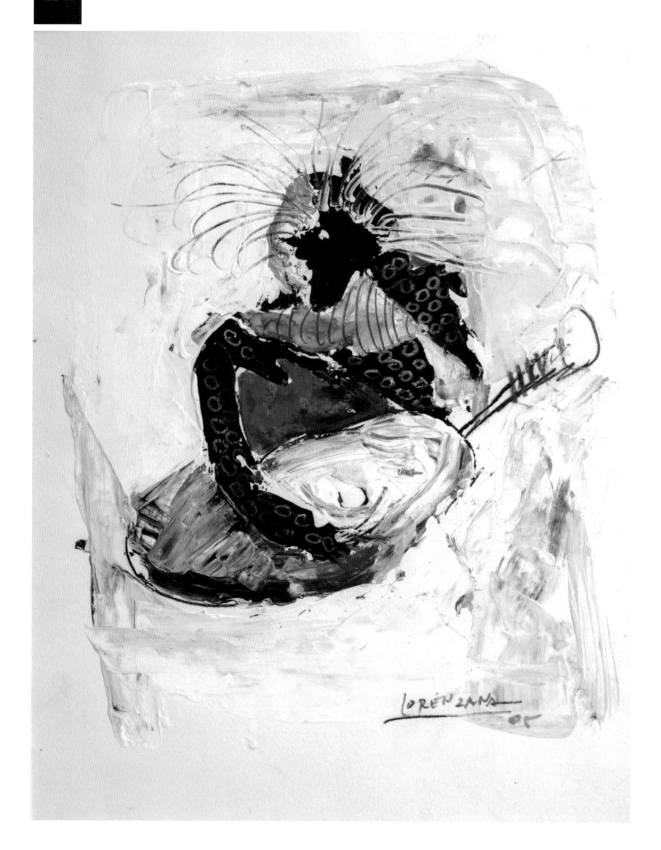

Guitar Man, 2005, Acrylic on Paper, 10 3/4 x 8"

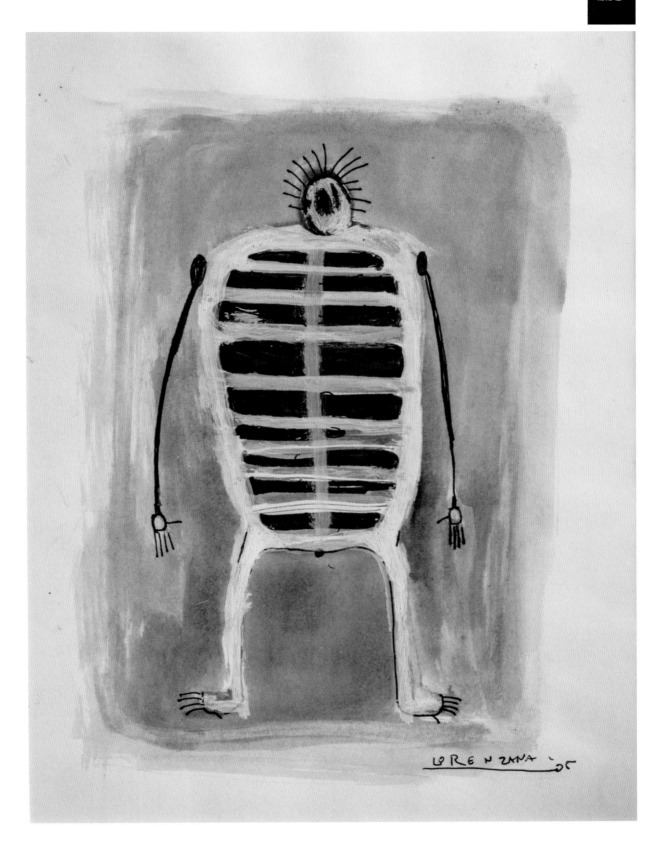

Homo Sapien, 2005, Acrylic and Pen and Ink on Paper, 10 3/4 x 8"

Sketchbooks & Studies

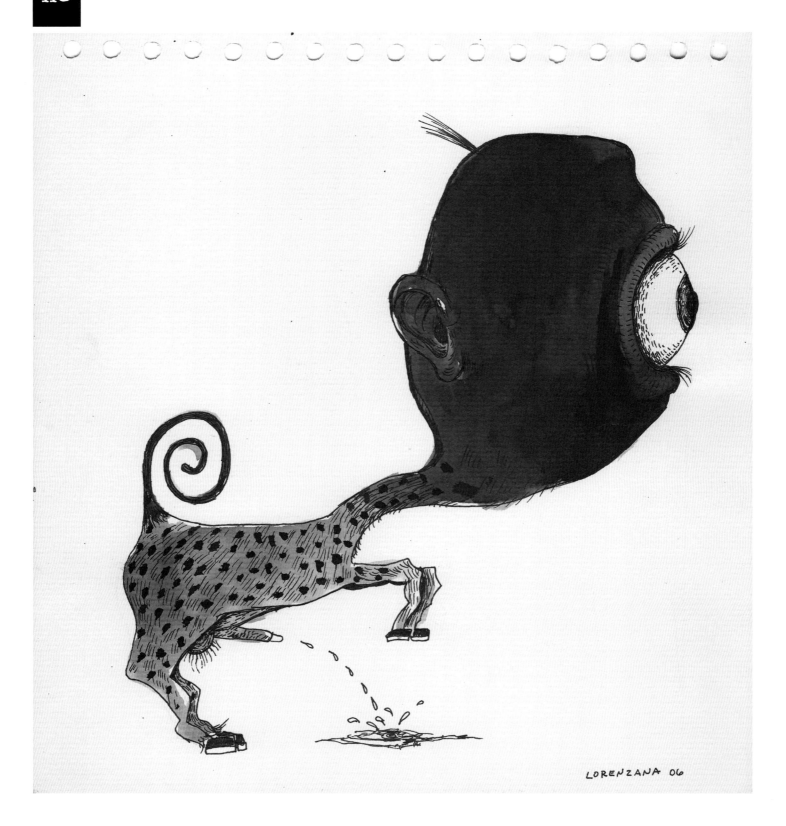

Untitled, 2006, Pen and Ink on Paper, 9 3/4 x 9"

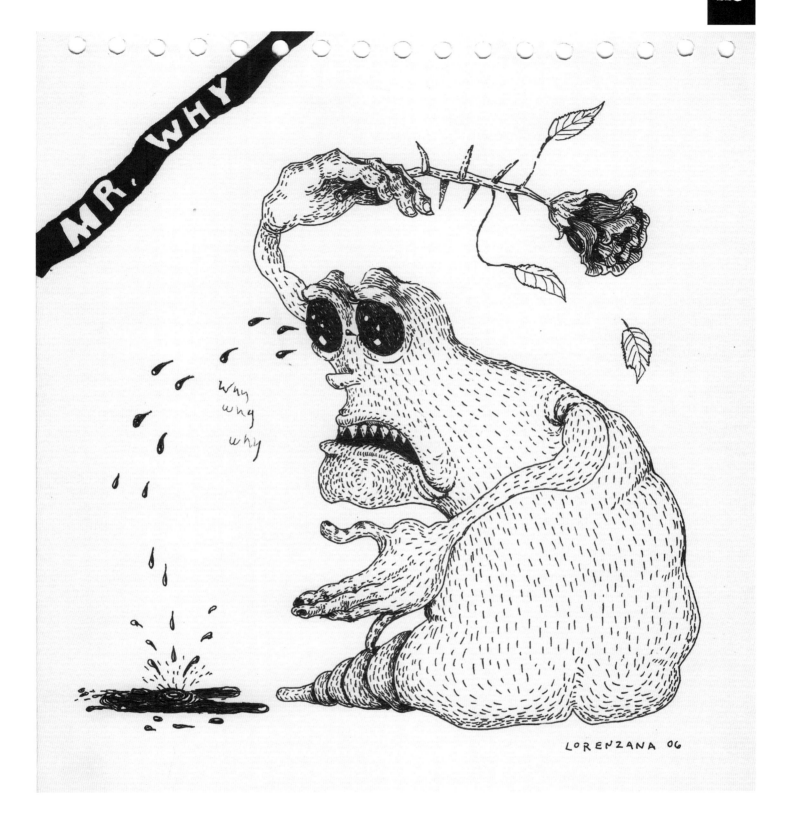

Mr. Why, 2006, Pen and Ink on Paper, 9 3/4 x 9"

Wanted, 2007, Pen and Ink on Paper, 9 3/4 x 9"

Ghost, 2007, Pen and Ink on Paper, 9 3/4 x 9"

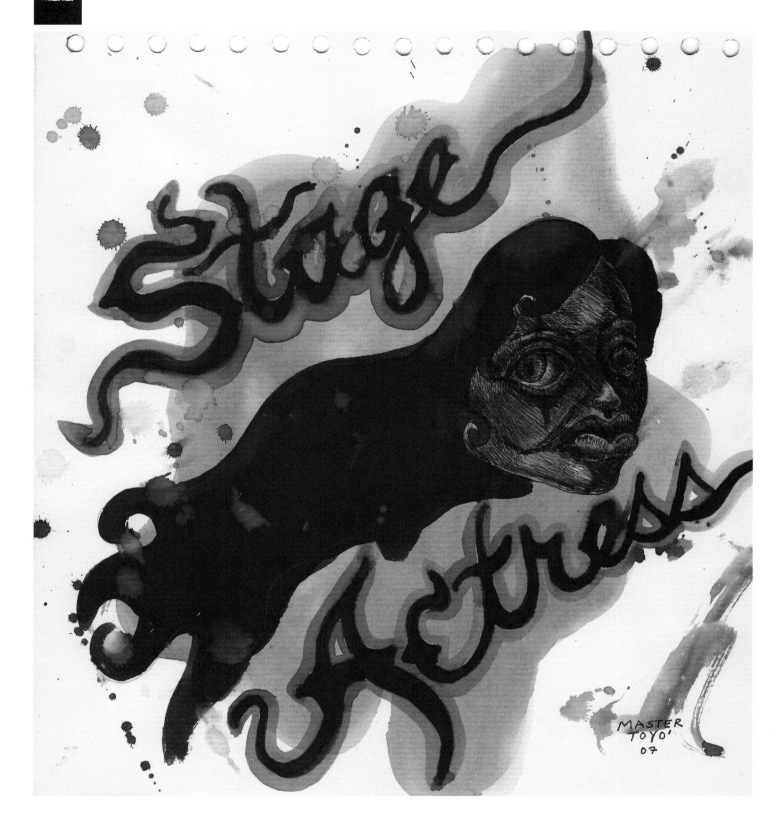

Stage Actress, 2007, Pen and Ink on Paper, 9 3/4 x 9"

Rubber Man, 2006, Pen and Ink on Paper, 9 3/4 x 9"

Mr. Vice, 2006, Pen and Ink on Paper, 9 3/4 x 9"

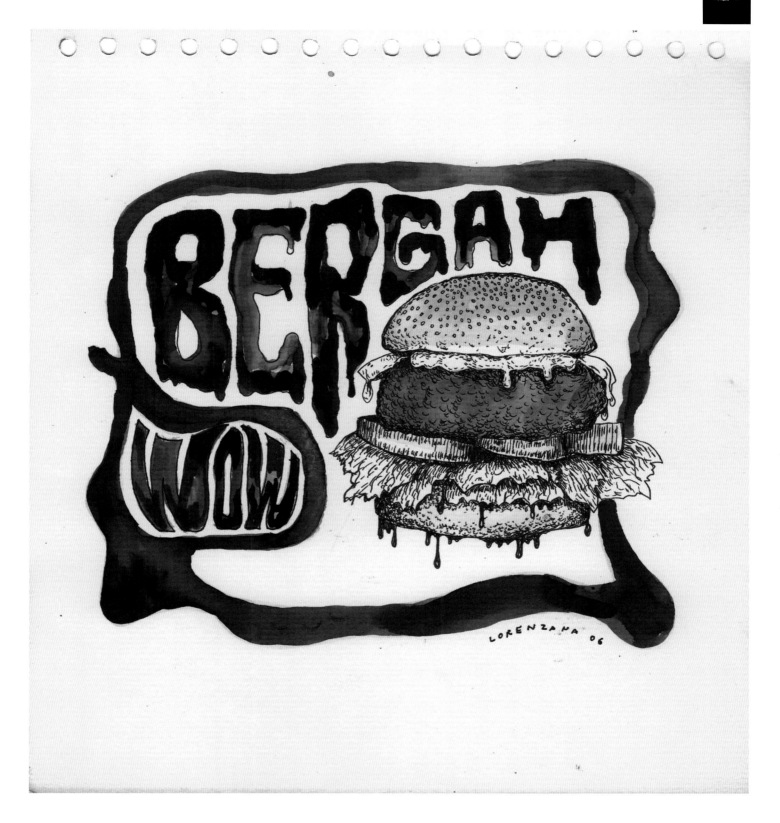

Bergah Wow, 2006, Pen and Ink on Paper, 9 3/4 x 9"

Untitled, Not dated, Pen and Ink on Paper, 9 3/4 x 9"

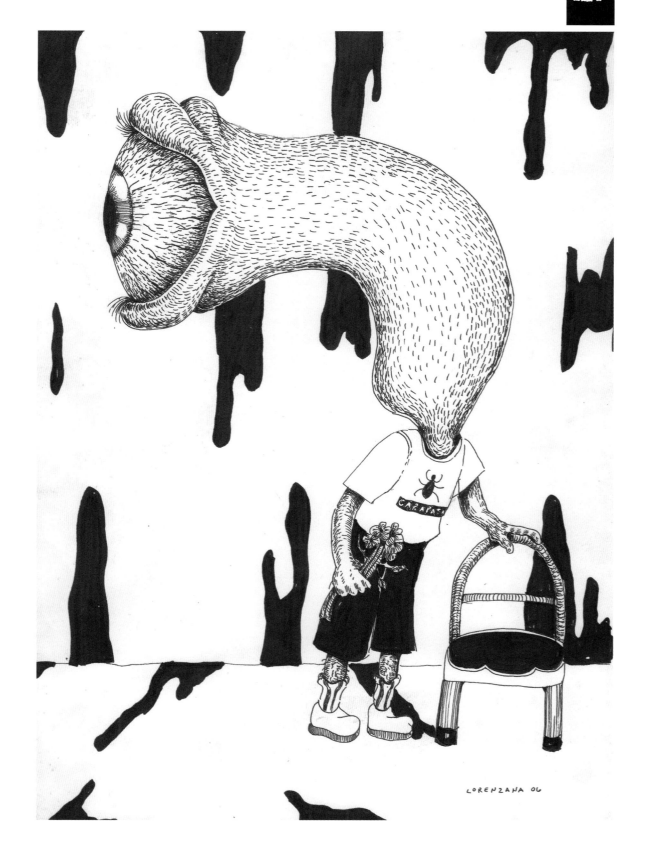

Garapata, 2006, Pen and Ink on Paper, 9 3/4 x 9"

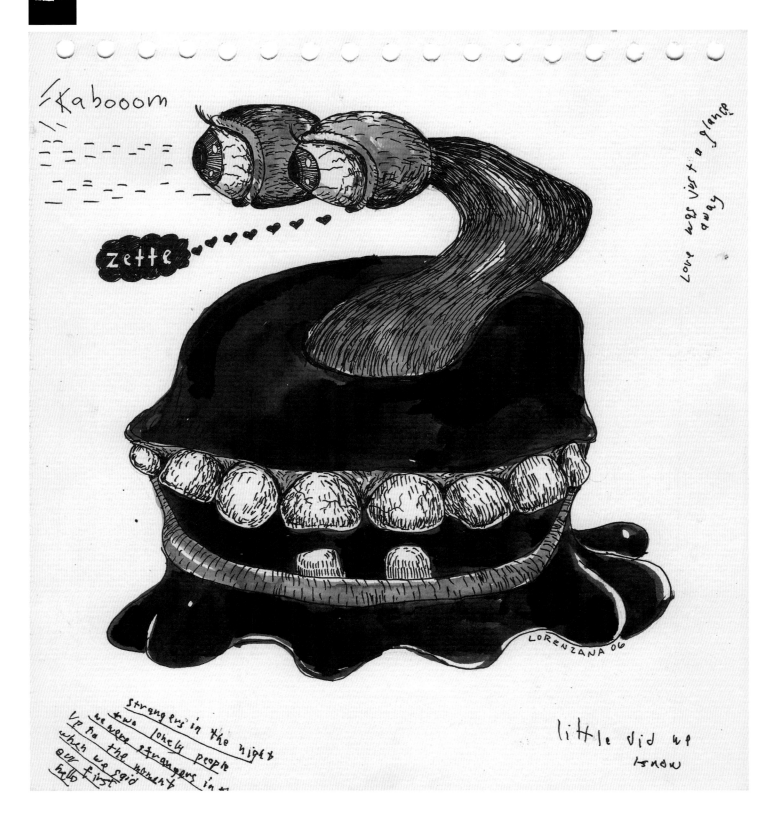

Kaboom, 2006, Pen and Ink on Paper, 9 3/4 x 9"

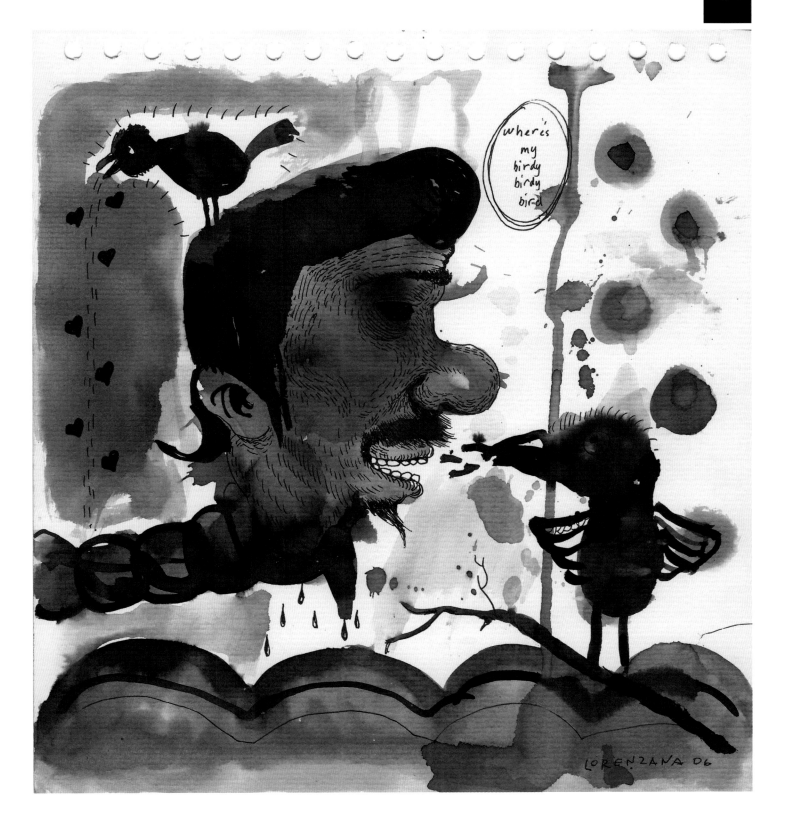

Birdy Bird, 2006, Pen and Ink on Paper, 9 3/4 x 9"

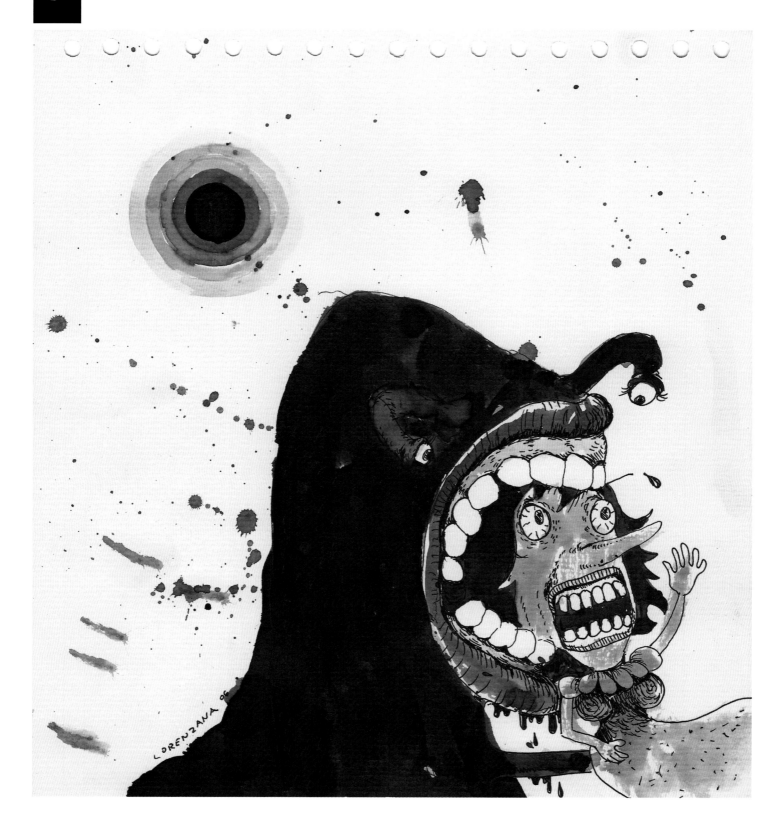

Revenge (Full Moon), 2006, Pen and Ink on Paper, 9 3/4 x 9"

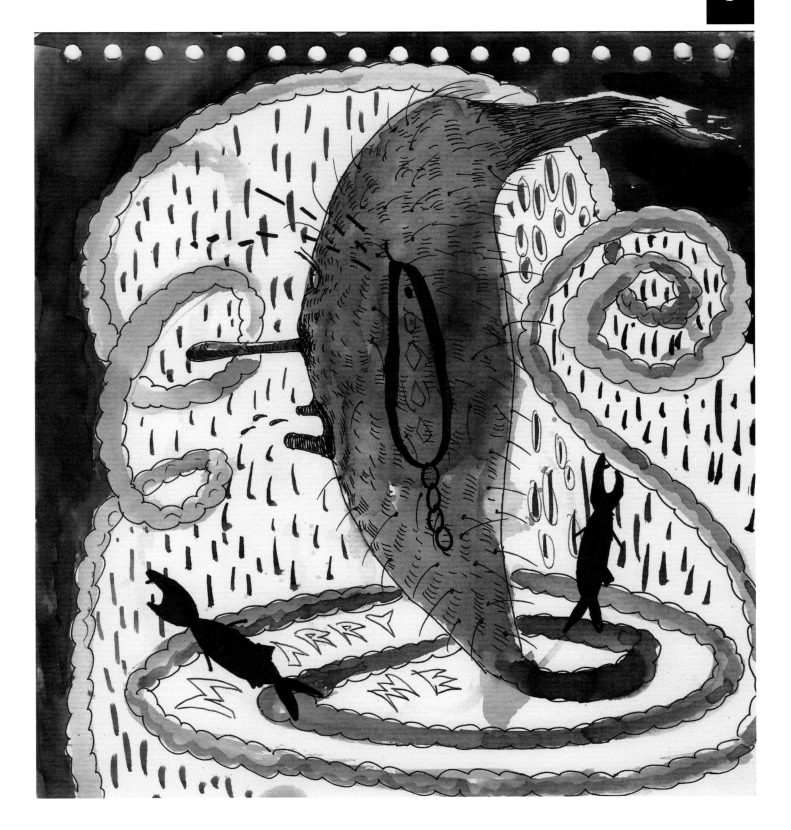

Plankton (Marry Me), Not dated, Pen and Ink on Paper, 9 3/4 x 9"

Untitled, Not dated, Charcoal on Paper, 9 3/4 x 9"

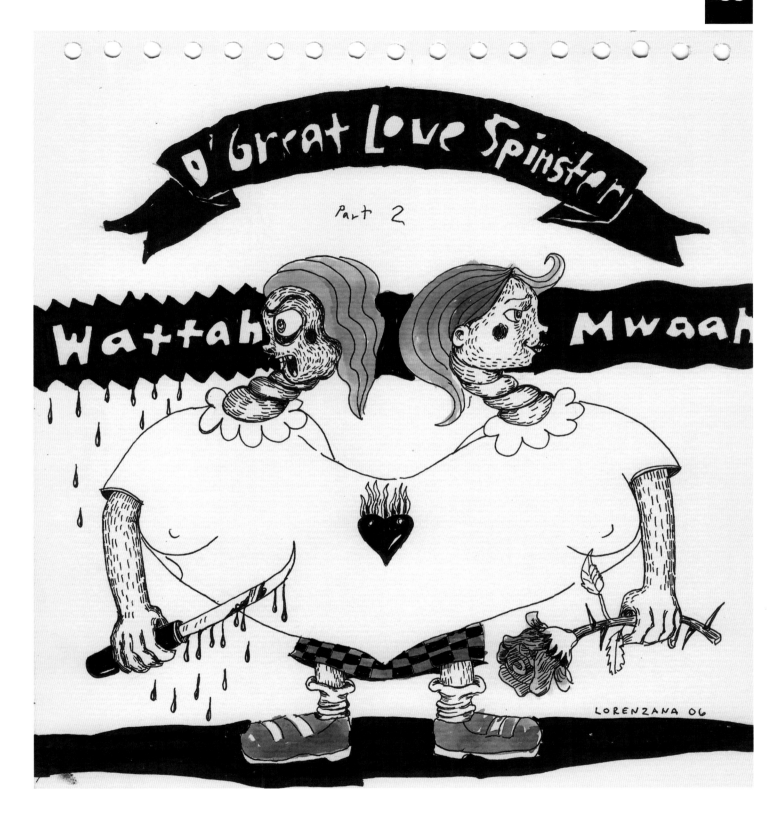

D' Great Love Spinster, 2006, Pen and Ink on Paper, 9 3/4 x 9"

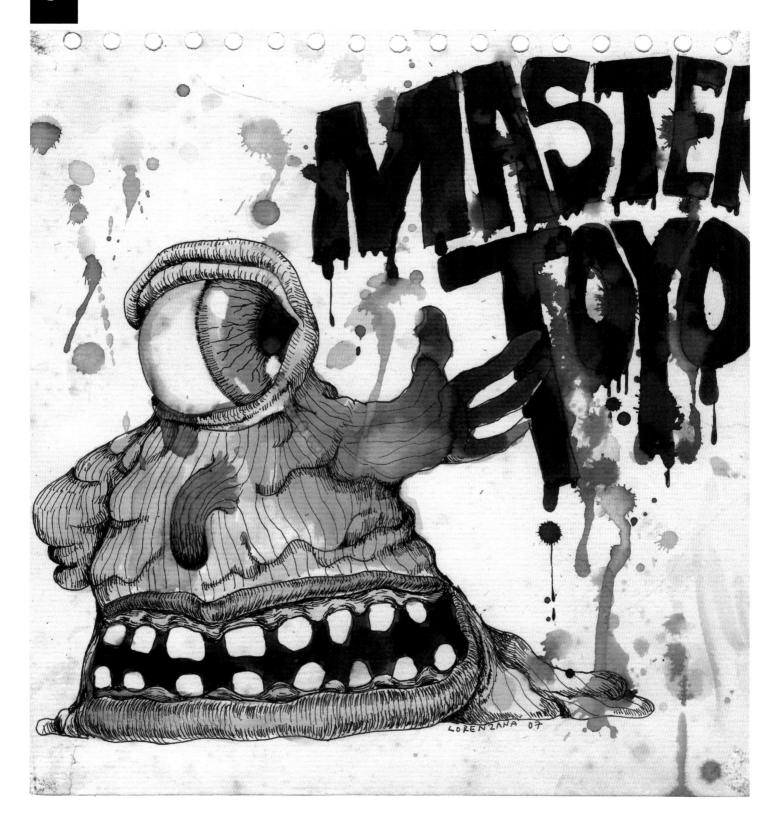

Master Toyo, 2007, Pen and Ink on Paper, 9 3/4 x 9"

LORENZANA 06

Love, 2006, Pen and Ink on Paper, 9 3/4 x 9"

Gooey, 2006, Pen and Ink on Paper, 9 3/4 x 9"

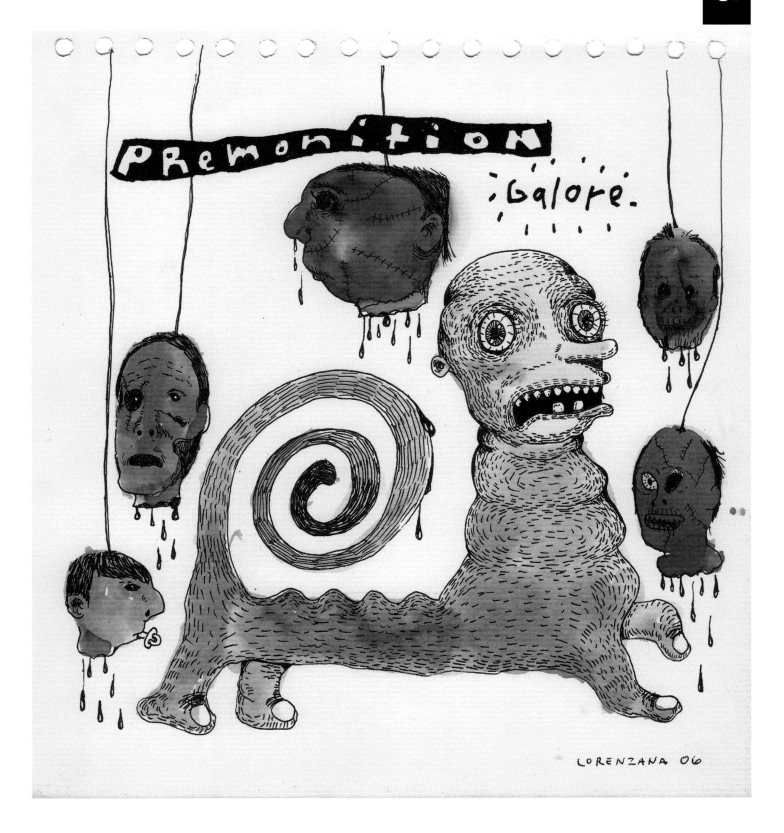

Premonition, 2006, Pen and Ink on Paper, 9 3/4 x 9"

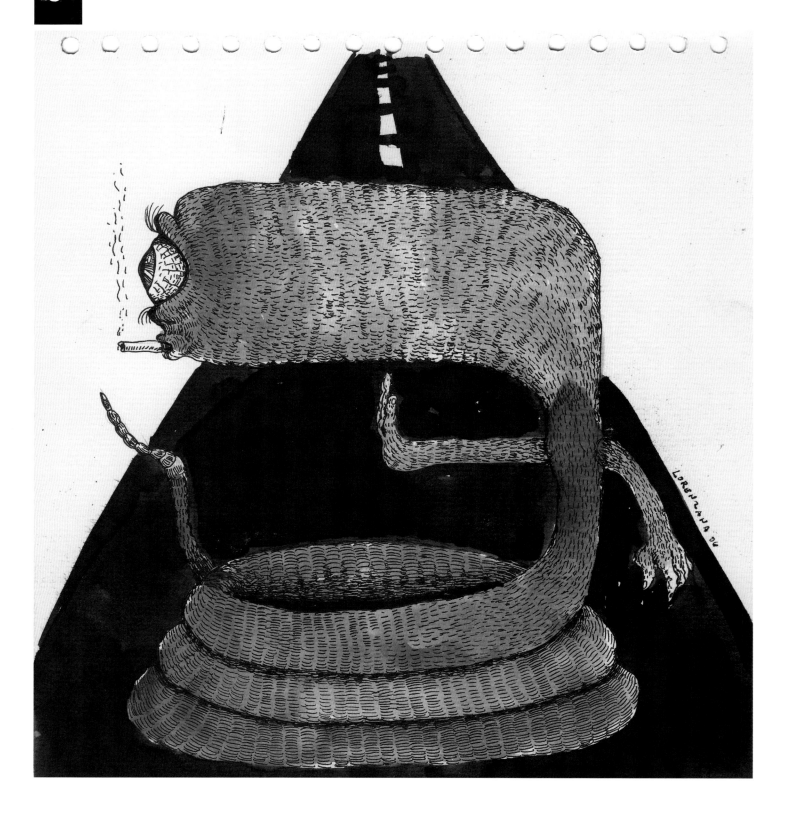

Mr. Traffic, 2006, Pen and Ink on Paper, 9 3/4 x 9"

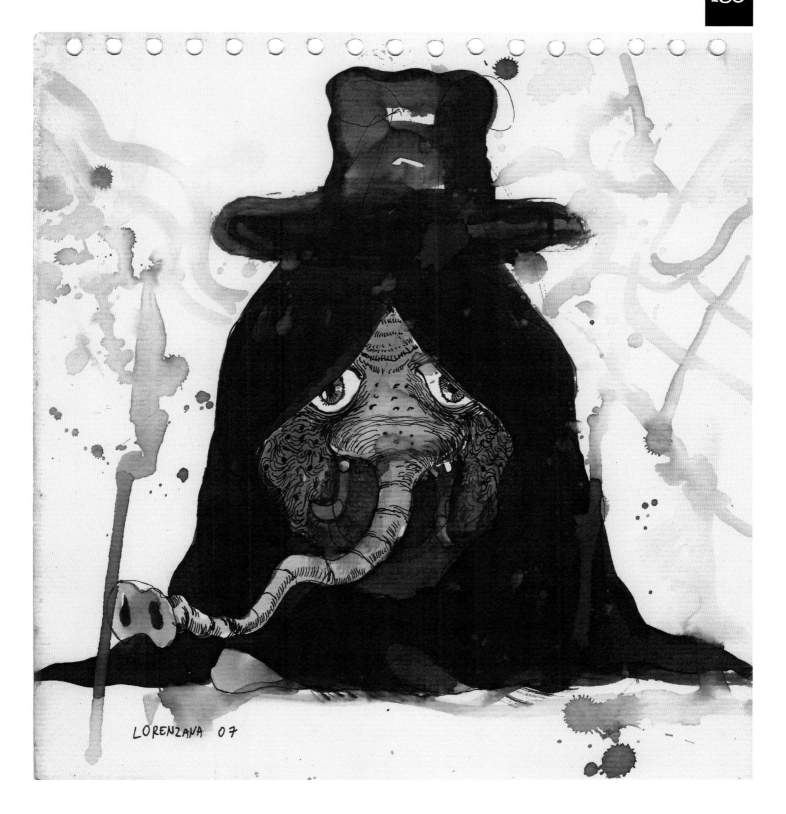

Boy Elephant, 2007, Pen and Ink on Paper, 9 3/4 x 9"

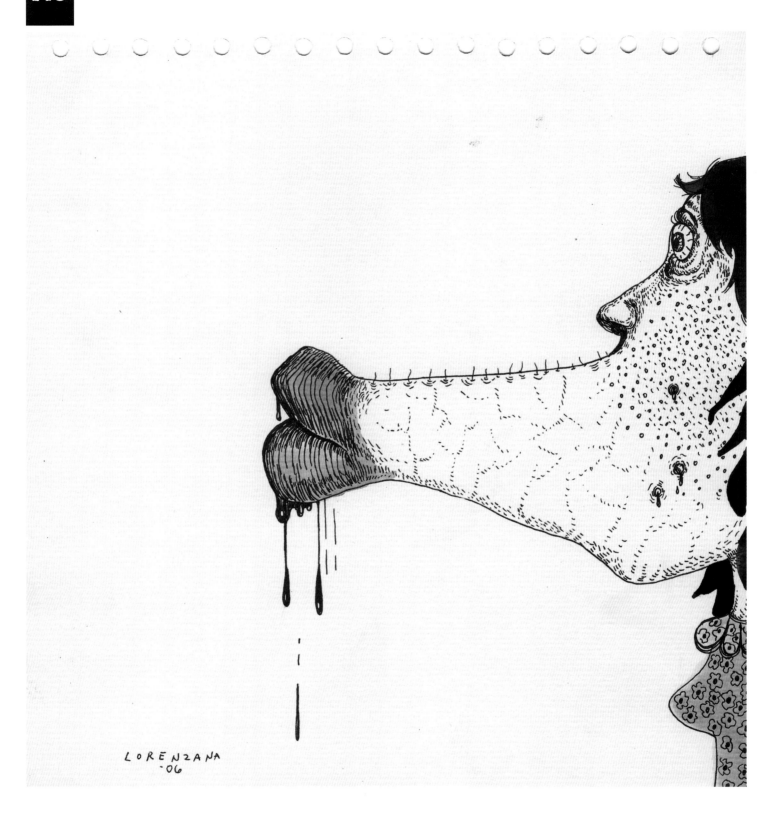

Mwah, 2006, Pen and Ink on Paper, 9 3/4 x 9"

Blob, 2006, Pen and Ink on Paper, 9 3/4 x 9"

El Bosero, 2006, Pen and Ink on Paper, 9 3/4 x 9"

Splat, 2006, Pen and Ink on Paper, 9 3/4 x 9"

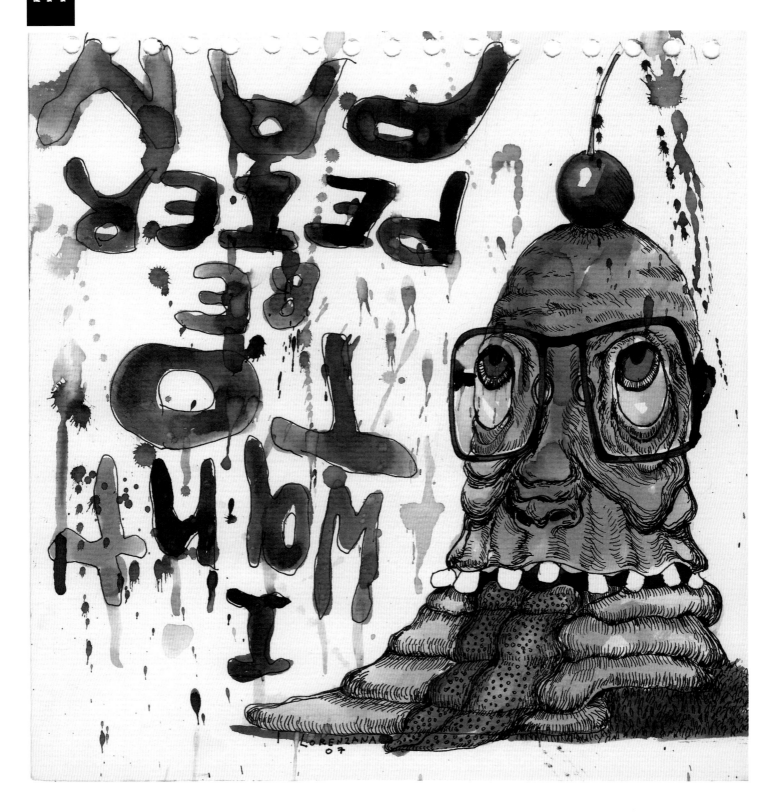

I Want to Be Peter Pan, 2007, Pen and Ink on Paper, 9 3/4 x 9"

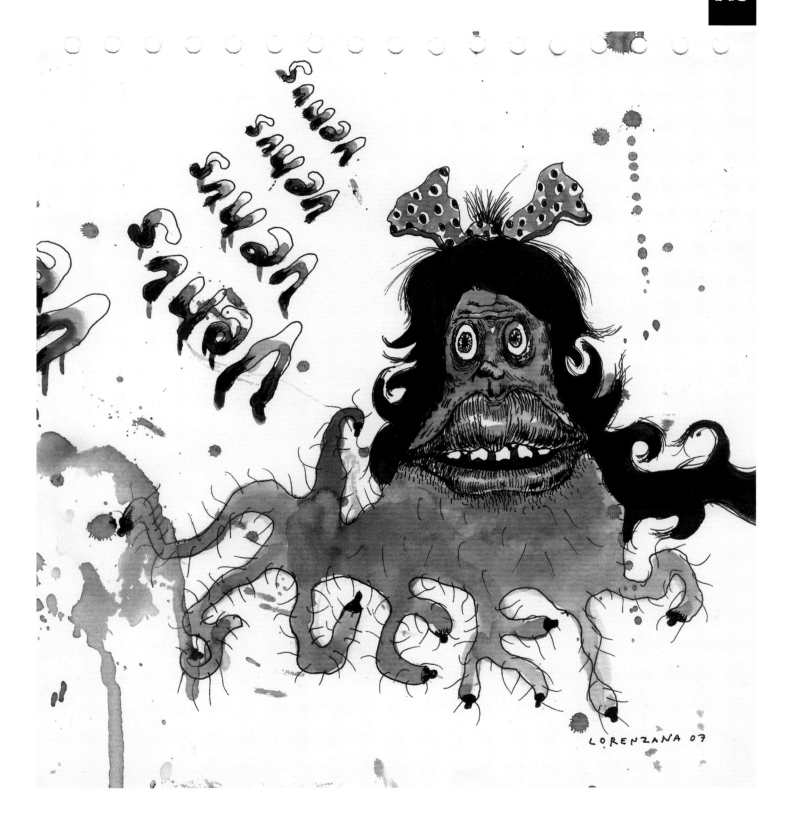

Venus, 2007, Pen and Ink on Paper, 9 3/4 x 9"

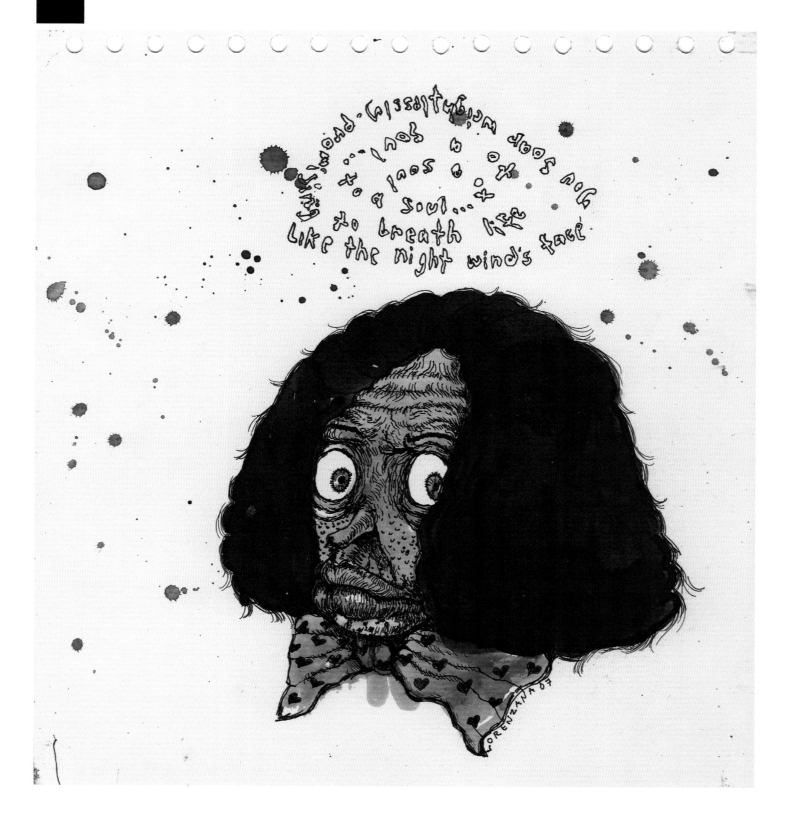

The Poet, 2007, Pen and Ink on Paper, 9 3/4 x 9"

The Great Martyr, 2007, Pen and Ink on Paper, 9 3/4 x 9"

Sketchbooks & Studies

II

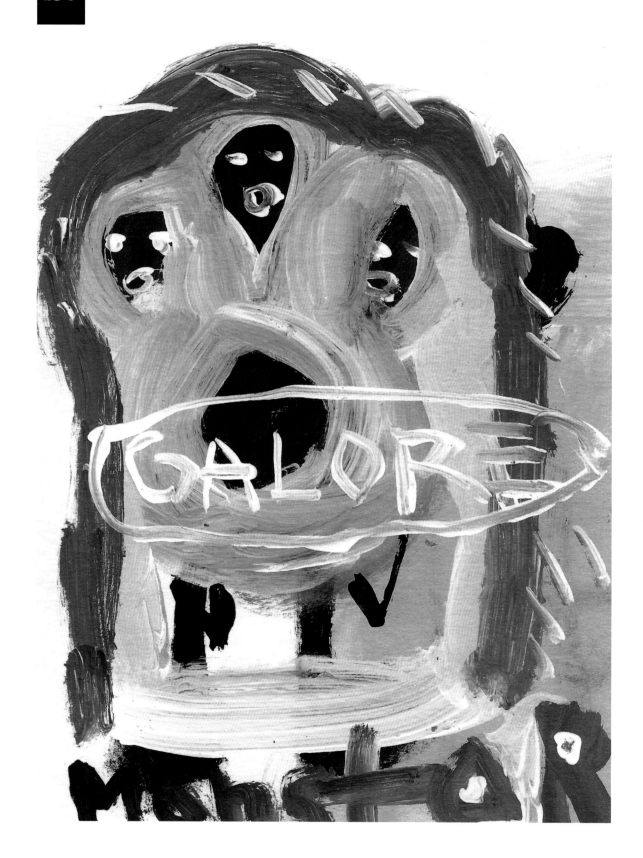

Untitled 1, 2006, Acrylic and Pen and Ink on Paper, 7 x 5"

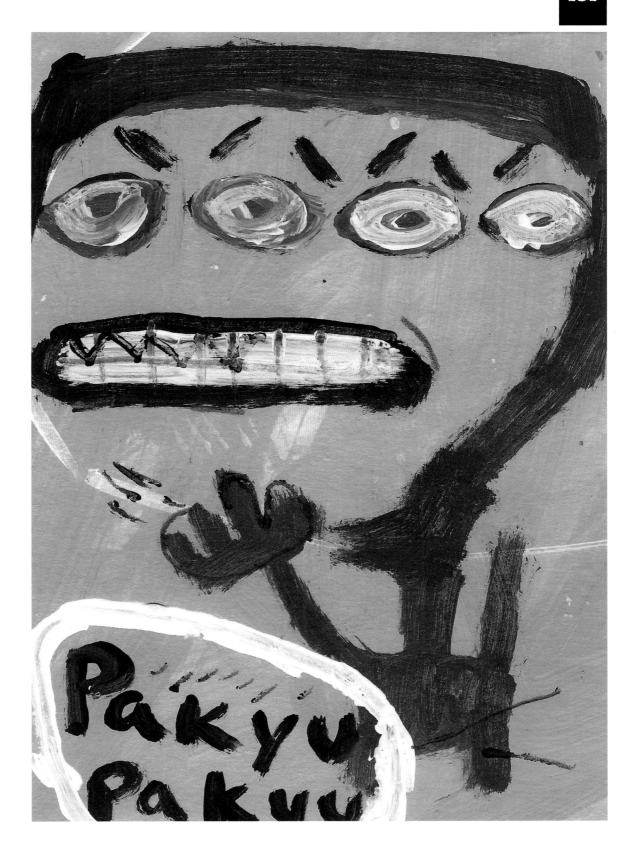

Untitled 2, 2006, Acrylic and Pen and Ink on Paper, 7 x 5"

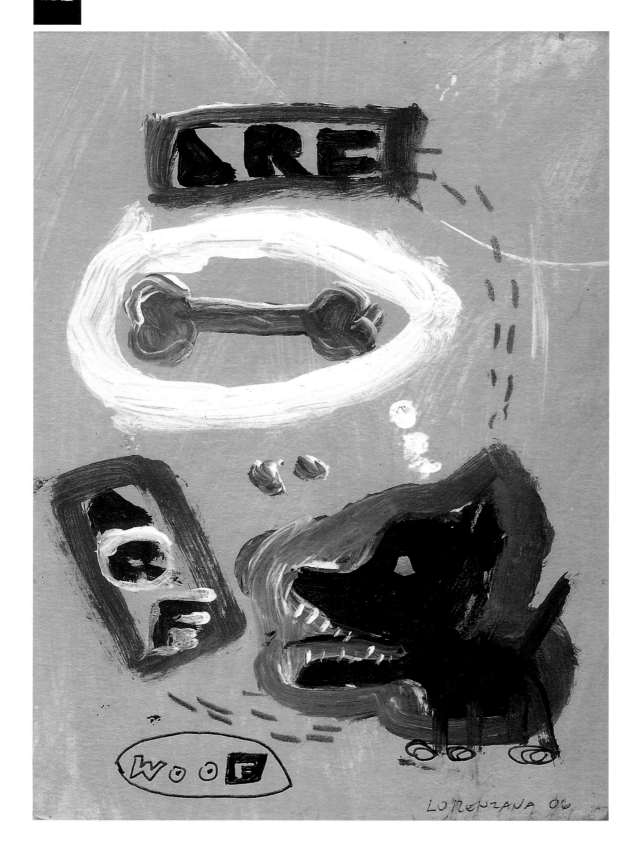

Untitled 3, 2006, Acrylic and Pen and Ink on Paper, 7 x 5"

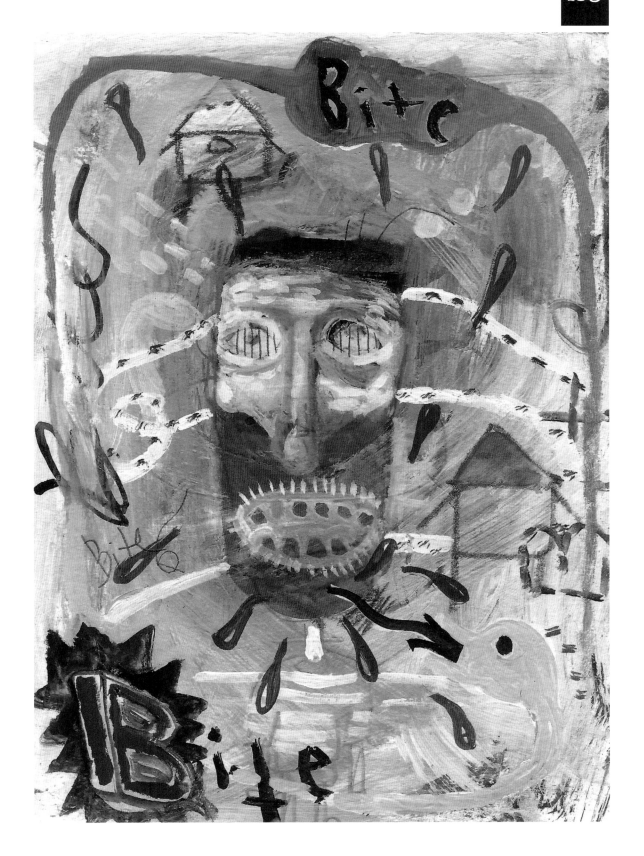

Untitled 4, 2006, Gouache on Paper, 7 x 5"

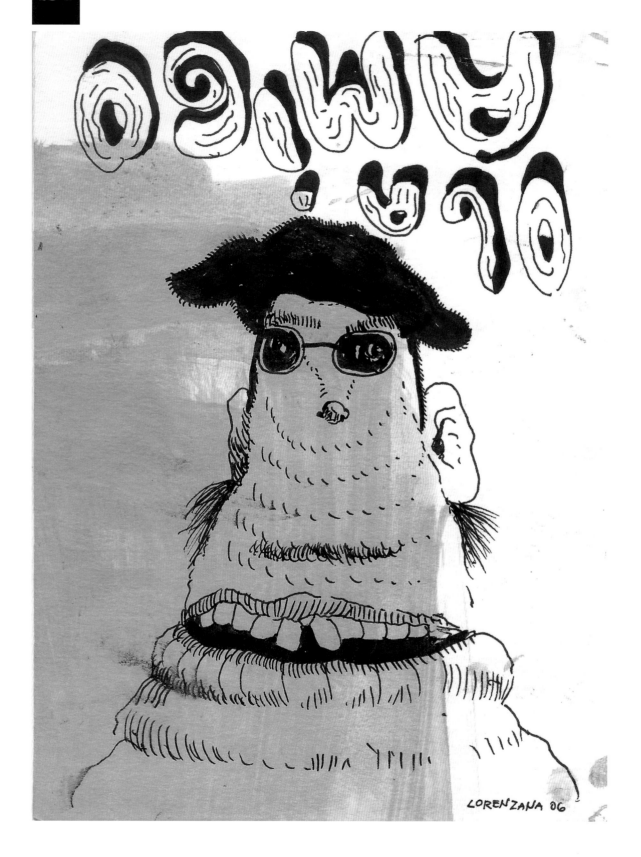

Untitled 5, 2006, Acrylic and Pen and Ink on Paper, 7 x 5"

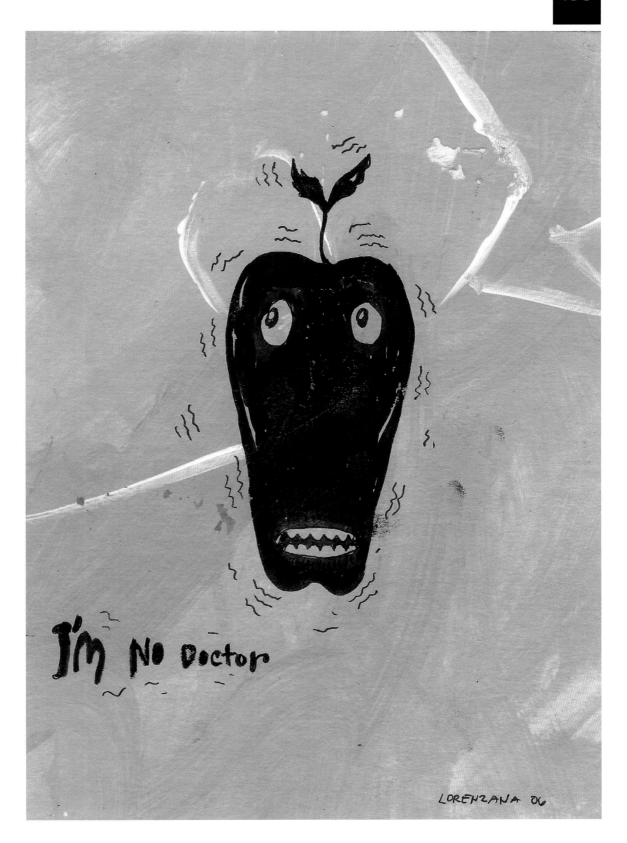

Untitled 6, 2006, Acrylic and Pen and Ink on Paper, 7 x 5"

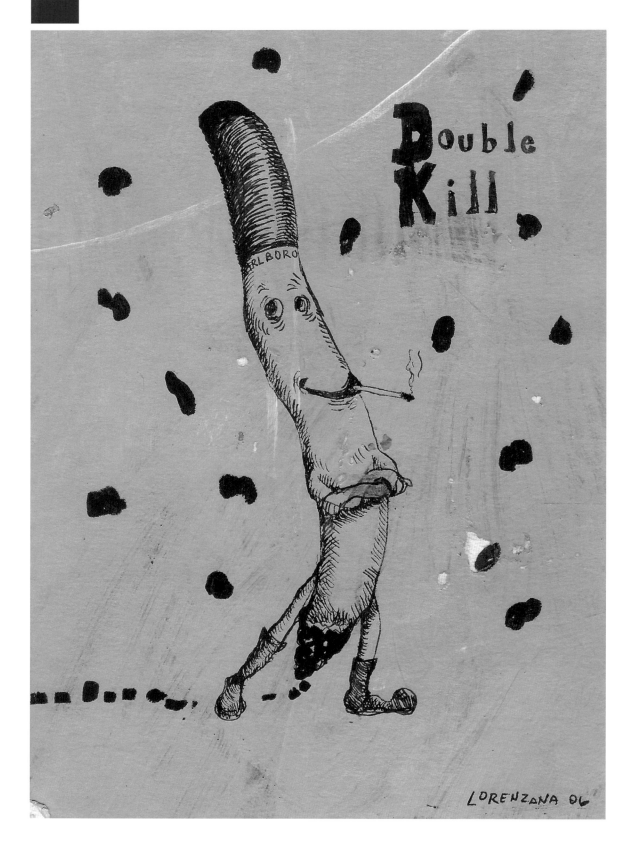

Untitled 7, 2006, Acrylic and Pen and Ink on Paper, 7 x 5"

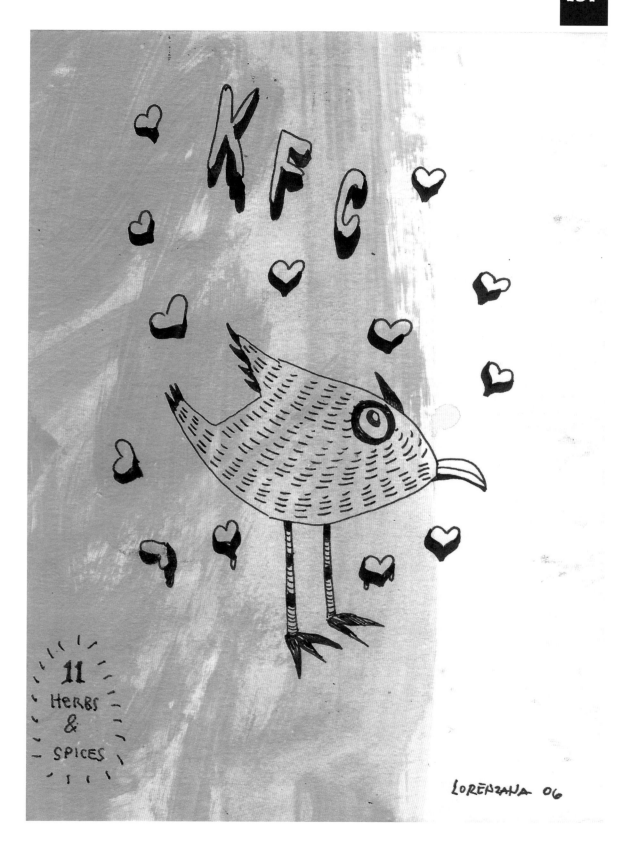

Untitled 8, 2006, Acrylic and Pen and Ink on Paper, 7 x 5"

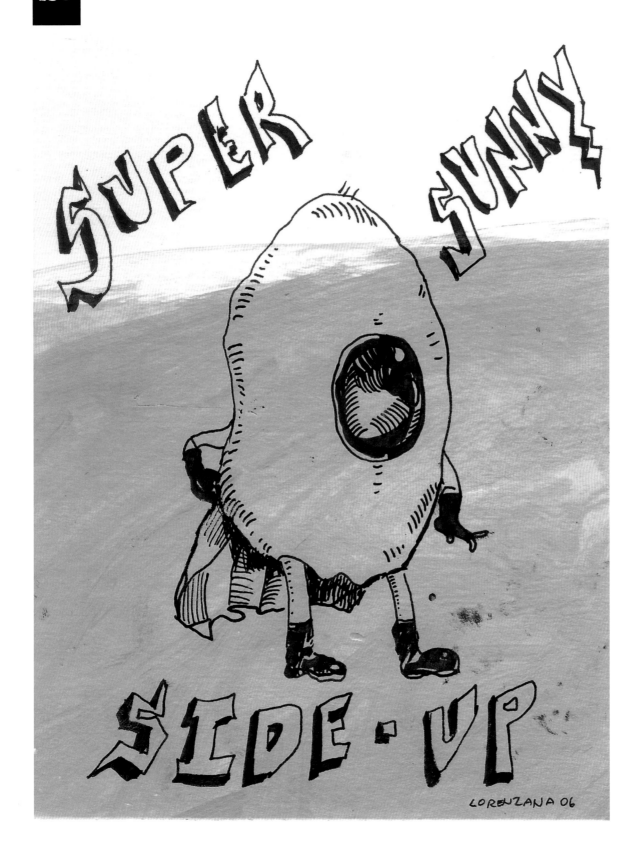

Untitled 9, 2006, Acrylic and Pen and Ink on Paper, 7 x 5"

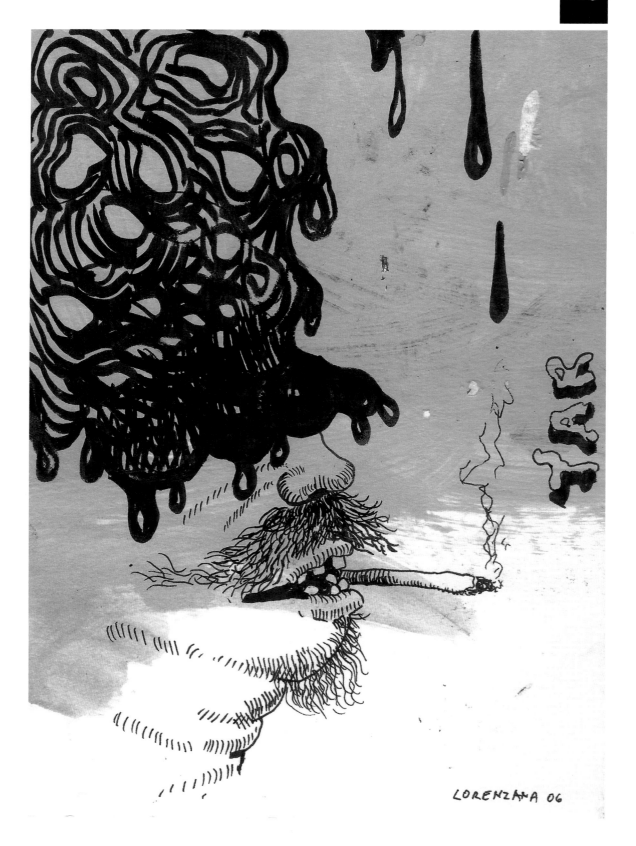

Untitled 10, 2006, Acrylic and Pen and Ink on Paper, 7 x 5"

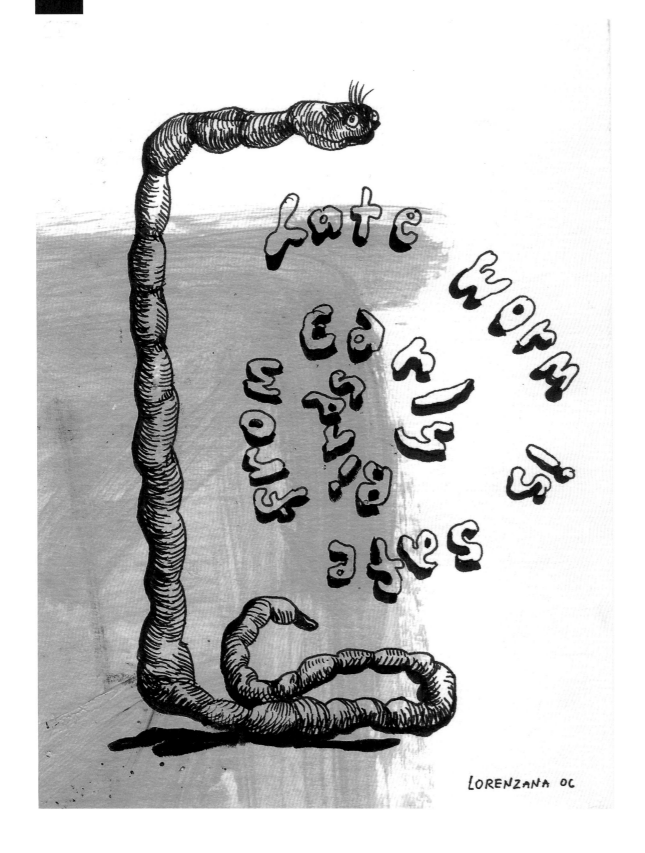

Untitled 11, 2006, Acrylic and Pen and Ink on Paper, 7 x 5"

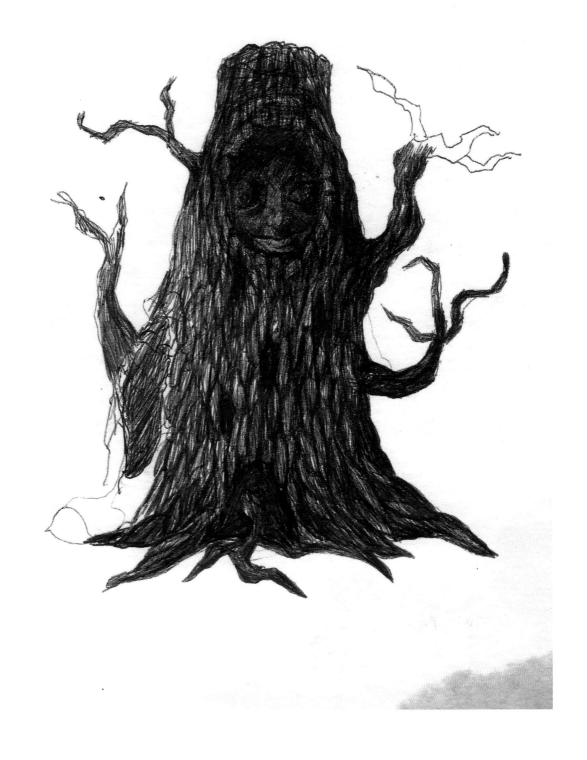

Untitled 12, 2007, Ballpoint on Paper, 7 x 5"

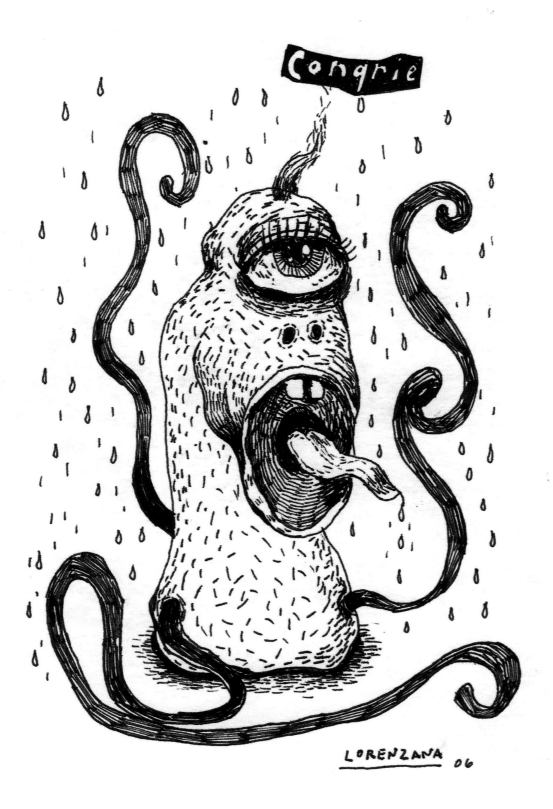

Untitled 13, 2006, Pen and Ink on Paper, 7 x 5"

Untitled 14, 2006, Ballpoint on Paper, 7 x 5"

Untitled 15, 2006, Gouache on Paper, 7 x 5"

Untitled 16, 2006, Pen and Ink on Paper, 7 x 5"

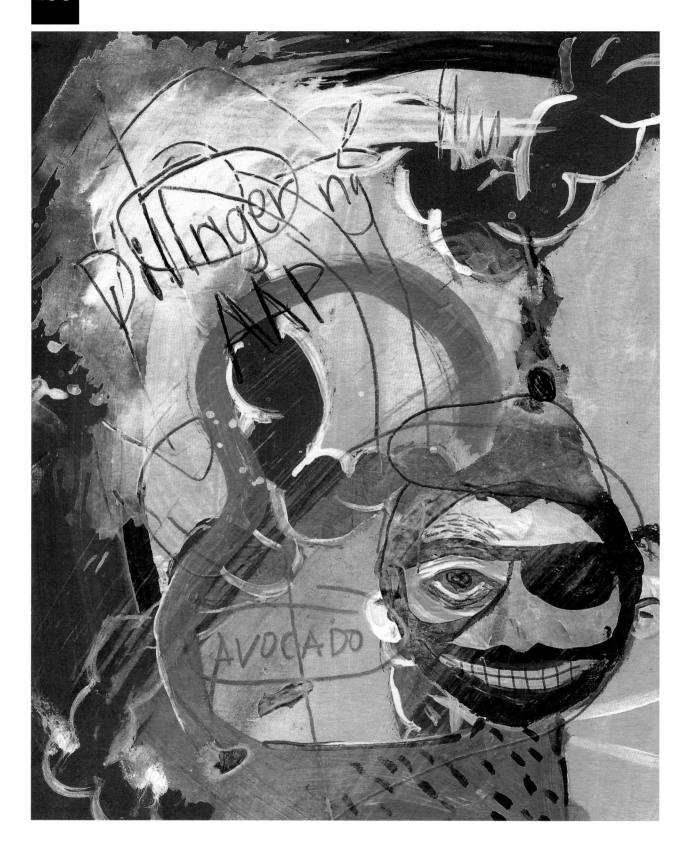

Untitled 17, 2006, Acrylic and Pen and Ink on Paper, 7 x 5"

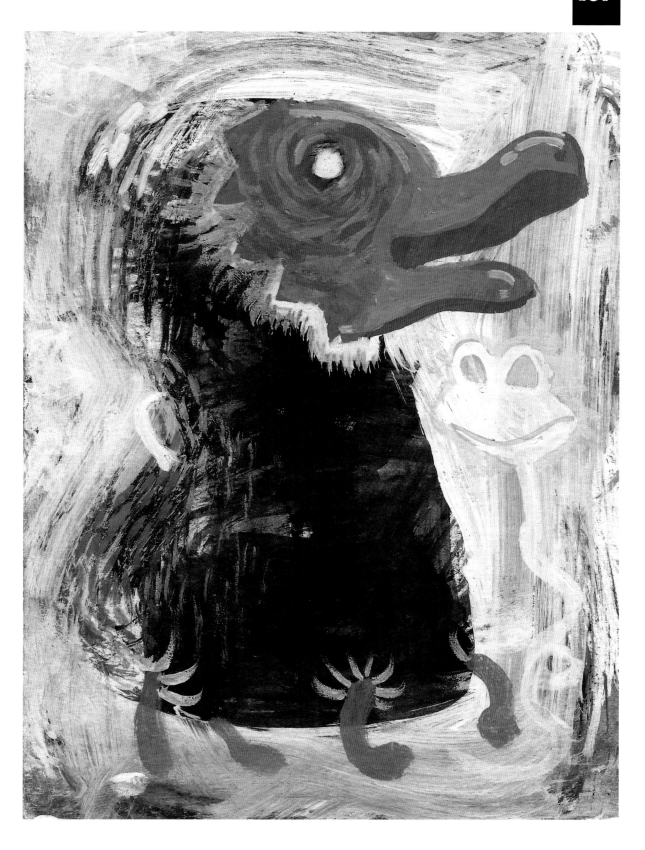

Untitled 18, 2006, Acrylic and Pen and Ink on Paper, 7 x 5"

Untitled 19, 2006, Conte on Paper, 7 x 5"

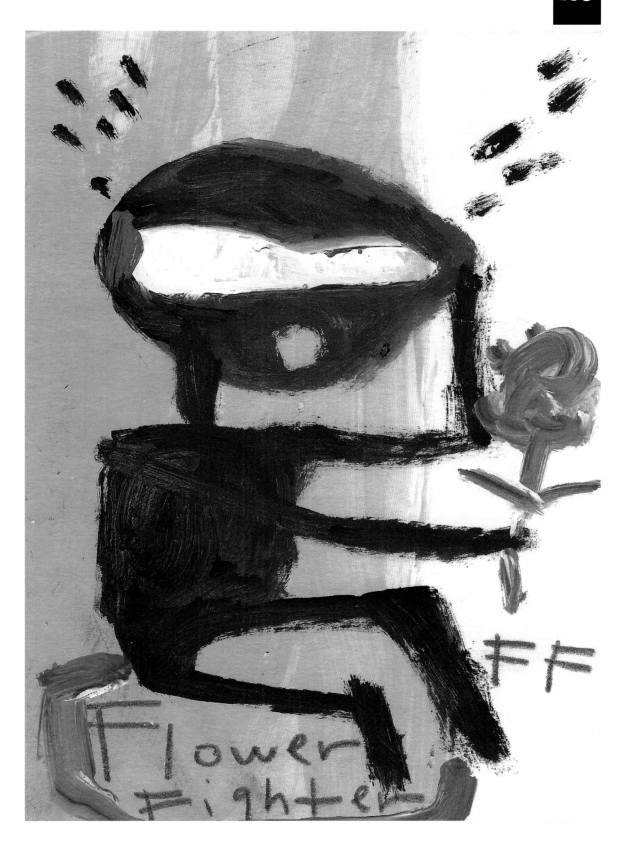

Untitled 20, 2006, Acrylic and Pen and Ink on Paper, 7 x 5"

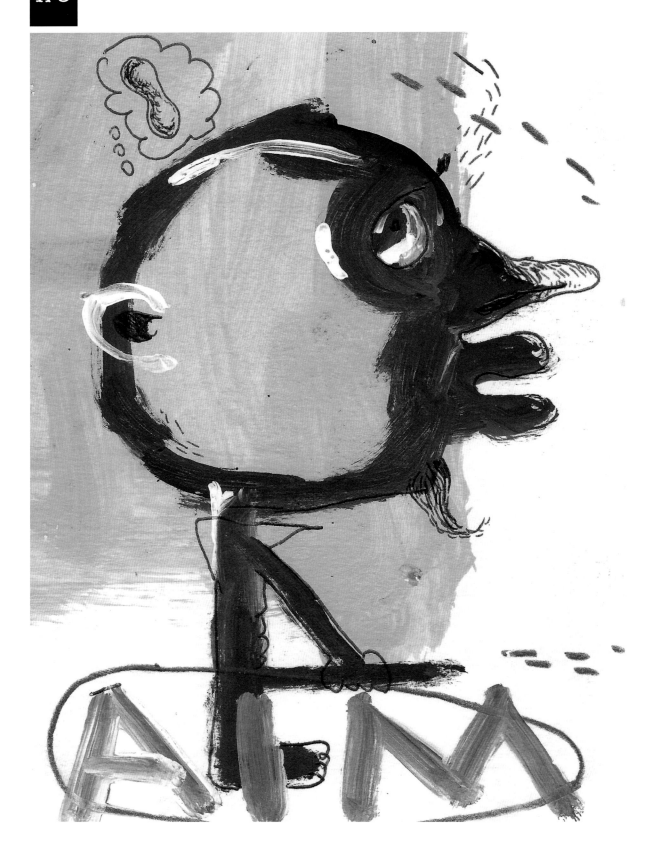

Untitled 21, 2006, Acrylic and Pen and Ink on Paper, 12 x 9"

Untitled 22, 2006, Acrylic and Pen and Ink on Paper, 12 x 9"

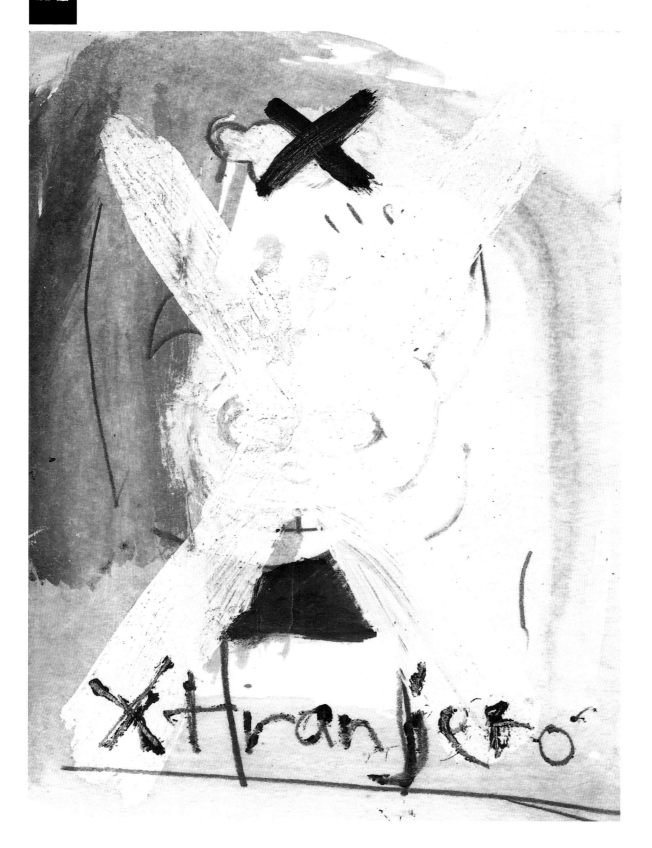

Untitled 23, 2006, Pen and Ink on Paper, 12 x 9"

Untitled 24, 2007, Ballpoint on Paper, 12 x 9"

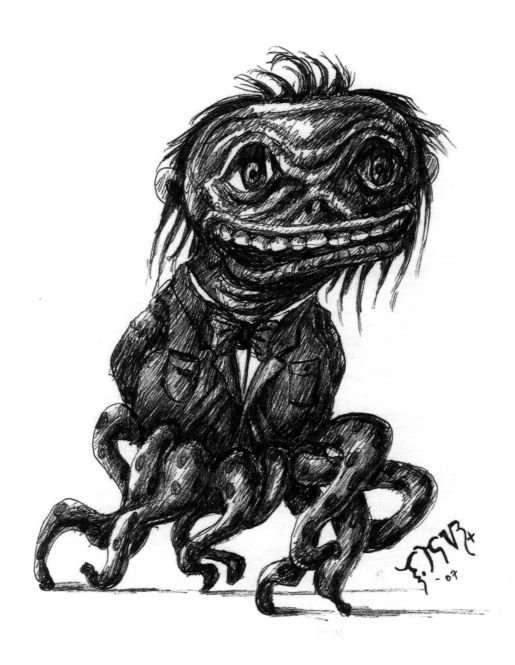

Untitled 25, 2007, Ballpoint on Paper, 7 x 5"

Talent

Untitled 26, 2006, Acrylic and Pen and Ink on Paper, 7 x 5"

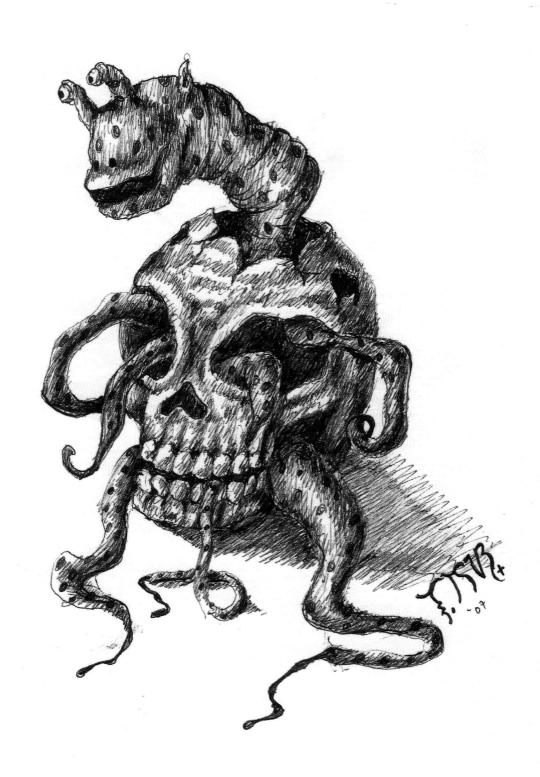

Untitled 27, 2007, Ballpoint on Paper, 7 x 5"

Untitled 28, 2007, Acrylic and Pen and Ink on Paper, 7 x 5"

Sketchbooks & Studies

III

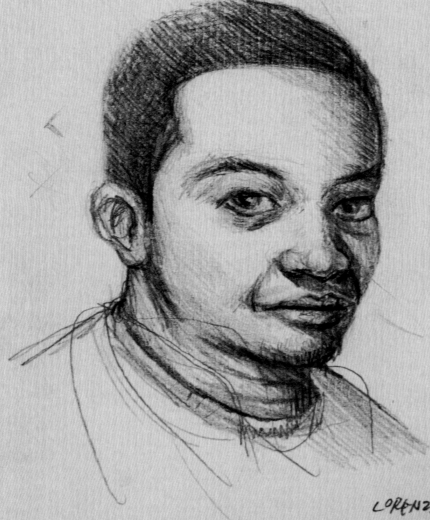

CONGRESS OF THE PHILIPPINES
SENATE
METRO MANILA

JOHN H. OSMEÑA
SENATOR

CHAIRMAN
COMMITTEE ON FINANCE
COMMITTEE ON ENERGY

GSIS BUILDING #209, FINANCIAL CENTER, PASAY CITY
TEL. NOS. 552-66-01 LOC. 2522 / 552-67-14 • FAX NO. 552-67-00

Self-Portrait, 2002, Graphite on Paper, 8 3/4 x 5 1/2"

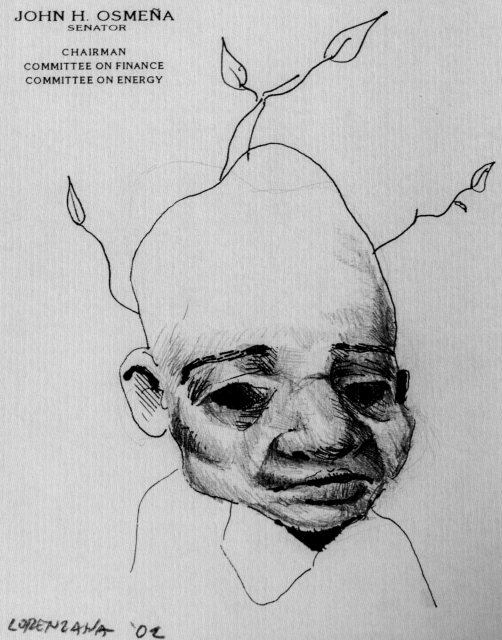

CONGRESS OF THE PHILIPPINES
SENATE
METRO MANILA

JOHN H. OSMEÑA
SENATOR

CHAIRMAN
COMMITTEE ON FINANCE
COMMITTEE ON ENERGY

GSIS BUILDING #209, FINANCIAL CENTER, PASAY CITY
TEL. NOS. 552-66-01 LOC. 2522 / 552-67-14 * FAX NO. 552-67-00

Untitled, 2002, Graphite and Ink on Paper, 8 3/4 x 5 1/2"

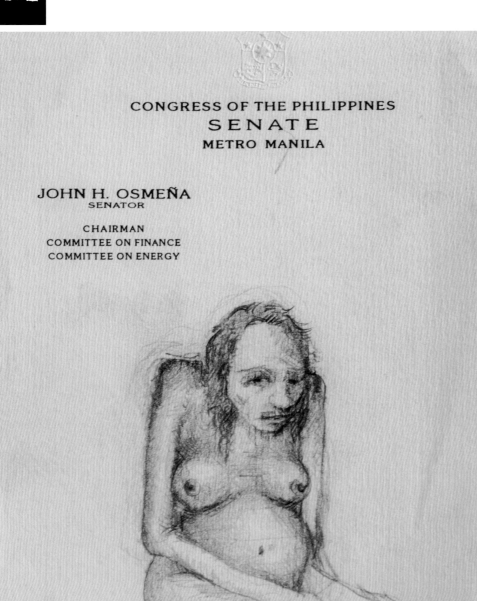

CONGRESS OF THE PHILIPPINES
SENATE
METRO MANILA

JOHN H. OSMEÑA
SENATOR

CHAIRMAN
COMMITTEE ON FINANCE
COMMITTEE ON ENERGY

LORENZONA '02

GSIS BUILDING #209, FINANCIAL CENTER, PASAY CITY
TEL. NOS. 552-66-01 LOC. 2522 / 552-67-14 • FAX NO. 552-67-00

Nude, 2002, Graphite on Paper, 8 3/4 x 5 1/2"

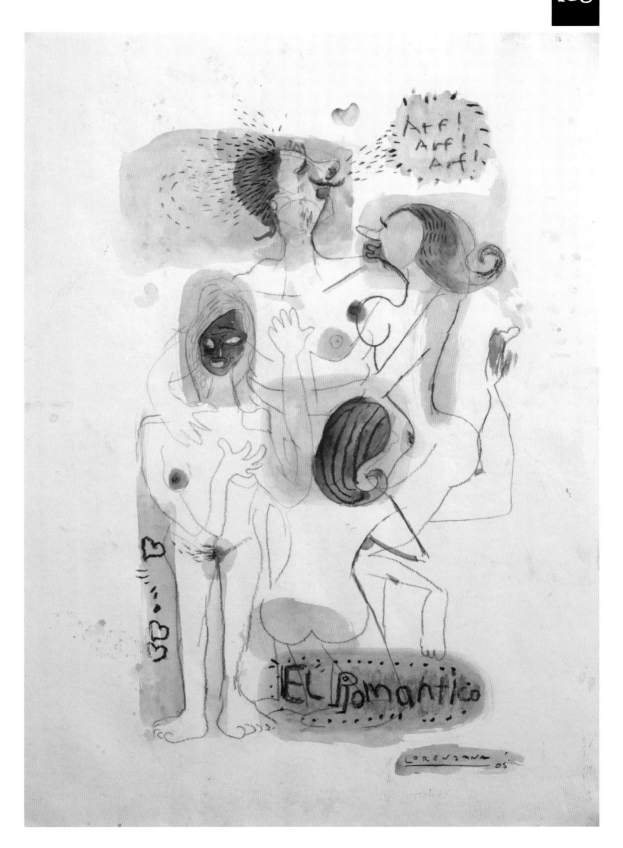

El Romantico, 2005, Conte on Paper, 19 1/2 x 13 3/4"

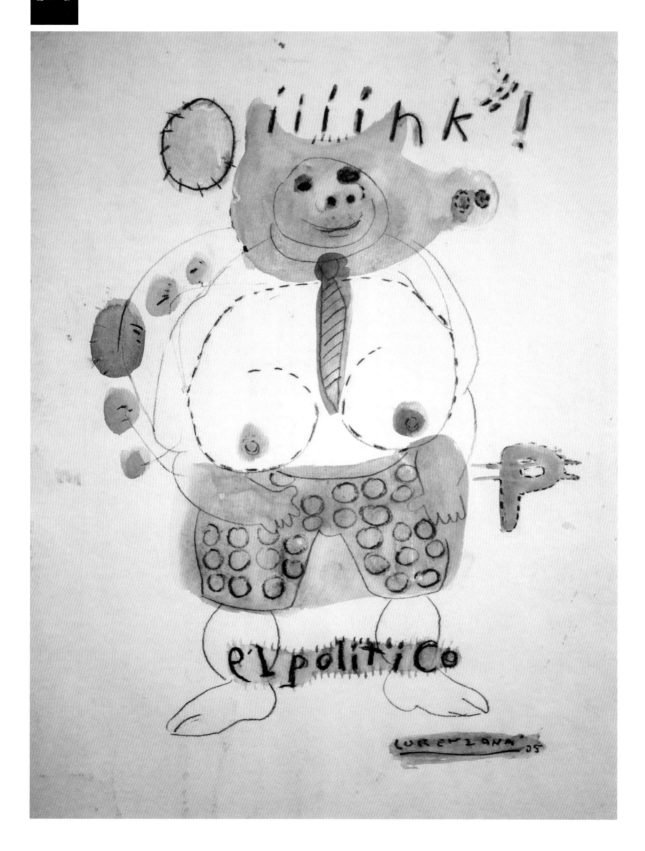

El Politicoiiink, 2005, Conte on Paper, 19 3/4 x 13 3/4"

Pulis Man, 2005, Conte on Paper, 19 1/2 x 13 3/4"

Untitled Abstract I, 2005, Acrylic on Paper, 10 3/4 x 8"

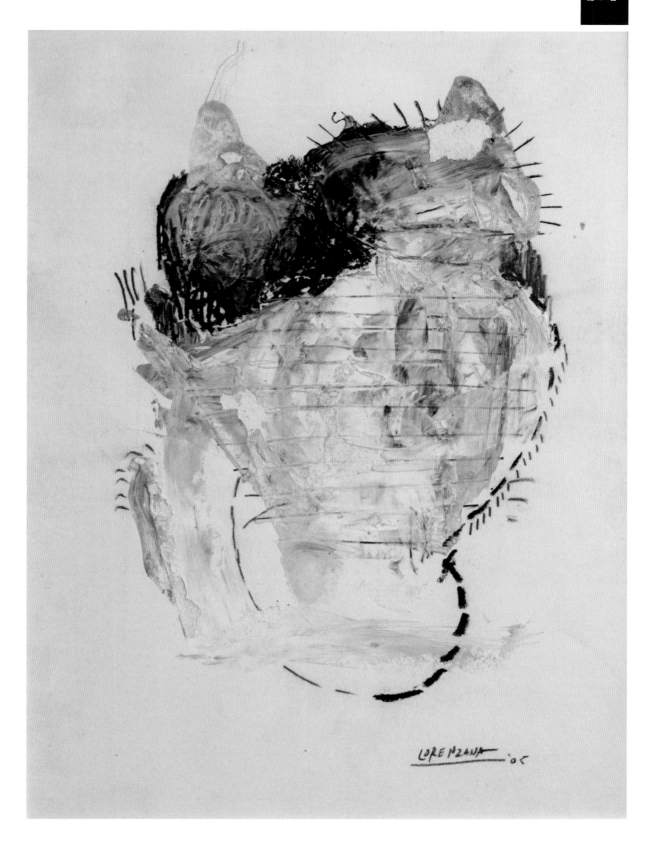

Untitled Abstract II, 2005, Acrylic on Paper, 10 1/2 x 8"

Baby Baby, 2006, Pen and Ink on Paper, 12 x 9"

Your Honor, 2006, Pen and Ink on Paper, 12 x 9"

Pac Pac, 2006, Pen and Ink on Paper, 12 x 9"

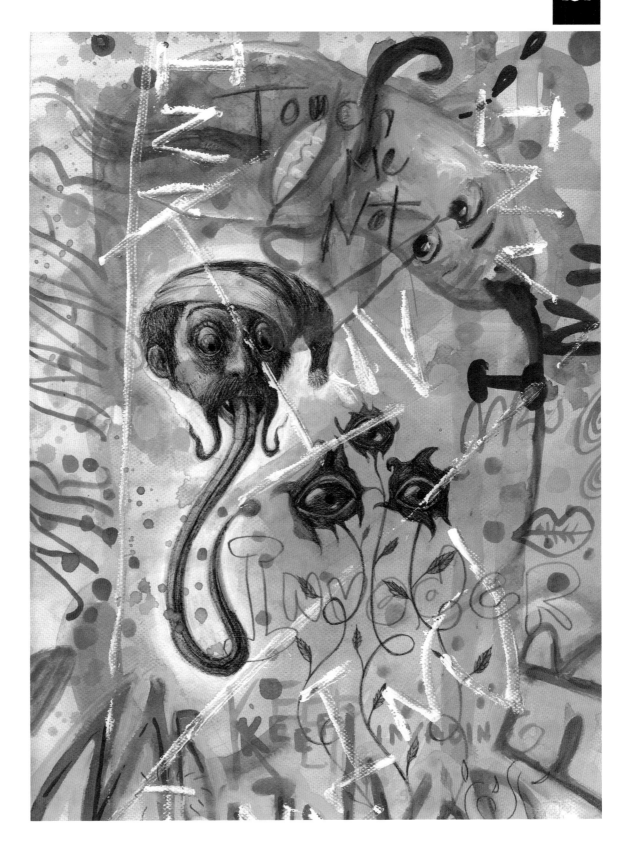

Mr. Invader, 2006, Pen and Ink, Gouache on Toned Paper, 12 x 8"

Beauty Queen I, 2006, Gouache on Paper, 5 3/4 x 5"

Beauty Queen II, 2006, Gouache on Paper, 5 1/2 x 5"

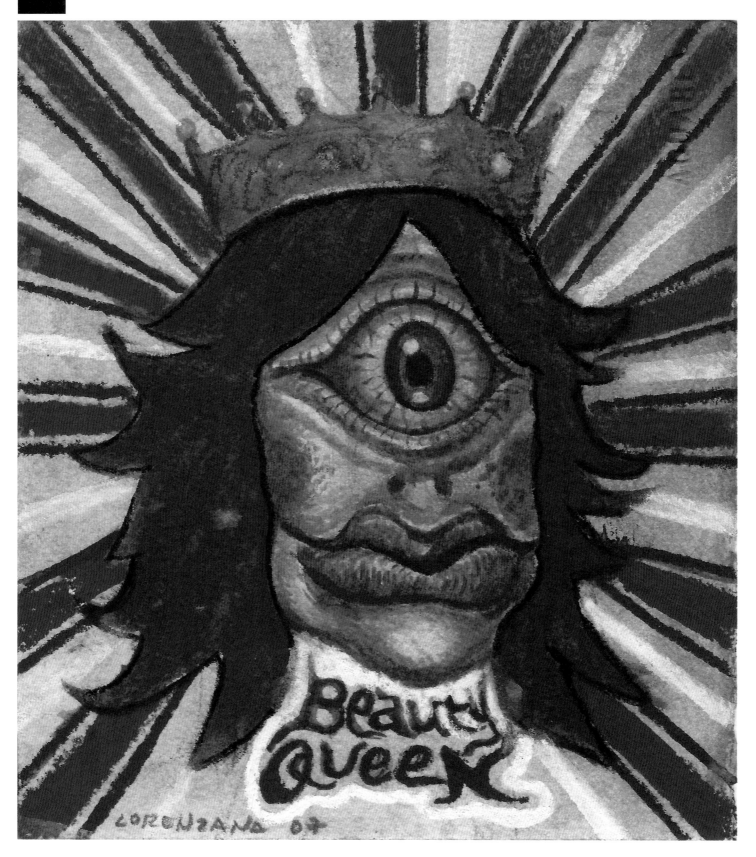

Beauty Queen III, 2007, Conte on Paper, 6 x 5 1/4"

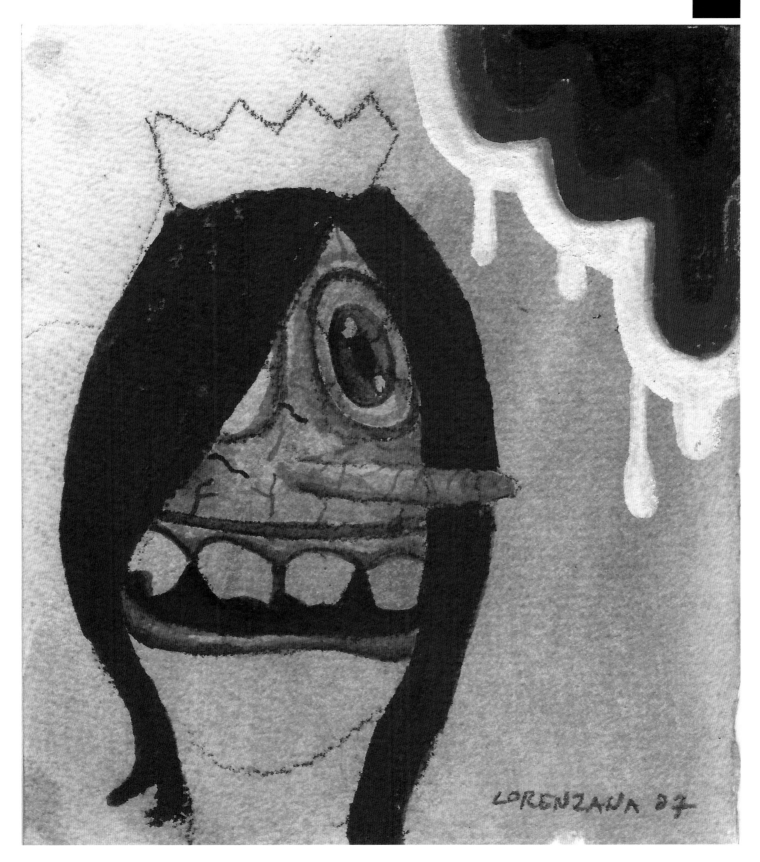

Beauty Queen IV, 2007, Conte on Paper, 6 x 5 1/4"

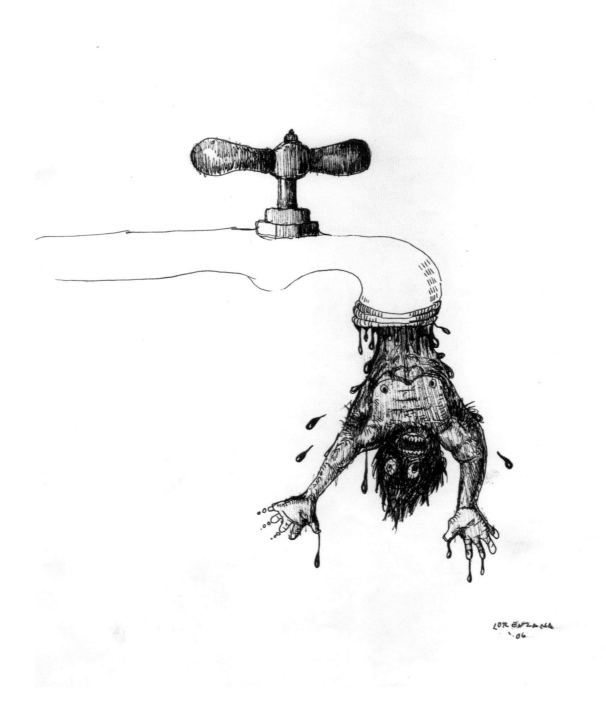

The Faucet Man, 2006, Pen and Ink on Paper, 12 x 9"

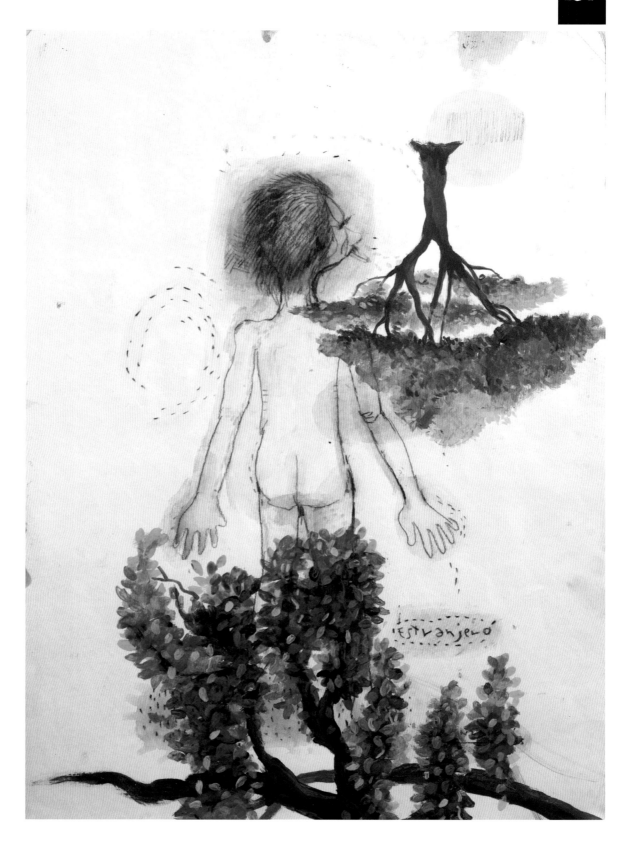

Estranjero, Undated, Conte and Acrylic on Paper, 19 3/4 x 13 3/4"

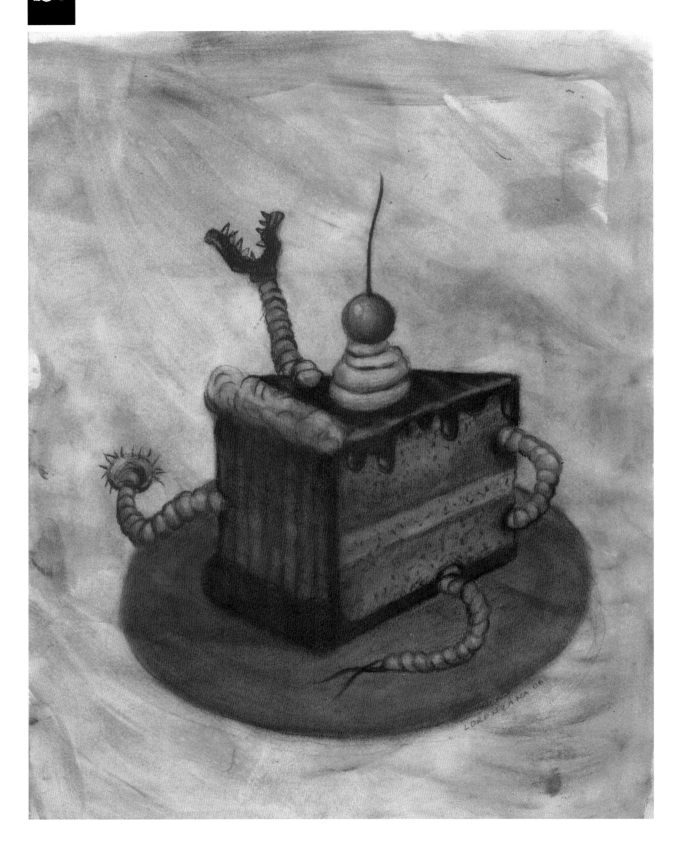

Choco Lava, 2006, Conte on Paper, 16 1/2 x 11 3/4"

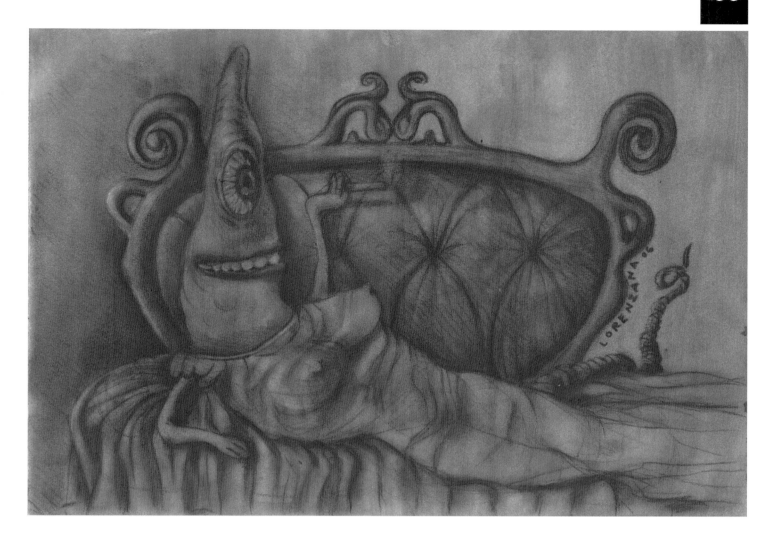

Princess, 2006, Conte on Paper, 11 3/4 x 16 1/2"

St. Snowman, 2007, Conte on Paper, 12 x 9"

Be My Love, 2008, Oil Pastel on Paper, 17 7/8 x 12"

Untitled, 2007, Graphite on Paper, 9 3/4 x 9"

Sketchbooks & Studies

IV

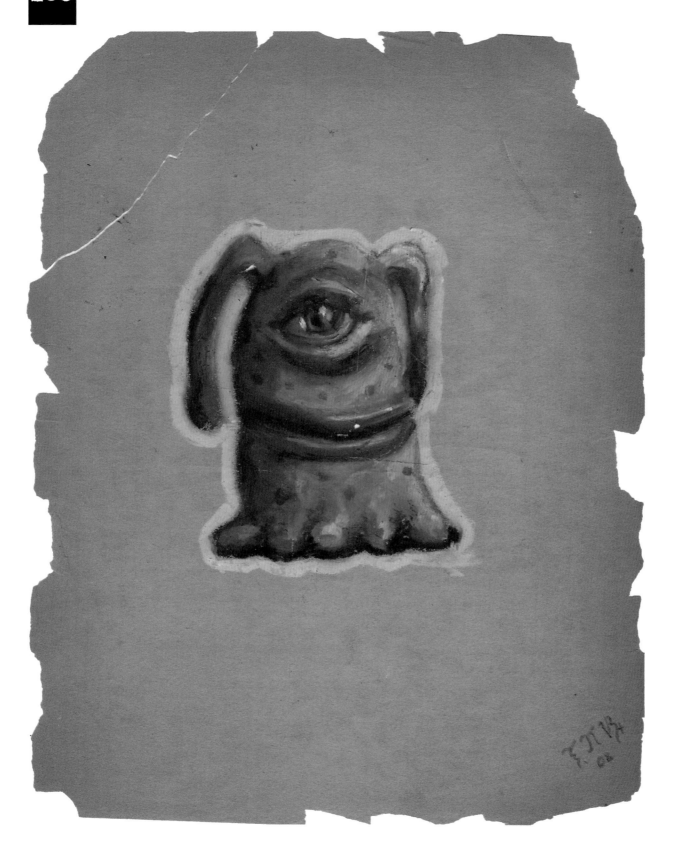

Untitled I, 2008, Oil Pastel on Vintage Parchment, 11 x 8 1/2"

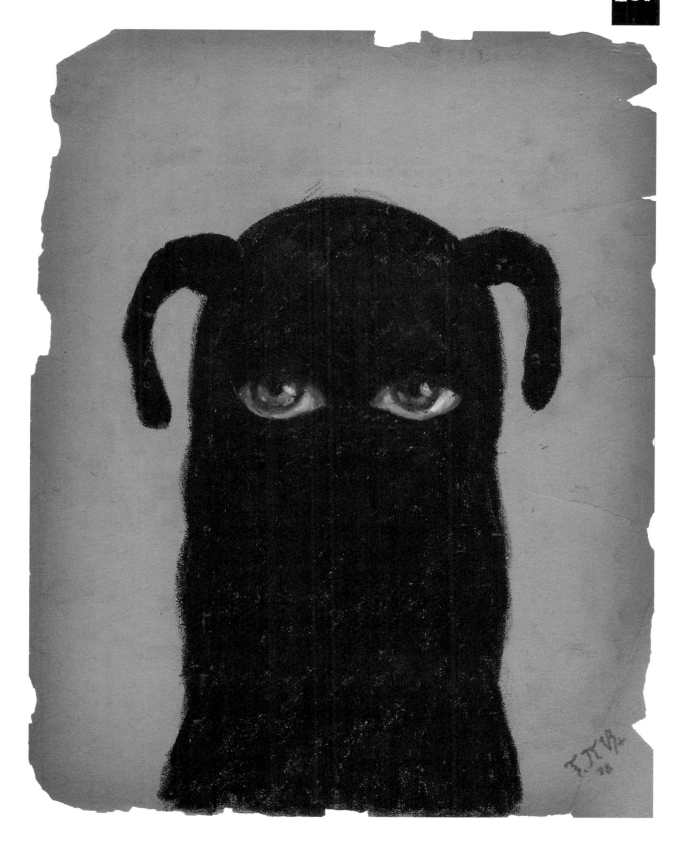

Untitled II, 2008, Oil Pastel on Vintage Parchment, 11 x 8 1/2"

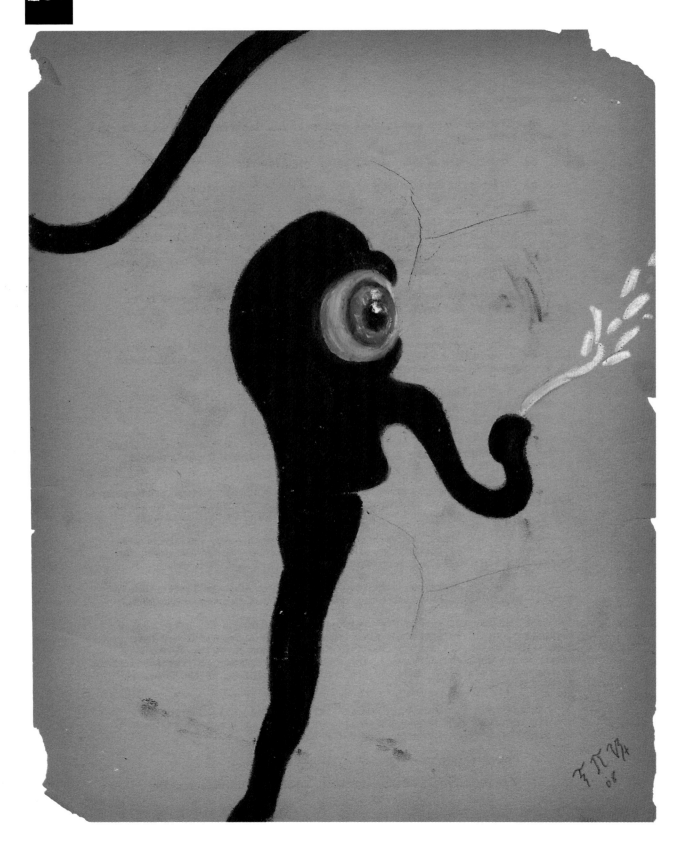

Untitled III, 2008, Oil Pastel on Vintage Parchment, 11 x 8 1/2"

Untitled IV, 2008, Oil Pastel on Vintage Parchment, 11 x 8 1/2"

Untitled V, 2008, Oil Pastel on Vintage Parchment, 11 x 8 1/2"

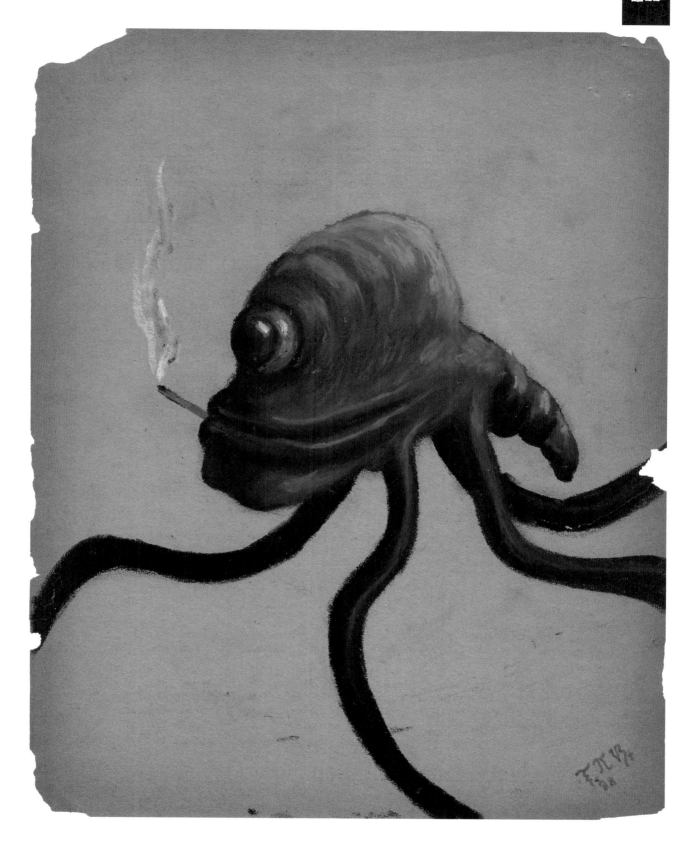

Untitled VI, 2008, Oil Pastel on Vintage Parchment, 11 x 8 1/2"

Untitled VII, 2008, Oil Pastel on Vintage Parchment, 11 x 8 1/2"

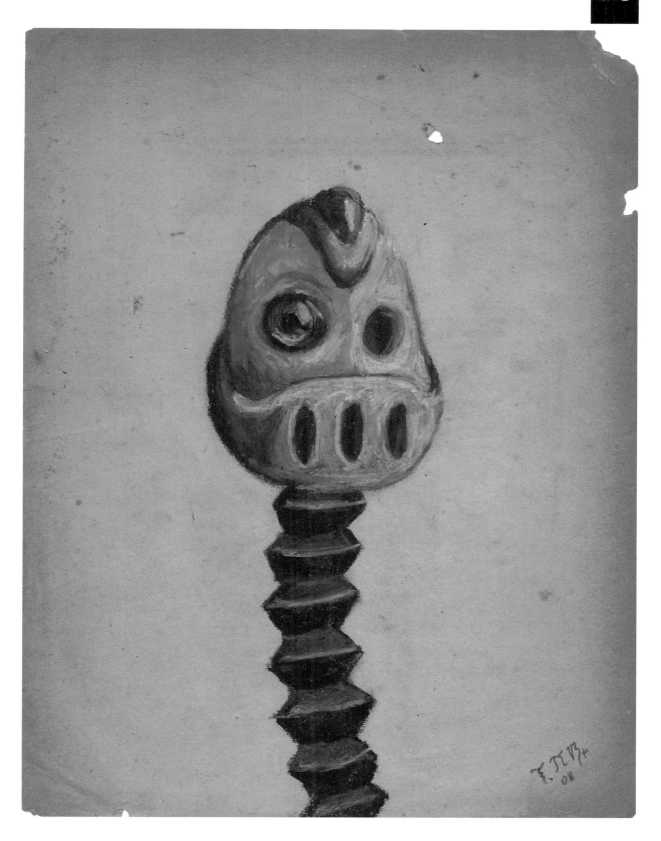

Untitled VIII, 2008, Oil Pastel on Vintage Parchment, 11 x 8 1/2"

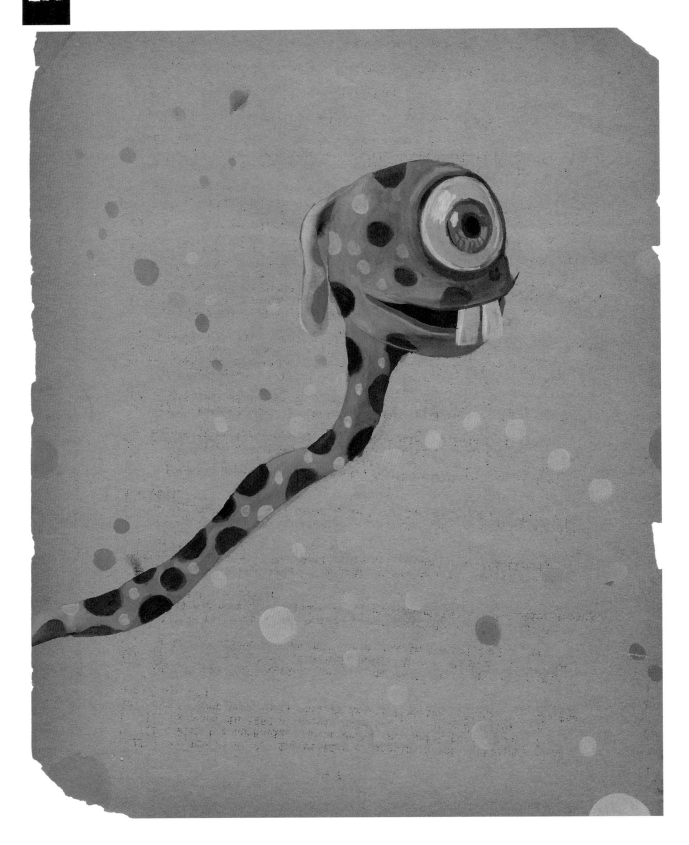

Untitled IX, Undated, Gouache on Vintage Paper, 11 x 8 1/2"

The Heroes of the Cretaceous Period
by Ryu Niimi

白亜紀の英雄たち
―躍動と暴動、あるいは、生の高揚。
―Luis Lorenzana の描く、未生の私たちじしん。

[　英雄たち　]

　９．１１。それはつまり、民族間の絶えない抗争の激化、その始まり。３．１１。それはつまり、人類が破壊し略奪し続けた自然からの、逆襲の始まりと、テクノロジーの脅威、その怪物的姿の出現の始まり。

　ポストモダンを体験して遥かな２０１０年以降の今日ほど、「英雄」不在の時は、歴史上かつて無かったのではないだろうか。

　そこで、ロレンザナの描く、これら、白亜紀の怪物のごとき、極めて「現代的な」英雄たちは、やがて、私たち自らの姿そのものとなり、やがては現代社会に、あるいは、自然のかそけき生命に映り込みながら、文明へ逆襲する、未来の「怪物」と出現になるのだろう。

　かくして、ロレンザナは、現代社会の猥雑、錯綜、混沌、奇妙奇天烈、摩訶不思議、阿鼻叫喚の、「まさに、坩堝の中心」的ブラック・スポットたるフィリピンにあって、突如として、産声を上げた、文明逆襲の英雄そのものである。

　ロレンザナの描くモチーフは、未生の私たちじしんを予想して、時空逆転的に変容しつつある。

　それは、文明の変容でもあり、また「絵画」そのものの起源を問う、芸術史の変容でもあるだろう。

　つまり、ロレンザナの絵画は、単に文明を逆襲する自画像としての「私たちじしんの現在」には、決して止まらないのだ。

　何故ならば、仮に起源論だけが究極的に正しいものではないとしても、あらゆる

優れた絵画とは、「絵画とは何か」を徹底して、根源的に描く「問いかけの絵画」であり、ロレンザナの絵画もまた、十全にその価値を有しているからである。

[　絵画史の背理　]

　西欧絵画における、私どものポストモダン的記憶、それは、おそらくは、１９８０年代に遡ることが出来る。

　結論から言うと、その総決算を、昨今世界的に流行しつつある、所謂ネオ・ポップなる（私的で、パーソナルで、断片的で、フラジャイルな、「小さな物語」を語る）世界的に著名な作家群いじょうに、このロレンザナが行う可能性がある、ということである。

　７０年代の冬の時代、つまり熱き狂想の６０年代、ネオ・ダダ、ポップが去って、ベトナム戦争が終結に向い、ホー・チ・ミン軍の戦車部隊が圧倒的な民衆の熱狂に迎えられてサイゴンに入城した、あの１９７５年。

　冷戦終期の時代に突入し、コンセプチュアル、さらには、ミニマルを経由した美術そのものが、再び具象的表現主義に投企した、かのニュー・ペインティング、ネオ・エクスプレッショニズの登場に、それは遡る。

　それは、来たるべきベルリンの壁の崩壊すら予想される、マルチン・グロピウス・バウでの「ツァイト・ガイスト（時代の精神）」展によって、口火を切られた。

　その後に、ハイチからやって来たあのバスキアが、そしてアメリカ・インディアンの古層や、マヤやインカの壁画群の「死と性の共存」をマンハッタンの地下鉄に甦らせた、あのキース・ヘリングが来た。

　例えるならば、それは、シカゴの病院の夜警として生き、死に、そして死後発見されて、今日ではニューヨークのアメリカ民俗美術館の至宝として、世界的な評価を得ている、ヘンリー・ダーガーの怪物群にも、比肩出来得るだろう。

　だが、ロレンザナの絵画は、それらを一気に突き抜けて、宮殿にかのイメルダ夫人の莫大な高級靴や、ハイ・クチュールの何千という衣装群を残して、かのマルコスがヘリコプターで消えてからちょうど三十年後、現代の虚無ならぬ、無常の廃墟

の「崇高なる」生命力を描き出す。

あれから三十年後、英雄は怪物となり、ポストモダン以降の絵画史を覆す、絵画の凶暴として、出現した。しかも、フィリピンに。

[　冬のロマン　]

私はまた、意外なことに、ロレンザナの表現に、その北方的に醒めた、ロマン性を見るものでもある。

冬の花火。

私はかつて、一度だけ訪れたかのマニラで、しかも、夜には街中がクリスマスの大小ファロ（聖家族を模った、極彩色の、クルクル光が回転するネオンならぬ、光源飾り）で溢れかえるあの冬の日、しんと静まり返った、ホセ・リサール公園の、ガランとして、あっけらかんと、虚無に開かれたような白い広場の佇まいを、忘れることが出来ない。

それはスペイン風というのには、余りにも、即物的に人間性を拒否するような、南の光の横溢であった。

冬の花火。

赤道直下で無いとはいえ、熱帯の熱気のふんぷんとするフィリピンにあって、ロレンザナの画期的な新作群、謂わば、新具象的表現の野獣性を謳歌するかのごとき、生命力溢れる、ネオ・プリミティヴ・ポップ的なる、旺盛な表現群を見るとき、私には、彼の個性のなかに意外にも、根づよく息づいている「ロマン的感受性」に驚かざるを得ない。

それは、実は風土的に言ういじょうに、北方的感受性、つまりは、十八世紀から十九世紀にかけて胎動した、ロマン主義、理性と可視的な物質のプロポーションの均整に基づく「古典主義」を司るアポロ神に対する、情念の神、つまり踊るディオニソスが、「今、ここで」、フィリピンに息づいている、その実存に対する、瞠目の事である。

ロレンザナは、だから言うまでもなく、ロマン派が否応なく、宿命的に持ってい

る「英雄主義」を匂わせる。

　彼の描くものは、その色彩、形象、いずれをとっても、極めて悲劇的な現世の救済譚であって、英雄の登場する、民衆の情念の彷彿がそのまま造形化したものであろう。

　ではそれは、何を誇っての、何に投企しての「英雄主義」なのか？

　それは、明らかに、ホセ・リサール的なる、民族神話ではなく、つねに「生成と消滅を、無限大から無限小にまで、瞬時瞬時に圧縮しながら繰り返す」フィリピン的時空間にたいしてだろう。

　たとえば、そこに響いているのは、アメリカの前衛音楽を切り拓いた、かのフィリップ・グラスが、２００９年に作曲した「アメリカの四季」、しかも、ヴァイオリンの震えるように、「虚無」の振動する「冬」であろう。

　ロレンザナの絵画の底には、また、現代音楽、ミュージック・コンクレートやミニマル・ミュージックの、ドラムの「虚無的」に鳴り響く、リズムの頽廃が横たわる。またそれこそが、グラスやライヒが、非ヨーロッパ圏の音楽の律動や躍動から、掬いあげていった、「ポストモダン的＝マルチ・カルチュラルな」制作欲動であった。

　私は、２０１２年、スティーヴ・ライヒ自身が東京で演じた、１９７１年の大作「ドラミング」を聴いたのだが、終わって後半、グラス自身も参加した「手拍子（クラッピング）」の、虚無への行進のごとくに、連続や繰り返しの進むごとの、圧倒的なリズムの力動に感動したのを、思い出す。

　あまりにも有名になった、バーバーのヴァイオリン協奏曲の、「削り込んで」「絞り込んで」、やがては、「無の薫る」終章とも交錯するだろうか。

　ロレンザナの描くものは、実存的存在としての人間ではなく、ユング的に跳梁跋扈する、無意識下の「怪物」どもである。

　それが、ロレンザナの描くのが、現代に甦った白亜紀の英雄たちとして、私どもを限りなく魅惑し、そして躍動させ、暴動させる原因なのだろう。

ARTIST CURRICULUM VITAE

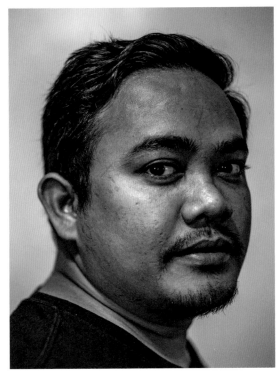

Luis Lorenzana, November 2016

SOLO EXHIBITIONS

2016 *Quickstrike*, Secret Fresh Gallery, San Juan City, Philippines

2014 *Instanity*, Silverlens Gillman Barracks, Singapore
 Monalisa Overdose, Secret Fresh Gallery, San Juan City, Philippines

2013 *League Of Luminous Lunatics*, Silverlens Gallery, Makati City, Philippines

2012 *Beautiful Pain*, Silverlens Gillman Barracks, Singapore
 Beautiful Pain, Silverlens Gallery, Makati City, Philippines

2010 *The Tales Of The Beer Fairies*, SLab, Makati City, Philippines

2009 *The Midnight Lullaby*, SLab 20Square, Makati City, Philippines
 Chasing Fantasies, Distinction Gallery and Studios, Escondido, California, USA

2008 *The Manila Folder,* Distinction Gallery and Studios, Escondido, California, USA

SELECT GROUP EXHIBITIONS

2016 Art Fair Philippines, Makati City, Philippines

2015 Art Fair Philippines, Makati City, Philippines

2014 *Extended Play*, Vinyl on Vinyl Gallery, Makati City, Philippines
 Art Basel Hong Kong, Hong Kong
 Art Fair Philippines, Makati City, Philippines

2013 *Ley Hunting, Pt. 2*, Silverlens, Makati City, Philippines
 Art Flood: Fundraising for Yolanda, Silverlens Gallery, Makati City, Philippines
 Art Basel Hong Kong, Hong Kong
 Art Taipei, Taiwan

2012 *Ley Hunting,* Silverlens Gallery, Gillman Barracks, Singapore
 Art HK 12, Hong Kong
 Art Stage Singapore, Marina Bay Sands, Singapore
 Taetrurn Et Dulce, MondoPOP, International Gallery, Rome, Italy

2011 ManilArt 11, Manila, Philippines
 Art HK 11, Hong Kong
 Pulse New York 2011, New York, USA

2010 Pulse Miami 2010, Florida, USA
 JEST in Time, Distinction Gallery and Studios, Escondido, California, USA
 Metamorphosis: BeinArt International Surreal Art Collective Group Exhibition, CoproGallery,
 Bergamot Station, Santa Monica, California, USA
 Art HK 10, Hong Kong
 Pulse New York 2010, New York, USA

2009 *Magistrates*, Strychnin Gallery, Berlin, Germany
 Tabi Tabi Po, 1AM Gallery, San Francisco, California, USA
 Life Essential, Art Whino Gallery, Maryland, USA
 Heavy Hitters-Maryland, Art Whino Gallery, Maryland, USA
 The Quantum Exhibit, Daniel Fountain Contemporary, Maryland, USA
 Inked Souls 2009, Art Whino Gallery, Maryland, USA

2008 *"2008 Toy Show" Customized Artist's Toys Exhibit*, MF Gallery, Live Fast NYC, USA
 Project 5X7, Distinction Gallery and Studios, California, USA

2006 *Philippine Art Awards 2006 Exhibition*, National Museum of the Philippines, Manila

2000 *Philippine Art Awards 2000 Exhibition*, Metropolitan Museum of Manila, Manila
 Dos Por Dos, Boston Gallery, Boston Street, Quezon City, Metro Manila

AWARDS

2006 Top 30 Artists, Philip Morris *Philippine Art Awards 2006*, Philippine National Museum
 Top 5 Finalists, International Book Illustration Competition for the Booker Prize Awardee, "*Life of Pi*," sponsored by
 The Times UK and Canongate Publishing, London, England. Featured in *The Times London*, 2006

2005 Finalist, *2005 Epson EPIX National Photography Competition*, Mandaluyong City, Metro Manila
 Finalist, *2005 Metrobank Art and Design Excellence*, Metrobank Foundation Oil Painting Category, Manila
 3rd Place, National Commission for Culture and the Arts (NCCA) National Arts Month,
 Web Gising National Digital Art Competition, Manila
 Finalist, National Commission for Culture and the Arts, *National Arts Month Painting Competition*, Manila

2004 Finalist, Painting Category, *Art Association of the Philippines Annual Competition 2004*, GSIS Museo ng Sining, Manila
 Grand Prize Winner, *Spanish Festival for Culture and the Arts Painting Competition*,
 sponsored by Instituto Cervantes, Manila
 Finalist, Oil Category, 2004 *Young Painters' Annual*, Metrobank Foundation, Manila

2003 Finalist, Oil Category, 2003 *Young Painters' Annual*, Metrobank Foundation, Manila

2002 Semifinalist, Oil Category, 2002 *Young Painters' Annual,* Metrobank Foundation, Manila

2001 Semifinalist, Oil Category, 2001 *Young Painters' Annual,* Metrobank Foundation, Manila

2000 *Top 50 Artists*, Philip Morris *Philippine Art Awards 2000,* Metropolitan Museum of Manila

EDUCATION

2000 Bachelor of Arts in Public Administration
 University of the Philippines Diliman, Quezon City

-LGN

OPPOSITE FIGURE 31: *Number 16F*, 2006, Graphite on Paper, 11 3/4 x 8 1/4" (color graphically altered)